Masters of the Japanese Print

Masters of the

Japanese Print

BY RICHARD LANE

90 plates in colour 50 in black and white

THAMES AND HUDSON
LONDON

THIS BOOK IS DEDICATED TO
JAMES A. MICHENER
ROBERT P. GRIFFING JR
FELIX JUDA

FIRST PUBLISHED IN GREAT BRITAIN 1962
BY THAMES AND HUDSON LONDON
PLANNED AND PRODUCED BY CHANTICLEER PRESS NEW YORK
ALL RIGHTS RESERVED. EXCEPT FOR BRIEF QUOTATIONS IN
REVIEWS NO PART OF THIS BOOK MAY BE REPRODUCED WITHOUT
PERMISSION IN WRITING FROM THE PUBLISHERS
TEXT AND PLATES PRINTED BY AMILCARE PIZZI MILAN ITALY
THIS EDITION MUST NOT BE IMPORTED FOR SALE INTO THE
UNITED STATES OF AMERICA SPAIN CENTRAL AND SOUTH AMERICA

CONTENTS

	Preface	6
	Introduction	7
I	THIS FLEETING, FLOATING WORLD *The Rise of Japanese Genre-Painting*	10
II	THE FLOWERING OF UKIYO-E *The First Prints and Moronobu*	34
III	GODDESS IN A KIMONO *The Kaigetsudo Painters*	61
IV	FROM BOMBAST TO SERENITY *Kiyonobu and the Torii Masters*	75
V	GRACE AND LIVELY WIT *Okumura Masanobu and Others*	102
VI	BEAUTIES IN THE SHADE *Some Eighteenth Century Painters and Illustrators*	125
VII	THE FLEETING DREAM *Harunobu, Koryusai, Buncho*	149
VIII	REALISM AND THE WORLD OF KABUKI *Shunsho and Sharaku*	178
IX	LOVELY GIRLS *The "Golden Age" of Ukiyo-e*	200
X	A TOUCH OF DECADENCE *Utamaro and After*	220
XI	" THE OLD MAN MAD WITH PAINTING " *Hokusai*	250
XII	VIEW FROM AN ENCHANTED WINDOW *Hiroshige and the Japanese Landscape*	269
Epilogue	FROM UKIYO-E TO INTERNATIONAL ART *The Twentieth Century*	297
	Note on Pronunciation and Size of Prints	313
	Acknowledgments and Credits	314
	Index	315

PREFACE

This volume reflects the following convictions: first, that ukiyo-e—Japanese prints and genre paintings—achieved a peak of artistic quality practically from its commencement, and in general maintained that level throughout the seventeenth and eighteenth centuries. Most Western books on ukiyo-e emphasize styles that are closest to our own; after some years of considering the subject and living among the Japanese people, I have here chosen the artists who seem really significant, whether or not they are yet well known in the West.

My second conviction is that the finer ukiyo-e paintings are fully as great as the prints. The paintings are comparatively rare and are, by their nature, beyond the reach of the average Western collector; the fact that there are few important ukiyo-e paintings in the West has been the principal reason for their being little known even among enthusiasts or scholars. Yet in the artists' own day, it was their paintings upon which they concentrated their greatest efforts. The reader will therefore find here a departure in the form of a unified discussion of both paintings and prints. In several cases—e.g., Kaigetsudo Ando and Miyagawa Choshun—he will realize for the first time the stature of artists who devoted their lives to the painting of ukiyo-e masterpieces yet never allowed their work to be printed for popular consumption, and hence are hardly known among either collectors or connoisseurs in the West. No stronger argument could be presented for a re-evaluation of ukiyo-e painting than this.

Tokyo - Honolulu - Kyoto, 1958–1962.

INTRODUCTION

*Neither Kano nor Tosa
can paint it:
Main Street — Yoshiwara*

(Eighteenth-century epigram)

SPEAK of Moronobu, and to the mind's eye appears a procession of vigorous, picturesque figures, all the motley citizenry of old Edo; the magic name of Harunobu evokes slender, ethereal girls, as lovely and fragile as the first frost of winter; Utamaro, Hokusai, Hiroshige — each name stands for a unique and arresting kind of beauty, whether of voluptuous femininity, masculine strength, or scenic grandeur. These men, and several dozen more, represent the ultimate glory of ukiyo-e (*ookee-yóh-eh*) — "pictures of the fleeting, floating world."

The ukiyo-e masters mark a fitting conclusion to the long and glowing tradition of classical Japanese art. Like the era which nurtured it — the Edo Period (1600–1868) — ukiyo-e art represents a unique development in Japan, the growth of a great renaissance based upon a largely *popular* foundation, whereas the earlier high points of Japanese civilization had been forged largely by the aristocracy or the priesthood. That such popularization did not result in vulgarization is one of the wonders of the world of art. This was the consequence, in part, of the innate sense of restrained form and color harmony of the Japanese populace as a whole. At the same time the determined efforts of an enlightened group of artists, artisans, publishers, connoisseurs, and patrons ensured that ukiyo-e standards would always remain several degrees above the level the populace considered "acceptable."

Politically and socially this was a feudal, almost totalitarian age; the masses accepted the voice of authority in most of their social activities. In their arts, too, they were willing to follow the lead of a loosely bound group of "style dictators," much as women have sometimes followed Paris fashions in our own day. The result was two centuries of ukiyo-e woodblock prints, a continuous flow of high quality which was both the reflection and the

7

arbiter of popular taste. And while we may give most of the credit for this phenomenon to the masters who directly produced ukiyo-e, we should not underestimate the power of the populace which supported it. What was even more critical than their taste was the inner need they felt for possessing fine art of their own. What makes the phenomenon of ukiyo-e even more curious is the fact that the Japanese populace was primarily obeying aesthetic instincts, rather than consciously anticipating the unique art form is was to support for such a long period.

After a brief period of intercourse with the Western World, Japan's feudal rulers, the Shoguns, had decided in the early seventeenth century to shut off their nation from the rest of the world. Their motives were largely political, including a fear of the encroaching colonial powers and a 'firm resolution to concentrate their efforts on maintaining the delicate balance of power among the dozens of feudal barons at home. This policy of national seclusion was maintained until the United States forced the opening of Japan, over two centuries later, in 1854. Japan thus missed the glories of the European Renaissance and the Age of Scientific Discovery. Commodore Perry opened the country to the effects of the Industrial Revolution, and that was the end of ukiyo-e, and of Old Japan.

Although the general course of Japanese art has, of late, become widely known, it may be of interest to outline the immediate predecessors of ukiyo-e, most of which continued to exist side by side with the new form — though usually appealing to a different class of society.

During the preceding Heian, Kamakura, and Muromachi periods (in the ninth to sixteenth centuries), Japanese painting had developed on two broad fronts, one principally native and one based upon Chinese models. The Japanese styles of painting generally emphasized gorgeous coloring and softness of contour, and most often took their themes from native subjects. Originally termed *Yamato-e* ("Yamato pictures" — from the old word for Japan), by the fifteenth century the style had come to be associated most closely with the painters of the Tosa school, who enjoyed the patronage of the declining Kyoto court nobility. The more linear Chinese styles of painting, on the other hand, were highly varied in manner, depending upon several sources of inspiration. Most prominent of the Chinese styles was the school of Buddhist ink painters (headed by the great Zen priest Sesshu), who concentrated on boldly simplified monochrome paintings of Chinese subjects; and the members of the Kano school, who eclectically

combined the features of the Chinese styles with the coloring and other devices of the Japanese—style painters, and were often the favorites of the military rulers, the Shoguns. Due partly to its intimate connection with the dictatorial ruling class, the Kano school was the most popular and influential of the classical schools during the period of ukiyo-e's development, and it was only natural that several of the greatest ukiyo-e masters should have received training under Kano teachers—although at the same time, they indirectly derived much from the Tosa painters as well.

Ukiyo-e, in short, was a hybrid school of painting and print design which took its basic themes from the current scene but adapted many classical methods to the treatment of its new subject. After long generations of exposure to the well-worn classical Chinese and Japanese subjects, it is not surprising that an artistic school devoted to parodies on the classics, and pictures of the more glamorous aspects of the modern world should have found a receptive audience—among art connoisseurs as well as the populace of the cities. Ukiyo-e was never quite to attain the prestige of the Kano and other traditional schools, but it captured the hearts of the Japanese people almost immediately.

THIS FLEETING, FLOATING WORLD

The Rise of Japanese Genre Painting

" ... *Living only for the moment, turning our full attention to the pleasures of the moon, the snow, the cherry blossoms and the maple leaves, singing songs, drinking wine, and diverting ourselves just in floating, floating, caring not a whit for the pauperism staring us in the face, refusing to be disheartened, like a gourd floating along with the river current: this is what we call the* floating world... "

—Asai Ryoi: *Tales of the Floating World* (Kyoto, *ca.* 1661)

IT is rare indeed for a single word to express within itself the changing concepts of an age. *Ukiyo* ("this fleeting, floating world") is such a word: in medieval Japan it appeared as a Buddhist expression which connoted first "this world of pain," with the derived sense of "this transient, unreliable world." Etymologically it thus meant "this fleeting, floating world." But for the newly liberated townsman of the seventeenth-century Japanese renaissance, "floating world" tended to lose its connotations of the transitory world of illusion, to take on hedonistic implications and denote the newly evolved, stylish world of pleasure—the world of easy women and gay actors and all the pleasures of the flesh.

By the time the suffix *e* (meaning "pictures") had been added to form the new compound *ukiyo-e* ("floating-world pictures") around the year 1680, this hedonistic significance had become predominant in the expression. Thus the subject of our book, ukiyo-e, meant something like the

following to the Japanese of the age which engendered it: *A new style of pictures, very much in vogue, devoted to depicting everyday life, particularly fair women and handsome men indulging in pleasure, or part of the world of pleasure—pictures, as often as not, of an erotic nature.*

But what brought about this new development in Japanese art, this revolutionary shift from the overworked themes of classical tradition to those of the workaday world?

Ukiyo-e had its origins in the sixteenth century, a period of social and political unrest when the country was torn by civil wars, a period when even a peasant's son, Hideyoshi, could become ruler of the Empire. The newly risen feudal lords could hardly make up overnight for their ignorance of the subtleties of the Chinese philosophy, literature, and art which had been the delight of their cultivated predecessors, the Muromachi Shoguns. They did, however, want immediately the symbols of victory and power—magnificent castles, with their full complement of elaborately painted screens and murals. Thus it was that the first great developments in the culture of the new age came in the field of architecture and painting rather than in the other arts. For it must be said that liberal patronage was a primary stimulant in nearly all the great developments of traditional Japanese art, and that the concept of the impoverished genius painting unrewarded in his garret is a relatively recent one in Japan.

What the newly rich feudal lords demanded was not the perceptive, subtle monochrome imagery of the Chinese-inspired paintings favored by their predecessors, nor the miniaturistic color harmonies of the Tosa court painters, but something rich and bold and magnificent, great paintings that would burst forth like fireworks from the inside of a dimly lit castle, and proclaim to all the world that a new master had arrived. Thus was born the characteristic art of the Momoyama Period (late sixteenth to early seventeenth centuries)—gorgeous screens and panels featuring bold patterns of trees and animals painted in vivid colors on a glittering ground of pure gold leaf. But who were the painters?

Obviously, superior painters could not develop overnight, and what happened was simply that the traditional artists were requisitioned by the new lords, and had no choice but to adapt their styles to the new age and new demands. In effect, though, this enforced change served to give new life to their art, which had declined through the absence of just such fresh stimuli. For this reason the art of the Momoyama Period, though often

patronized by uneducated warlords, was to prove one of the permanent glories of Japanese civilization.

Momoyama painting is not characteristically ukiyo-e; yet from time to time in the art of the late sixteenth century we catch magnificent glimpses of the everyday life of the times, and it is in these genre scenes that ukiyo-e found its immediate origins. An occasional interest in the details of the life of the commoner and peasant had, it is true, been revealed in the classical scrolls of earlier periods. Yet these were but passing glimpses, and were never to develop into any sustained interest or style. In many of the Momoyama paintings, however, we note a continued fascination with scenes of daily life. Clearly the feudal nobility, either in fond reminiscence of their own humble origins or in simple curiosity at the activities of the common people, had discovered that the current, passing world could form a subject just as absorbing as the traditional scenes from nature and classical legend.

In short, genre screens and murals came to be painted in considerable numbers by the artists of the traditional schools—principally the Kano and the Tosa. Their subjects included, of course, the elaborate excursions of the lords to famous sites, the magnificent popular festivals of the great Buddhist temples and Shinto shrines, but also vivid scenes of life along the highways or detailed views of the streets of the capital, Kyoto—with the multiform activities of the common citizens recorded in minute detail. Such screens were already in existence by the time Japan was unified around the year 1600 and the Edo Period established. From that time Japan settled down to a peaceful regime unique in world history, a strict feudal reign which soon purposely isolated the Empire from the rest of the world, and thus maintained a freedom from destructive war for more than two and a half centuries. This, the Edo Period, was so named from the fact that the feudal capital was moved to Edo (the present Tokyo), leaving the Emperor behind in the nominal capital, Kyoto, as a figurehead of ritual. The Edo Period (1600–1868) was to produce one of the most unusual bodies of culture ever known to man, with ukiyo-e not the least of its marvels.

Ukiyo-e developed in no vacuum—indeed, much of its success lay in its striking adaptation of the best of classical Japanese art to the new age. Plate 1 gives us a graphic idea of the world from which ukiyo-e evolved.

Although the great age of the classical picture scrolls was some two to five centuries earlier, the best of the traditional Tosa work in the sixteenth century is of considerable interest and charm. Plate 1 shows a pano-

rama from one such scroll, painted toward the end of the sixteenth century, just at the time when the ukiyo-e style was beginning to develop. There is no real sign of such impending developments as ukiyo-e here, but we do note the firm tradition of color harmony and graceful composition that was to provide the artistic background of the new art. Without this splendid artistic tradition to draw upon, ukiyo-e would, at best, have been a crude, if interesting, folk art, and possibly it might never have gone beyond the bounds of such a plebeian art form as the Otsu pictures (Otsu-e), a style of powerful but limited folk painting for tourists, which flourished at the village of Otsu, near Kyoto, from the seventeenth century.

Contemporary with the scroll and book illustration shown in Plates 1 and 3, the new interest in everyday life began to express itself in work done by other members of the traditional schools of painting—for example, the Kano, the Tosa, and even the followers of Sesshu—for their patrons among the feudal nobility. The scenes represented were often of the upper classes at leisure. For example, there is the famous large screen of this type by Kano Hideyori (in the Tokyo National Museum), painted around the 1550's, which depicts a spirited maple-viewing party at Mt. Takao, or the pair of screens by Kano Naganobu, of the late 1590's (Hara Collection), showing dancers under cherry blossoms before a noble audience. The numerous "southern barbarian screens" (namban-byobu), depicting the European traders and missionaries in Japan during the first quarter of the seventeenth century, reveal another interesting adaptation of traditional styles to contemporary themes.

Whether we may consider such works as these true ukiyo-e, though, is a matter of debate among Japanese scholars, some of whom hold that this early genre painting has an "ukiyo-e flavor," but lacks the plebeian atmosphere that is one of the characteristics of ukiyo-e in its full development. Carried to its logical conclusions, however, this limited definition of ukiyo-e would exclude many of the nonplebeian subjects of the later prints (Plates 19, 73, 84, 110, 118, 125, 134, 140, etc., in this book, for example). It would seem more reasonable to include the late sixteenth-century genre screens at least among the "semi-ukiyo-e" works that laid the foundation for the more fully developed style of some decades later.

The Tosa school of painters for the Imperial Court, whose colorful, graceful work we have seen in Plates 1 and 3, gradually declined—as did their patrons. Removing from the capital to the port of Sakai in the

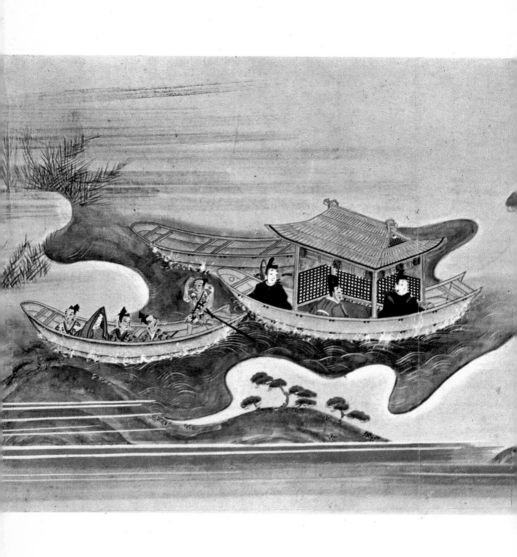

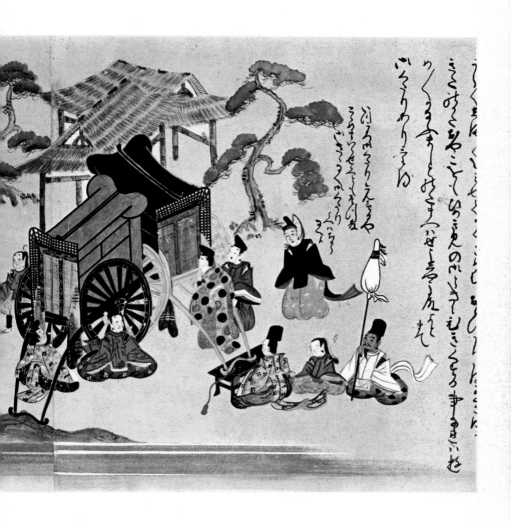

1 Tosa School. The Cave Tale Scroll. *Late sixteenth century. At left, a small ship bears the young princess, heroine of the tale, into exile—victim of her wicked stepmother's malicious plot. At right, courtiers with their bullock carts by a seaside village. Painting on paper; section of a long hand scroll.*

turbulent sixteenth century, this school was never able to recover its formerly dominant place in Japanese painting. The Tosa painters continued to do refined work for the declining court nobility; their traditions were also carried on in modified form in a semipopular style called Nara pictures (*Nara-e*), which continued to meet the need among the middle and upper classes for finely illuminated books and scrolls in a period when printing was not yet widespread and efficient color printing yet to be developed. The best of the Nara pictures (see Plate 3) are in a modification of the late Tosa style we have seen in Plate 1; the majority of them represent, however, a less skillful, more artisan kind of modification of this courtly style.

The scroll seen in Plate 2 belongs rather to this latter type. But though most of its dozens of illustrations treat the legends of the founding of the Tenjin Shrine in traditional late Tosa style, in the final panorama (over five feet in length), of which only a detail is shown here, we see an intimate, realistic view of the actual populace of the time, the Tosa style fading into ukiyo-e by the force of the very genre subject represented. In this scroll it is thus possible to see the late Tosa and the early ukiyo-e side by side and produced by the same artist. One of the remarkable features of the ukiyo-e to come will be just this habit of radical adaptation of style to content. Even in such late masters as Kiyonaga, Eishi, Hokusai, and Hiroshige we will find many prints and paintings which hark back to aristocratic themes and, accordingly, reflect traditional Tosa or Kano, rather than ukiyo-e, styles. (Plates 7, 19, 49, 52, 73, 78, 79, 84, 87, 95, 110, and 118 each show facets of classical vestiges in the Ukiyo-e school.)

So far we have concerned ourselves with early genre representations of ordinary scenes of daily life and leisure. Ukiyo-e, however, was soon to choose as its special domain the amusement quarters of the great Japanese cities—the courtesan districts and the Kabuki theaters—and these themes were to provide the basis for at least two-thirds of ukiyo-e art in the seventeenth and eighteenth centuries. In the early nineteenth century, when that art was dying out through lack of new subjects and themes, Hokusai and Hiroshige revived it with their fresh approach to landscape, a subject hitherto fully exploited by traditional painters but never by the artists of the Ukiyo-e school.

Quite frankly, then, much of the best of ukiyo-e chose as its subjects the courtesans and actors—classes which were considered "parasitic outcasts" by the feudal government, but which were actually the idols of the

16

masses and the bourgeoisie alike. It must be said at the outset that anyone who finds pictures of poised courtesans and posing actors uninteresting will have difficulty in enjoying or appreciating ukiyo-e during any but the last few decades in which it flourished.

One does not have to be able to read Japanese to find out that the courtesan was an important person in the social life of Old Japan: that fact will be obvious even from a glance at the art or literature of the period. The Japanese male, his marriage prearranged for him by his parents while he was still in puberty, apparently needed some outlet for the urge to romantic adventure. High adventure was well-nigh impossible, for the land was ruled by a strict military dictatorship; travel outside Japan was, after the 1630's, punishable by death, and it was rare for a townsman, whatever his wealth, to rise into the glamorous samurai society. The townsman's only area for adventurous self-expression lay in the making of money and the spending of it, the latter principally in the courtesan district. Though love was largely an item of commerce in this quarter, a man was at least free to choose his own sweetheart and, if he could afford it, reserve her for his own pleasure.

So it was that, following the establishment in each of the major Japanese cities of licensed quarters, these districts, with their highly trained and educated courtesans, soon became the acknowledged centers of male social life, the haunt of connoisseurs and literati as well as of rakes and gallants. During the first half of the seventeenth century the upper levels of this pleasure-bent society were apparently dominated by the more wealthy samurai. But from midcentury on it was the townsman who gradually came to reign supreme. With the continued growth of a mercantile economy, the average samurai became more and more impoverished and less and less able to afford such costly pleasures. Thus from the 1660's onward, the

17

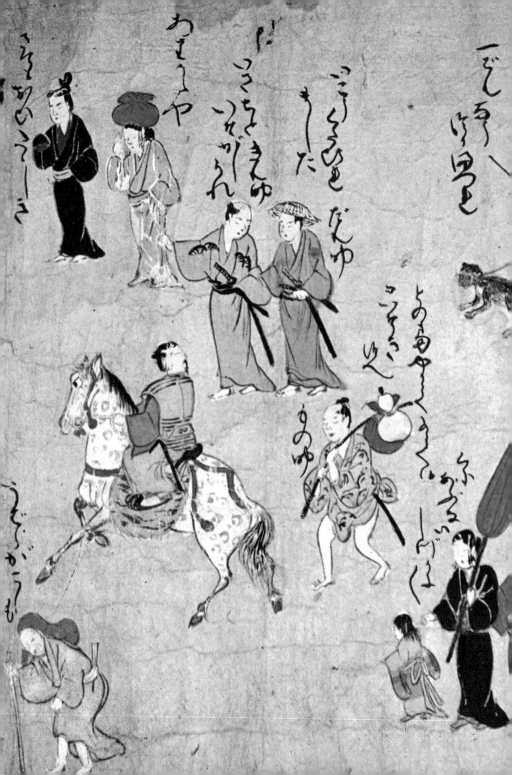

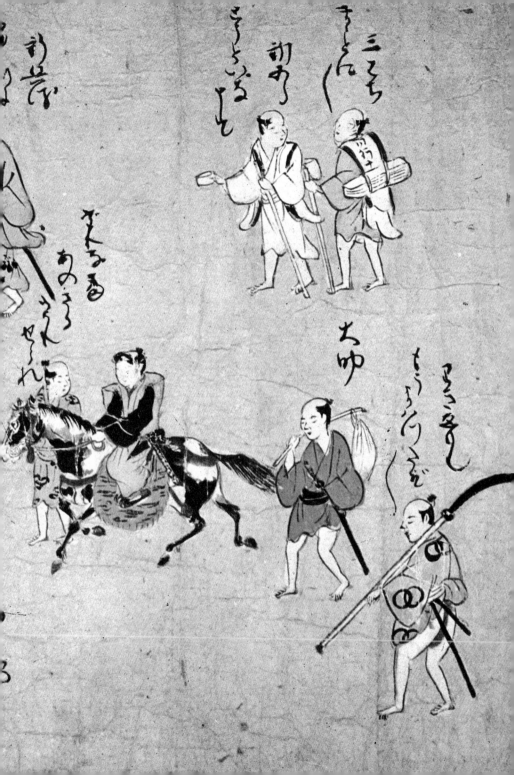

demimonde became almost a monopoly of the middle- and the upper-class townsman.

Such quarters as the Yoshiwara in Edo formed the centers of pleasure and refined entertainment in the cities of Japan; as they grew, there developed a large body of literature and art, produced almost exclusively to amuse or celebrate this world. The literature was a type of gay novel that came to be called *ukiyo-zoshi*, or "floating-world booklets"; Saikaku is the best known of the authors of this literature, but he had numerous imitators and followers. On the artistic side, the result of this "renaissance of gaiety" was the flowering of ukiyo-e, or floating-world pictures.

In a world where money reigned, it was only natural that the more strong-willed of the courtesans should develop certain standards of their own in judging a lover or would-be lover. This code and these standards were to play a major role in molding the average townsman's attitude toward the courtesan. She could be had, theoretically, for money; at the same time, a guest who tried to force himself upon a courtesan would be considered a *yabo*, or "crude boor," and become the laughingstock of the gay quarter. The Japanese courtesan was thus at once a prostitute and not a prostitute. She was, indeed, bought for money; but at the same time she enjoyed a considerable degree of freedom and influence in her own limited world. It was this unique quality—plus the traditional Japanese unconcern with "moral problems" in this connection—that was to make the Japanese courtesan (at once resembling and differing from the ancient Greek *hetaera*) the subject and the stimulus of a vast body of surprisingly excellent literature and art that was to sustain itself for nearly three hundred years.

The following brief sketch, translated directly from an Osaka "courtesan book" of 1680, offers an early example of the type of literature which celebrated the courtesan, and at the same time gives a more direct insight into this peculiar world than my own words could. The scene (taken from *The Gong of Naniwa*, Book I) is a house of assignation in the Shimmachi gay quarter of Osaka.

MADAM: Ah, Mr. Shichi, it's good to see you. But I'm afraid Miss Masayama is already engaged for today. I'm really very sorry.

THE MAN: Well, I'm glad to hear she's so popular. But I doubt that I'll have another chance to come this year, so I'd like to have her cancel the other engagement.

MADAM: Now you're being unreasonable—particularly since her present guests are here for the first time. Please postpone it until tomorrow.

THE MAN: Apparently there's use no talking to you. Please call Miss Masayama.

3 Anonymous. Lovers in Flight. 1590's. The love-hero Narihira hides in a moor with his sweetheart, as armed pursuers search for them. Painting in colors on paper; detail from an early "Nara-picture" edition of the Tales of Ise.

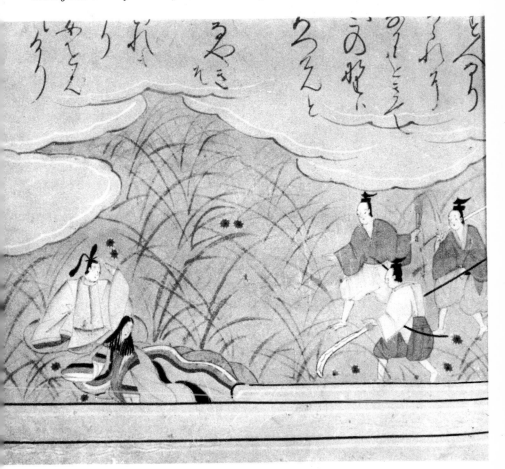

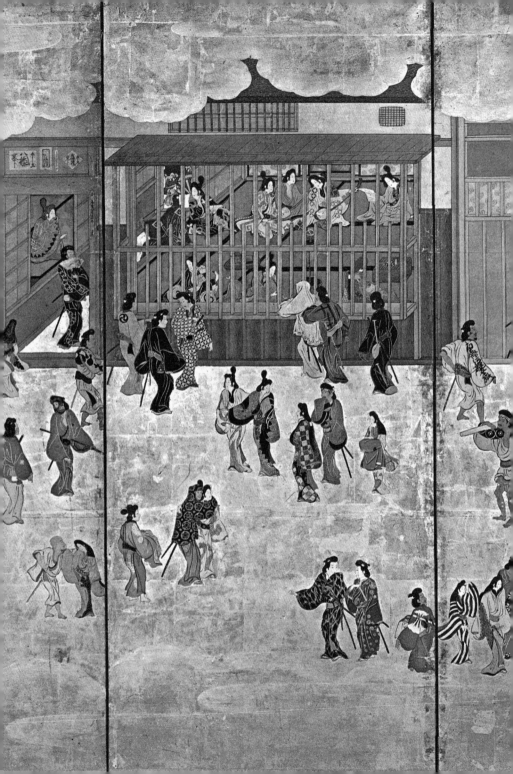

*(Left) Early Ukiyo-e
ool. Scene in Kyoto Gay
rter. 1640's. At top is a
se of assignation, where
tesans display their charms
nd grilled windows. They
e love letters, play instru-
ts, or converse with men
ugh the grillework. In the
et travelers, rakes, dilet-
es, and girls of the quarter
s on parade. Painting on
l leaf and paper; detail
a large six-panel screen.*

*(Right) Early Ukiyo-e
ool. Courtesan with Dog.
o's. Painting on gold leaf;
ge panel.*

MADAM: But you know that in a case like this, there's nothing that even Miss Masayama can do about it.

THE MAN: Well, anyway, have her come.

MISS MASAYAMA: (entering) You always seem to arrive just at the wrong time. Why can't you come when I'm free for once? Especially since it's the first visit of these gentlemen, you know there's nothing I can do. Please go right home now, and come tomorrow without fail.

THE MAN: No, I'm going to see you whether it's allowed or not. Today's the day I want you.

MISS MASAYAMA: Well, then, you can do just as you please. But since I can't see you, we'll have to find you a substitute.

THE MAN: That's just fine with me. Find me a courtesan I'll like.

MISS MASAYAMA: One you would like, I won't like. Since that's the case, you can't have a substitute either. Please go right home.

THE MAN: Now, that is silly talk. Since I won't be seeing you any more, you can't expect to restrain me.

MISS MASAYAMA: So you aren't going to see me any more. *That's* why you've been acting so unreasonably. If that's the case, by the gods, you'll see me whether you like it or not. I won't move from this spot.

MADAM: That's all very reasonable, but you know that really won't do. Let me do the explaining. Mr. Shichi, for today, won't you please go home? And Miss Masayama, since it's the first visit of those gentlemen, won't you please go right back and attend them?

MISS MASAYAMA: No, I've already explained it to him. Since he won't listen to reason, there's nothing to be done. And as long as Mr. Shichi is being unreasonable, I will be, too. Though he says he will be satisfied with another girl, that doesn't satisfy me at all. Oh, I hate you!

THE MAN: Hey, what're you doing. Let go of my hair. You've messed up my hairdo, damn you. I'll slap you in the face.

MISS MASAYAMA: You aren't going to slap *my* face. If you were really serious about me, you wouldn't act this way. We're through.

MADAM: Miss Masayama, please compose yourself; this is really no way to act. Mr. Shichi is also to blame. For today please give

24

up the idea of being together, and meet tomorrow instead.

MISS MASAYAMA: Madam, your method doesn't appeal to me at all. For even though Mr. Shichi may have had a change of heart, that doesn't mean that my feelings for him will be any different from before. Though it may be inconvenient for the gentlemen here today, I cannot give up Mr. Shichi for their sake. Please do not interfere.

THE PROPRIETRESS (*entering*): Well, well, this is really a case of true love. This kind of courtesan is really too good for Mr. Shichi. Miss Masayama, please return for the moment. As for Mr. Shichi, we'll use our influence and not let him get away from you. Now please go back to your guests.

THE MAN: Well, then, if that's the case, I'll give in for today. I'll see you tomorrow without fail, whether you've got another engagement or not. Now go on back.

MISS MASAYAMA: I'll see you tomorrow without fail. At the cost of my life, I won't let you get away from me. Madam, please take good care of him... (*she exits.*)

THE PROPRIETRESS: Well, Mr. Shichi, did you hear what she said? Even after such a quarrel as this, she asks us to take good care of you. What a loyal heart she has. And saying she won't let you go even if it costs her life. Even when you're not here, she never speaks ill of you. When a day or two has passed without a letter from you, she always sends her maidservant here to inquire after you. Please treat her a little more affectionately, won't you?

THE MAN: Isn't this present disturbance just because I am so fond of her? The path of love is never easy, but really, I couldn't restrain myself today. I'll stay with her both tomorrow and the next day, too. Well, Madam, I'll be going now. Adieu until tomorrow.

If anything, the art which celebrated the courtesan tended to be more subtle, more universal, than the literature; this is surely the reason why the masterpieces of the ukiyo-e school appeal to connoisseurs the world over, whereas the literature, even when translated, interests only a small audience with a taste for the exotic.

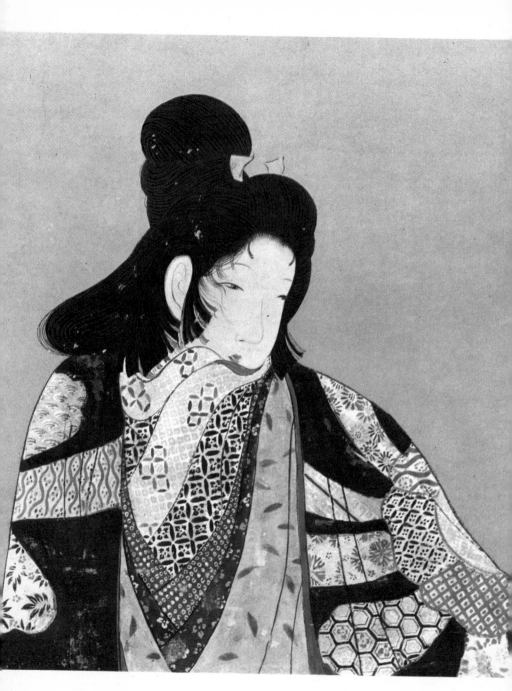

In Western art we have, of course, a school of portraiture specializing in full-length paintings of fair ladies, most often of specific eminent individuals. For the equivalent of the Japanese *bijin-ga*—paintings and prints of beautiful girls and courtesans as the focal point of a vast semipopular, semierotic art form—we must perhaps turn to the nude in Western painting.

The nude, it happens, never developed as a separate form in Japanese art; the emphasis in female beauty lay most often on the facial features, the long raven hair, and the kimono. Certainly it cannot be denied that the elaborate Japanese kimono was a work of art in itself, well worthy of enshrinement in the graphic arts. Perhaps more than in any other country, the dress became a vital criterion in the appreciation of feminine beauty. The matter was stated very plainly by the courtesan Naoe of the Shimmachi pleasure quarter in Osaka. At the time of the Kansei reforms of 1789 and after—a period when the feudal government was attempting to restrict all luxuries—this redoubtable female sent in a strong protest to the authorities against the ban on rich kimonos. She said, in part, "Our world is different from the ordinary world... If we were to dress ourselves just like ordinary girls, how on earth could we manage to attract lovers?"

The earliest ukiyo-e depictions of the pleasure quarters were probably those which were made as incidental parts of late sixteenth-century screen panoramas of the streets of Kyoto. During the first quarter of the following century, moreover, the beginnings of the Kabuki drama first received attention from genre screen painters, and were also featured in several notable scrolls and book illustrations in the Nara-picture style.

With the full development of the elaborate government-licensed courtesan quarters in the 1630's and 1640's, both literature and art began to take the courtesans as a prime subject. Plate 4 shows one section of a six-panel screen devoted to the Shimabara district in Kyoto, and is one of the finest early works now extant on the theme of life in the pleasure quarters. Needless to relate, such a screen—probably one of a pair—required some weeks of careful work by a skilled painter, and was generally beyond the means of any but the more wealthy samurai of the period. Within a few

6 *Early Ukiyo-e School. Figure of Courtesan. 1640's. It is doubtless winter, and the girl holds her hands within the bosom of her garments. Painting on gold leaf and paper; detail of medium-sized panel.*

27

decades the wealth was gradually to begin passing into the hands of the mercantile class, but during the first half of the seventeenth century it seems probable that both the genre art and the very pleasure quarters themselves were supported largely by the samurai class. This taste for high living doubtless contributed to the gradual impoverishment of the samurai, though their lack of business acumen and willing transference of troublesome commercial transactions to the merchants was, of course, an even more important factor in their decline.

With the type of depiction of the floating world of contemporary life which we find in Plate 4, we may with some certainty say that the ukiyo-e style has arrived. Critics who would deny this, citing the fact that a popular audience was still missing, are putting too much emphasis on the patron and not enough on the art itself. Here, indeed, we find all the world that was, for two centuries to come, to inspire the highest efforts of the ukiyo-e masters—and of the novelists and playwrights as well. It is the world of the courtesan and the gallant, the floating, fleeting world of pleasure.

The panorama type of painting of the pleasure quarters such as we see in Plate 4 was, in effect, an extension of the numerous earlier screens depicting detailed "scenes in and around Kyoto." The next step in the pictorializing of the floating world lay in the painting of individual portraits of noted courtesans, such as the semi-Tosa style masterpiece we see in Plate 5. As with most early ukiyo-e, the panel is unsigned, but the artist was clearly a gifted one, and it is difficult to believe that no other works by him exist. Most probably they do, but treat of non–ukiyo-e subjects and employ styles that are more traditional. For, as we have already suggested, Japanese painters often studied and practiced simultaneously several styles and techniques which varied with the subject matter and the taste of their patron. Thus we feel justified in calling this panel one of the first masterworks of true ukiyo-e, even though its artist surely worked in other styles as well and doubtless produced it for a nonplebeian audience.

In any case, this painting was seldom to be surpassed in later ages. The profound but subtle impact of the large screen painting and its mellowed hues on pure gold leaf may be suggested by the color and the design of Plate 5, but hardly its size or the depth achieved by the seemingly flat planes of old gold leaf and the now oxidized heavy tempera colors. The subject is

a courtesan, a girl available to almost any man with the price; yet, as we shall see throughout Japanese courtesan protraiture, the subject is nevertheless idealized womanhood. Though we possess somewhat less realistic ideas of the necessity of that profession than the Japanese, the mists of time may serve us just as well in obliterating any moral bases of judgment, so that we may perceive a feminine beauty no less moving because she is a courtesan and not a debutante or queen.

Where the courtesan of Plate 5 is somehow quite removed from the world of sex, there is another, more frankly sensual type of girl in ukiyo-e, and we see one of her early appearances in the detail of Plate 6. In such personal matters it is perhaps unwise to suppose that the reader here catching his first glimpse of Japanese figure painting will feel the same impression; but to me, at least, the courtesan of the earlier plate is idealized and antiphysical; she is aloof in the profound sense that no man can ever know her. The courtesan of Plate 6, however, is definitely more approachable, the type of girl who accepted each lover as a new experience and never gave herself to brooding. Though of approximately the same periods, Plates 5 and 6 are emotionally and even artistically worlds apart. Plate 5 represents a formalized aristocratic approach to the floating world, whereas Plate 6 meets that world on its own level. Such later artists as Sukenobu, Harunobu, Choki, and Eishi were to hark back to this type of idealized vision in their work, but it was the more worldly girl of Plate 6 who was to prove the forerunner of much of ukiyo-e's view of womanhood.

At the same time, interestingly enough, the courtesan of Plate 6 bears a strong resemblance to certain figures in the famous " Hikone Screen, " one of the monuments of Japanese art, and the most reproduced of all early ukiyo-e paintings. Originally two six-panel screens, this work is now extant in what appears to be four panels from one screen and two from the other. (It should be added that this is the author's view; in Japan it is traditionally considered as one complete six-panel screen, even though the two right panels are obviously not part of the composition.) Dating from roughly the same period of the 1640's, the Hikone Screen shows the work of a skilled Kano painter adapted to ukiyo-e subject matter. We may assume that the artist of Plate 6 had had the same original training—indeed, he may just possibly have been the same man—though here the standing figure of the lone courtesan is quite removed from the Kano style of background we see in the more elaborate Hikone Screen. In any event, with Plates 5 and 6 we

29

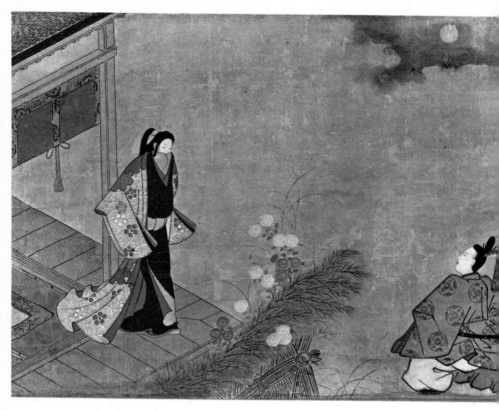

7 Tosa Ukiyo-e School. Courtesan and Courtier. 1660's. Under a moonlit autumn sky the courtesan, in contemporary dress, stands on her veranda; outside the stylish fence of reeds and chrysanthemums squats an amorous courtier in ancient garb. Paint-ing in colors and gold wash on paper; medium-sized hanging scroll (kakemono).

have arrived at what was to be the staple subject of ukiyo-e for two cen-turies to come—the lone standing courtesan.

Along with the development of individual portraits of girls and cour-tesans came also depictions of them in rendezvous with their lovers. Indeed, love and love-making form perhaps the dominant theme of ukiyo-e, a theme often implicit even when only one figure is actually shown. I do not know that it has been pointed out before, but it was probably not until ukiyo-e that love scenes began to appear as a prominent and established theme in

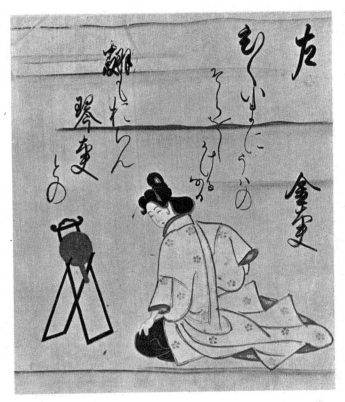

8 Early Ukiyo-e School. The Courtesan Kindayu at Mirror. 1660's. A verse eulogy is inscribed above her head. Painting on decorated paper with mica ground. One of a set of thirty-six small paintings of noted courtesans of the Yoshiwara.

Japanese art. There are scattered examples of erotic scrolls as early as the twelfth century, but I recall very few other paintings that take love scenes as their principal and consistent theme, and those that do exist are usually incidental parts of a series of Tosa illustrations to a love novel.

The painting shown in Plate 7 is of great interest in more than one respect. It represents, first, an early adaptation of a classical scene to the ukiyo-e style—a trend that was to continue throughout ukiyo-e. Moreover, it illustrates within the painting two schools of art: The man seated at the

right is clearly patterned after the great ninth-century court lover, Narihira, hero of the *Tales of Ise*; he not only wears the ancient court robes, but is even painted in the traditional Tosa style. The girl he is courting, however, is the heroine of the new seventeenth-century world, the stylish courtesan; she stands aloof in all the glory of her elaborate modern kimono, arms withdrawn into her garment in a subtle, vaguely erotic gesture typical of the courtesans—a gesture which we have already seen in Plate 6. Between the courtier and the courtesan bloom chrysanthemums on a rustic but stylish fence. These elements—like every part of the scene except the girl— are all traditional Tosa work; indeed, one's first impression is that a modern girl has stepped into a ninth-century scene. To a Japanese of the time, however, it would have seemed less incongruous: Narihira was the symbol of the great classical lover, like our own Paris or Adonis, and to substitute a stylish courtesan, feminine ideal of the new age, for Komachi (the Japanese equivalent of Helen or Venus) was doubtless considered the height of sophistication. Certainly it lends the picture, even today, a flavor unique among the numerous experimental ukiyo-e paintings of the period. And it forms a rare example of how ukiyo-e developed at first within the traditional schools, so that the same painter could, as here, paint, as part of the same inspiration, in styles which were centuries removed in both technique and spirit.

One further point to be made about this painting is its place of origin. Hitherto we have been dealing primarily with artists of Kyoto, the ancient capital of Japan. Now, though we know nothing of the artist concerned, we sense a certain bold wit and stylishness that was soon to become the distinguishing mark of Edo ukiyo-e. Even the courtier shows signs of a rakishness rather removed from the overcultivated Kyoto court, and we may well suspect that the artist was a man trained in the Tosa tradition, but through natural inclination drawn to the new spirit of boom-town Edo.

Unlike the earlier paintings shown, which were mounted either as lateral scrolls or as standing screens or plaques, Plate 7 is mounted as a *kakemono*, a vertical scroll hung in the alcove of a Japanese house and rolled up for storage. In Plate 8, we meet yet another format of Japanese painting, the " poem card, " a nearly square sheet of decorated paper some seven inches wide, upon which from ancient times poetry, and often portraits of the poets, had been inscribed and collected for display, either preserved unmounted in lacquered boxes or pasted in albums or on standing screens.

32

These poem cards (*shikishi*, meaning "colored papers" in Japanese) constitute a remarkably intimate type of miniature; they are of soft but heavy paper, just the right size for holding in one's hands, and later (Plates 69-75, 77-80, for example) the format was adapted by Harunobu and his followers for some of the most charming prints in all ukiyo-e.

Plate 8 is notable as one of the earliest and most engaging examples we possess of this intimate form of ukiyo-e; characteristically, the subject is a Yoshiwara courtesan. (The hairdo is a variation of the "pony tail" we saw in Plate 7, but with the tail wound up and tied on top of the head. Naturally, all these coiffures have their special names, and they form one of the antiquarian delights of ukiyo-e collecting.)

Compare now (without, for the moment, attempting any value judgment of artists separated by a century or more) the courtesan of Plate 8 with Harunobu's girl in Plate 71, or again, the lovers of Plates 7 or 10 with those in Plates 109 or 124. You will then perceive that ukiyo-e achieved its ultimate subject and approach almost from its inception, and that it was only left to later artists to exercise their ingenuity in novelty of background, coloring, and design. For this reason it seems a little surprising to learn that all pre-Harunobu ukiyo-e is generally labeled as the period of "The Primitives." There were, to be sure, artists of great charm but limited training, such as the Otsu-picture painters and the anonymous artist whose work is reproduced in Plate 2; there were also artists possessed of a primitive elemental power such as we see in Plate 14, and today in the modern printmaster Munakata (Plate 147). But though the art of full-color printing was yet to be developed in Japan, there is little that is really primitive in the best of seventeenth-century ukiyo-e. Its masters had behind them the tradition of ten centuries of Japanese painting, magnificent both in line and color, a tradition going back to the ancient Horyuji frescoes. When, with the seventeenth century, these painters turned to the new world of pleasure "floating" about them, they had only to make the effort—admittedly a strenuous one—of escaping from the oppressive tradition of formalized subject matter. Once they had made that leap, they found themselves masters of a new dominion, liberated to create a new art and adapt the best of the ancient techniques to depicting a vibrant new world—a world expanding suddenly with the vigorous pangs of renaissance.

THE FLOWERING OF UKIYO-E

The First Prints and Moronobu

IF UKIYO-E—as is the popular misconception—implies only *prints*, then our story begins here.

For, just at the time that the paintings shown in Plates 7 and 8 were being made for well-to-do connoisseurs, some printer or artist in Edo got the idea of multiplying ukiyo-e by printing from woodblocks and distributing the results at popular prices. Contrary to what one might expect, the result was not just cheap editions or popular reproductions, but a whole new art form that was eventually to overshadow the ukiyo-e painting that gave it birth, a form eventually to be recognized as one of Japan's principal contributions to aesthetic beauty.

The basis for the success of Japanese ukiyo-e prints lay, from their inception, in several simple but vital factors. First, the technical skill already existed, as fully developed as it would ever be: Japanese woodblock carvers had behind them the experience of more than four centuries of fine work in the printing and illustration of Buddhist texts and Chinese classics. Too, Japanese handmade paper was the finest in the world, peculiarly adapted to the exacting needs of woodblock printing—durable, absorbent, impervious to centuries of handling; moreover, it possesses a peculiar life of its own, which makes the very blank spaces of a print a minor thing of beauty, and it absorbs the native pigments year by year, so that a print may well appear to be even more beautiful today than when it was originally produced.

Artistically, the three great contributions of the Japanese tradition to prints were line, space, and coloring. The glowing line was as old as the

eighth-century Horyuji frescoes; in the fifteenth century it had absorbed the subtle influence of the great Zen ink paintings, and now it drew fresh stimulus from the very resistance of the hardwood boards to the engraver's knife. Further, in spacing and design the prints again went back to the great traditions of Japanese arts and crafts, incorporating a sense of beauty as fully developed as any in the world. Lovely coloring had also been a characteristic of Japanese painting from its inception—influenced, perhaps, by the very beauty of the natural countryside, and quite different from anything in Chinese or Korean art. Beyond these, and perhaps the most crucial factor of all, was the fact that Japanese prints were from the beginning designed as prints; they were not (like many Chinese and European prints) copies or reproductions of paintings; on the contrary, they consciously abandoned every element of painting that could not be better done by woodblock; at the same time they developed methods and techniques that no paintbrush could effectively duplicate.

These are the reasons why Japanese prints are today admired the world over. In practice, the question seldom arises, "How can a print, issued in hundreds of copies, be a work of art equal to a unique painting?" If it does arise, it does not pose a problem for long because the results of this technique are equally great, though totally different: a print can often express its particular aim better than any other form could. Whether the reasons are clearly understood or not, it is a fact that the great ukiyo-e prints, even though extant in a dozen copies, may today be considered two or three times as valuable as an equally great ukiyo-e painting. These small prints speak intimately to collectors the world over, and in ways that paintings seldom can. Though we have devoted our first chapter to demonstrating that ukiyo-e began with paintings, many—perhaps a majority—of the real masterpieces of ukiyo-e are prints. Do not ask me to choose between, say, Plate 5 and Plate 104, works I consider at the very pinnacle of ukiyo-e, even of world art: we may love them equally, but at different times and in different ways. True, in a conflagration I would doubtless carry the early screen out first: but this is primarily because so few great works from that period now exist, whereas we have so many for the later time, and even several originals of the print in Plate 104.

Acknowledging, then, that ukiyo-e prints form the largest single glory of the school, it is with no little interest that we search out their origins. I hope it will not offend any art lovers, but the fact is that ukiyo-e prints

began as bold erotica, or, at the least, handbooks of sex that no publisher would consider today.

Why this should have been so is difficult to explain conclusively. The early prints were, of course, limited, relatively costly experiments, and it was to be over a decade before they appealed to a popular market. Thus, just as we will see in a later chapter that the experiments of a group of dilettante connoisseurs in the 1760's produced full-color printing, so we may imagine that the first prints of the early 1660's were a culmination of the ideas of some connoisseurs of erotica for multiplying choice specimens for limited distribution.

Of course, these erotica must be regarded in the light of seventeenth-century Japanese life and mores: sex was considered a most natural function, and means to increasing its enjoyment were, among the intelligentsia, considered more commendable than censorable. Thus, if we think of the early erotica simply as very frank and detailed sex manuals, we may be able to approach them with greater understanding.

Quite naturally, ukiyo-e book illustration preceded the production of single prints by several years. Already by the mid-1650's the ukiyo-e spirit had made itself felt in Kyoto book illustration (Plate 9). Edo, which remained the center of ukiyo-e through nearly all its history, suffered in 1657 a tremendous fire that destroyed most of the city and, with it, whatever examples of early printed ukiyo-e may have existed there. Within two or three years after the great fire, however, the city had made its comeback, and was soon to surpass forever the older centers of Japan in its production of that art devoted to the floating world.

Plate 11 shows one of the earliest and finest ukiyo-e books, the *Yoshiwara Pillow* of 1660. Conveniently enough, the book combines the two most popular forms of Japanese gallant literature, the manual of sex and the "courtesan critique"—the latter consisting of guides to the famous courtesans of the day, including their faults and beauties, where the girls could be located, and at what price. We need not try to idealize the sex life in Japan of these times; we can only marvel that the art and literature which celebrated the pleasure quarters reached such a high level, and we must suspect that there was actually much good taste and refinement amidst all the apparent lubricity.

This little volume, then, consists of some forty-eight pages, each of which depicts a leading courtesan of the Yoshiwara (identified by her dec-

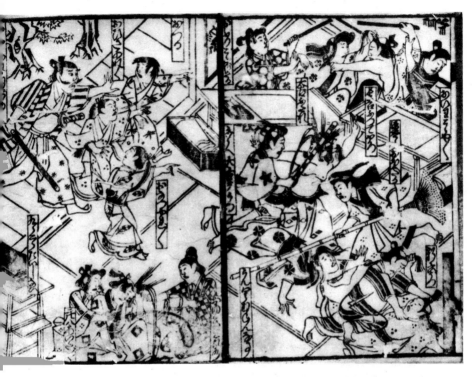

9 *Anonymous. Schoolhouse Brawl. Kyoto, 1658. A samurai teacher, left, rushes in
to halt his battling pupils. Small book illustration.*

orative crest rather than by her name) in some intimate relation to a par-
amour. The scene we show here displays a young Buddhist priest commenc-
ing dalliance with a courtesan. (The priest's fan and rosary lie discarded
behind him.) The girl, hand inside the breast of her kimono, pretends coy-
ness but does not really repel his attentions. The picture is frankly erotic,
but still printable today. Alas, that may not be said for most of the remainder
of the book, even though in manner and art it may seem charming. Each
of the famous courtesans is, in effect, identified with one of the "standard
positions" of love-making (in Japan, traditionally forty-eight in number)
and shown with her lover most often at the height of amorous pleasure.
These little books of the 1660's form the first peak of printed ukiyo-e. They

37

are rare—having been printed for a limited and highly sophisticated audience—and many veteran print collectors have never seen, much less owned, one.

But let us return to the promised first actual print, shown in Plate 10. As we have suggested, the connoisseurs of erotica of the period may well have sponsored the production of such experimental work. The print depicts, again, a courtesan with her lover, dates from about the same time as the Yoshiwara book just described, and is either by the same anonymous hand or by a close fellow worker.

Perhaps the first thing one remarks of this print is the curious coloring. Color *printing* was not to be widely used until well into the following century, but from the early seventeenth century book illustrations had often featured primitive hand coloring as a substitute. The colors were most often, as here, orange and green, sometimes with yellow or mauve added; they were applied with rapid, bold strokes by skilled artisans. This type of coloring was common in the illustrated novels, called "orange-green books" (*tanroku-bon*), of the early seventeenth century, and was used in ukiyo-e prints from the 1660's to the 1710's. Such prints (Plates 10, 19, and 35 in this book, for example) are called "orange prints" (*tan-e*), and are among the most treasured in ukiyo-e. The choice of orange and green went back to earlier practices in painting, sculpture, and architecture, and was a happy combination that was to characterize the primitive Otsu pictures already mentioned and predominate in ukiyo-e coloring through the 1750's, even after elementary color printing had been established. The pigments were mineral colors and were unstable: the orange (red lead) often turned a mild bluish-black with age, and the mineral green grew dark and sometimes ate into and destroyed the paper. The example shown in Plate 10, however, is excellently preserved in every respect.

A word about the format of this rare print, surely one of the most historically important in all ukiyo-e. It shows a courtesan playing upon the samisen while her paramour reclines at ease, his short sword and fan on the floor before him, together with wine cups, saké, and various delicacies. Above the lovers is written a commentary certainly intended to stir erotic thoughts in the viewer. (I should add that though seventeenth-century calligraphy is generally unintelligible to present-day Japanese—even censors—I have thought it best to obstruct two offensive words.) But when we have the original print in our hands, we see that this is by no means all.

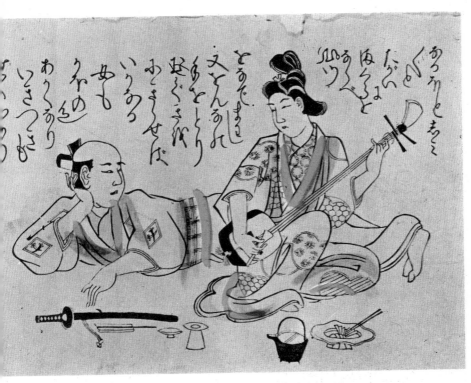

10 *Early Ukiyo-e School. Courtesan with Lover. Early 1660's. Playing the samisen, a courtesan entertains her lover in a house of assignation. On the mats are the man's sword and fan, together with refreshments. Above them is an erotic inscription. Small woodblock print on paper with hand coloring. The frontispiece to an otherwise unprintable hand scroll.*

Actually, our print is one of a *series* of uncut prints, a scroll all on one long piece of soft, heavy paper. There must have been twelve such scenes originally, though now the scroll is torn off at the fourth one. After the first plate, the scenes are all unprintable; they defy description even if we cared to provide it.

What was the next development in the flowering of this worldly new style? Plate 12 will indicate something of the modifications in the Edo ukiyo-e style about a decade after its inception. The figures are more rounded and

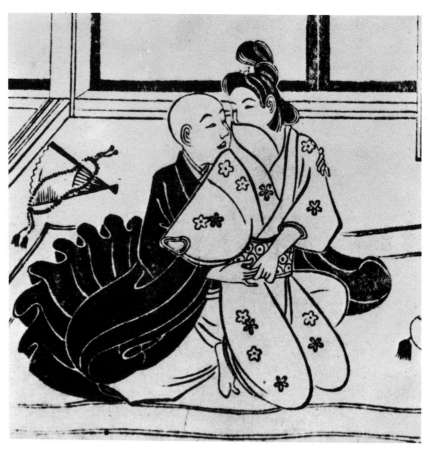

*11 Anonymous. Priest Dallying with Courtesan. Edo, 1660.
Detail of small book illustration.*

more bold. The artist may be the same as that of Plate 11, or his pupil.
(Nothing, unfortunately, is known of any of the earliest ukiyo-e masters.)
The book from which this print comes is also a manual of sex and is in
some ways more crude than that shown in Plate 11. We see, for example,
couples making love in a bathtub and on horseback—surely a sign that the
audience has become a trifle jaded with the simple sex manual and craves

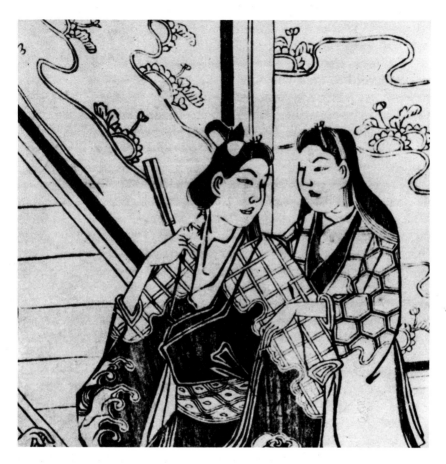

12 Anonymous. Lovers Parting at Dawn. Edo, 1669.
Detail of large book illustration.

something more extreme. The detail we give reveals a young samurai (his
hairdo may look somewhat feminine, but the youthful male style can al-
ways be distinguished by the shaved pate on the top of the head) parting
at dawn from his sweetheart, who is possibly a girl of the upper classes rather
than a courtesan. Again, the rest of the book is unprintable.

 This, then, is the beginning of ukiyo-e prints: sex manuals and guides

to courtesans, erotica exquisitely designed for members of a lively class of connoisseurs who gave sex the same care and study some of us give golf, hi-fi, and sports cars today.

But there was to be more to ukiyo-e than girls and sex, though, as we have already indicated, the terms "floating world" and "floating-world pictures" originally referred largely to that theme. Other popular subjects were soon to be adapted to the print form—warriors, actors, children, and finally, well over a century later, landscapes and rustic and nature themes. For the time being, however, the secondary subject of ukiyo-e was great warriors of the past.

The print we reproduce in Plate 14 is a large one, twice as large as this page and almost as big as any of the prints to be found in later times. It displays an armor-clad samurai, with a firm stance and lance in hand, ready to meet and repulse any foe. He is Shishi-o (The Lion-King) and his fierce courage and deeds of valor were legendary. Unlike the erotica designed for a limited audience of dilettantes, we may suppose this type of print to have appealed to boys in their teens, but also to older men of warrior stock or warlike disposition. In any event, this is one of the first large-size independent prints to be found in ukiyo-e. At one time this print boasted hand coloring in orange and green, but this has now largely faded away. Its designer is unknown, but was most probably the same artist (or one of the artists) who produced the erotica noted earlier. The great difference in subject matter is quite sufficient to account for the variation in style, as we shall often see throughout ukiyo-e.

Plate 15 also shows a warrior, Minamoto Nakamasa, this time seated in his armor, fan in hand, and with a famous verse of his printed above his head. The illustration is one of a hundred in a book called *One Hundred Warrior Poets*, published in 1672. The illustration is simple enough, but again historically one of the more important in ukiyo-e: it is the earliest signed work of Moronobu, the artist who was to consolidate the hitherto scattered styles and set ukiyo-e firmly on its feet and on the long, lovely road it was to take during the next two centuries.

13 Moronobu. Street Scene in the Yoshiwara. 1672. Two courtesans, at left, promenade through the licensed quarter as rakes and attendants look on. Painting on silk; detail of a hand scroll of scenes in the Yoshiwara.

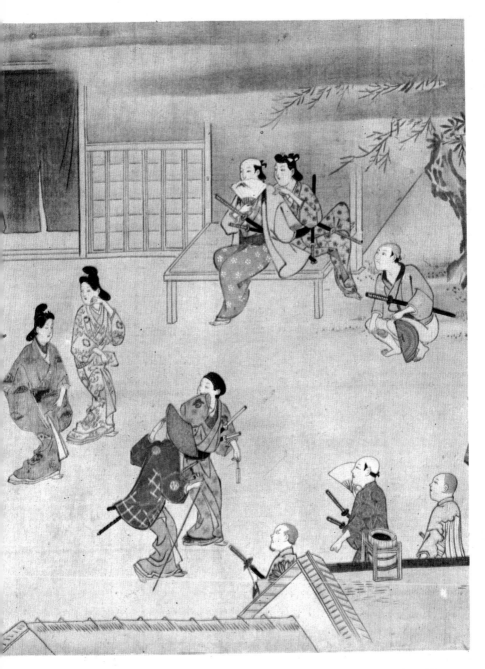

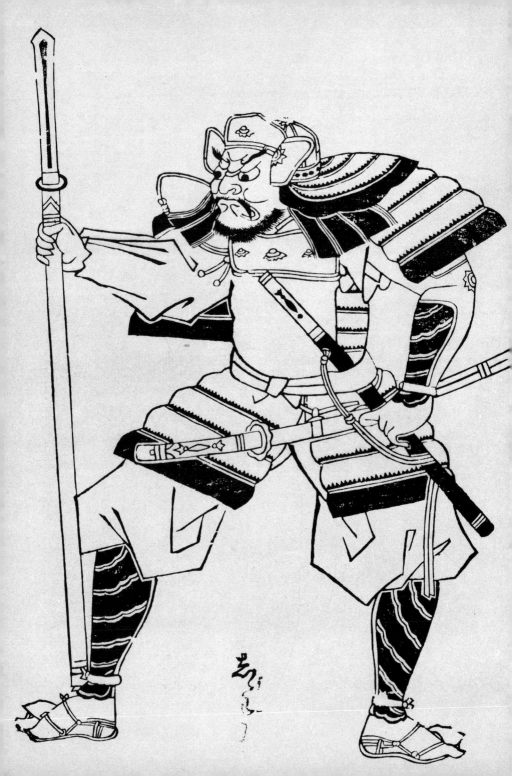

14 (Left) Anonymous. Warrior. Edo style, mid-1660's. Medium-sized woodblock print, hand colored.

15 (Below) Moronobu. Seated Warrior. 1672. Detail of large book illustration, from One Hundred Warrior Poets.

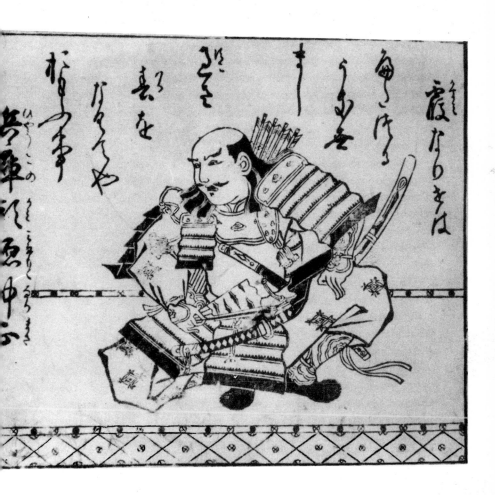

We have suggested above that Edo ukiyo-e, with its earliest productions around the year 1660, already possessed many of the qualities that were to distinguish it in later times—until, at least, the revolutionary development of full-color printing in the 1760's. Nevertheless, the style still lacked the integrating leadership of a guiding genius. Moronobu was a born artist and a born leader; he has often been dubbed the "founder of ukiyo-e," but it need not detract from his fame to modify that to "consolidator of the ukiyo-e style." Indeed, had ukiyo-e ended with the experiments of the 1660's, there would never have been any unified Ukiyo-e school or any lasting style worthy of a special name. Ukiyo-e required powerful, confident leadership at this point, and Moronobu provided it.

Hishikawa Moronobu (died 1694) had been born at Hoda, on the distant side of Edo Bay, and his father was a famed embroiderer of rich tapestries for wealthy temples and upper-class patrons. Moronobu was doubtless tutored in his father's intricate art as well as in the painting skills that lay at its foundation. But when he came to Edo around the late 1660's, it was to the field of genre painting and illustration that he devoted his full energies.

Already well trained, evidently, in the traditional Kano and Tosa painting styles, Moronobu soon mastered the newly created style of the Edo illustrator (or illustrators) we have shown in Plates 10, 11, 12, and 14. Earlier scholars have generally tried to assign all this preliminary work (plus, often, the even earlier Kyoto book illustration) to Moronobu, too. It is, of course, inconvenient to discuss pictures without some artist's name to attribute them to. But although Moronobu's first work naturally resembles that of his teacher or predecessor, once his own style was established, Moronobu did not deviate from it. And this is my principal reason for rejecting theories of earlier composition: the unknown Edo master (with, possibly, an equally unknown pupil) of the 1660's developed a uniquely Edo style of ukiyo-e. After a brief period of imitation Moronobu went on from that style in the mid-1670's and continued to develop his own individual manner until his death twenty years later. These facts, evident from a survey of the dozens of dated but unsigned illustrated books of the 1660's, point clearly to the existence of one or more masters before Moronobu. It is unfortunate that we cannot know the name of Moronobu's predecessor; nevertheless, we are sure that he existed.

In the earliest Moronobu work of Plate 15 we see a refined descendant

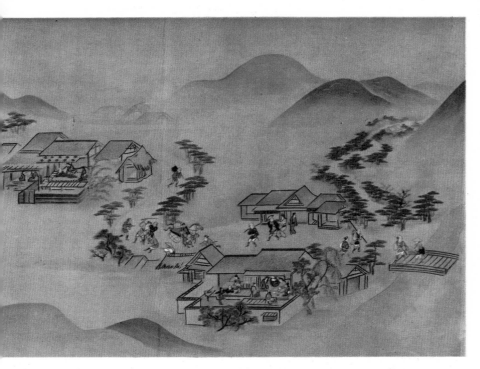

16 Moronobu. On the Tokaido Highway. 1683. At left, a samurai threatens to cut down an offending commoner, a packhorse unseats its rider, and toward the center a teahouse girl tries to drag in a new customer while her companion hopefully scans approaching travelers. To the left and in the foreground, wayside teahouses in which travelers relax with female companionship. Painting on silk; detail of a long hand scroll depicting the entire Tokaido Highway from Edo to Kyoto.

of the artist of Plate 14. Moronobu's greatness lay in his ability to retain the elemental power of early ukiyo-e while expanding its range through his native gifts and through his training in the traditional styles of painting. In the mustachioed samurai of Plate 15 we sense a field commander able to do bloody deeds, yet also capable of the sensitive poetry inscribed upon the same page. He has, clearly, a mind behind his intent visage. This is one sure sign of Moronobu's portraiture at its best. Look, for a moment, at Plate 18. I had seen a hundred Moronobu fakes, copies, works by pupils, before I came upon this genuine but unsigned painting. There is a mind

47

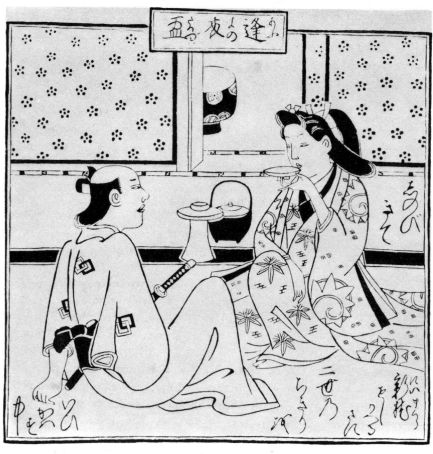

17 Moronobu. Lovers. ca. 1680. Medium-sized album plate.

behind the girl's face, and a particular mind found in the work of no one
but Moronobu. It is not intelligence, wit, or even humor that we feel,
but simply a quality—concentrated particularly about the eyes—of being
sentiently alive. The warrior of Plate 14 is alive, too, of course, but not with
any feeling or perception, only with brute vitality.

To return again to Moronobu's earliest work: though we have nothing
signed by him before 1672, it is obvious that he had already gone through
considerable training both in traditional painting and in ukiyo-e itself. The

48

finest examples we possess of his early work are sections of a painted scroll, also dated 1672, which depict several scenes in the Yoshiwara, the pleasure quarter of Edo. Plate 13 is a detail from this remarkable work.

Although prints and illustrations usually form the best-known portion of an ukiyo-e artist's work, it is in his paintings that we can discover his training and basic talent, unconcealed by the block-cutter's knife and the printer's skill. In the painting of Plate 13 it is evident that Moronobu in his first signed works is already a master of color, design, and the intricate fashions of the time. (Without a detailed knowledge of the latter, any ukiyo-e designer would soon have been ridiculed into abandoning his profession.) Moreover, we see here Moronobu's most striking contribution to ukiyo-e: a dynamic group composition in which every figure takes a dramatic part in the scene and adds to the total effect. Cover any one of the figures in this scene and you will see how tightly interwoven is the whole (of which, however, this detail is but a part). Compare, for a moment, the similar scene of the gay quarters three decades earlier shown in Plate 4, and you will discover the extent to which figures have become individuals and how the composition has been reduced to its basic dramatic elements. There is an unseen bond between every figure in a Moronobu composition, and this, with the dynamic line and the sentient portrait, is his unique contribution to ukiyo-e.

Moronobu produced only several dozen prints as such, but he was among the most prolific of Japanese book illustrators: at least a hundred and fifty extensive sets of illustrations issued from his fertile brush during the 1670's and 1680's. Of these, perhaps two dozen were erotic, but, unlike those of his predecessor, such books formed only a fragment of his work. Strangely enough, however, more than half the independent prints (*ichimai-e*) of the seventeenth century consist of erotica. This is probably because the prints were expensive, appealing primarily to the wealthy, highly select audience which also supported the exotic erotica. In any event, there was not yet so large and popular an audience for prints as there was for illustrated books. Most of the early prints were issued in a series of twelve, bound for convenience as a folding album. Of the erotica, usually the first in the series, and perhaps another later on, was only semierotic in nature.

One might suppose this latter feature an attempt to fool the censor, but, in fact, the Japanese feudal government was little concerned about erotica at this period, though it was strict indeed about the printing or distribution

49

18 Moronobu. Courtesan Walking. Mid-1680's. The kimono here is worn in the old style—long and raised in front, displaying the gaily colored underkimono. Courtesans often disdained the use of tabi stockings even in winter. Frequently, as here, the depiction of footgear is omitted in ukiyo-e. Painting on silk; medium-sized hanging scroll.

of seditious matter or books concerning affairs thought dangerous to the stability of the government. (The latter included Christianity, for the Japanese officials were much concerned that the Catholic missionaries might prove the forerunners of conquest by the Spanish and Portuguese governments which sent them.) Indeed, many of the early erotica were imprinted with the names both of publisher and artist—whereas the decent books were often anonymous. The custom of presentable frontispieces, then, seems unrelated to censorship, and was probably just an aesthetic device to lead the viewer more gradually into the attractions within—and perhaps to provide something to show the children when they wanted to see the book Father or Mother was reading.

These early albums have now generally been divided up; the excessively rare frontispieces have gone to grace the museums of the world, and

19 Style of Moronobu. The Courtship of Princess Joruri. Mid-1680's. The legendary Princess Joruri, playing the long zither in a concert with her attendants. Outside the gate the young Yoshitsune, hero of Japanese history and romance, serenades her with his flute. An attendant invites him in. Large woodblock print with hand coloring.

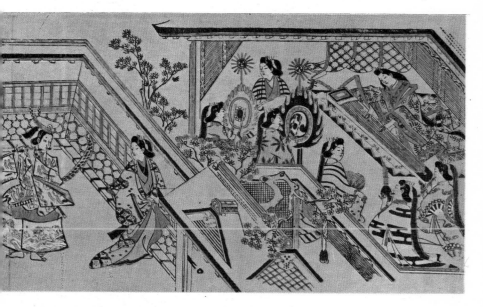

the erotic plates are collected by specialists in the subject. It is rare nowa-
days to see such albums in the "balanced" format in which they were
issued.

In this sense the album represented in Plate 17 is a rarity; in its fron-
tispieces it displays intact two of Moronobu's finest early prints; the remain-
der of the album is unprintable today. The scene we show is a familiar one
in ukiyo-e, the passionate but restrained vows of lovers after their first night
of intimacy. The design bears interesting comparison with the similar scene
by Moronobu's predecessor, shown in Plate 10. Compared with Moronobu,
the work of some twenty years earlier does seem a trifle "primitive"; with
Moronobu we achieve a dramatic intensity and a "magnetism of bodies"
which is generally missing from his forerunners. He purposely contrasts the
harshly carved lover with his soft and delicate sweetheart. The beauty of

20 Moronobu. Lovers in Garden. ca. 1682. Large album plate.

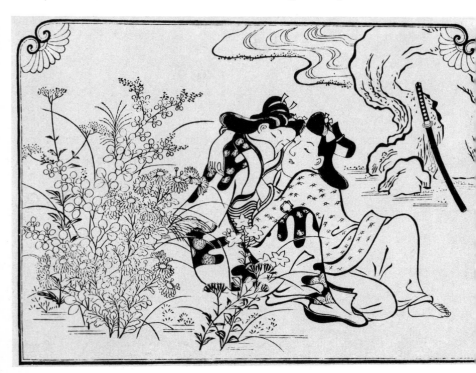

the girl's face (appreciable, I hope, even to readers first meeting the Orient) represents one of Moronobu's triumphs, and we can only wonder how the same artist could, in the following plates, subject such girls to all kinds of indecent exposure.

The design consists only of black and white, but these are colors enough for Moronobu, and his designs are often marred, rather than improved, by the addition of hand coloring. This is his famous "singing line," and no reproduction, even though by woodblock on Japanese paper and with ancient ink, can recreate the marvelous art of the seventeenth-century printer, in which the blacks seem to possess an independent life of their own. The girl of this print is not unlike the one we saw on the left in Plate 13, but note how far Moronobu has progressed in these few years; the influence of his predecessor is now fully assimilated, and the Moronobu style appears

21 Sugimura. Courtesan with Lover and Maidservant. ca. 1684. Large album plate.

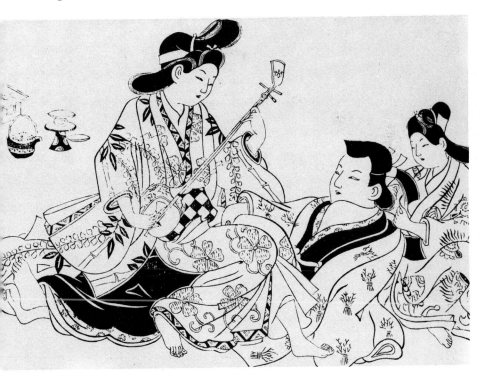

here in its full flowering—a style that was to serve, directly or indirectly, as the model for the following century of ukiyo-e.

Since Moronobu's prints show so little need of color to enhance their beauty, we may be justified in devoting our color plates to his paintings—a part of his work which both he and his contemporaries considered his greatest contribution, though it is overshadowed today by the more popular prints.

Plate 16 is of great interest, for it shows part of a rare scroll by Moronobu depicting life on the famous Tokaido Highway, which ran between Edo and Kyoto. This highway was, a century and a half later, to be the scene of some of the finest landscape work of the great Hiroshige (Plate 133), and throughout the Edo Period it remained the center of much of Japanese literature and art. Moronobu's magnificent scroll was prepared for one of the great feudal lords of his day, and its execution must have taken many weeks. In it we can glimpse the full range of Moronobu's skill as a painter, in the landscape genre as well as in ukiyo-e. The figures appear in miniature, but display that same dramatic cohesion seen in all his work. The scroll was intended partly as a topographical guide, partly for the diversion of noble ladies and connoisseurs who had little opportunity for travel. Every section reveals some facet of that genius we see in more concentrated form in Moronobu's prints and single paintings.

For the fullest expression of Moronobu's genius, which was basically that of a figure painter, we turn to his close-up portraits of the fair ladies of his day. Plate 18, to which we have referred already, shows Moronobu at the height of his powers, early in the closing decade of his active work. The girl Moronobu paints here lives yet today—seems, indeed, never to grow out of fashion—I have seen her on the streets of modern Tokyo myself. With this type of painting Moronobu consolidated the format of girl painting which ukiyo-e artists were to follow throughout the years to come: the solitary girl or courtesan, standing or walking, often in no special setting, but eminently alive and aware that she is a symbol of all that is notable in Japanese womanhood.

In such paintings as this we come as close as we may to the actual spirit of Moronobu's brushwork. But though Moronobu ranks among the great Japanese painters, it is for his bold black prints that he will always be set in a world apart. Thus we close this brief discussion of him with a print from his peak years (Plate 20), again the frontispiece to an erotic

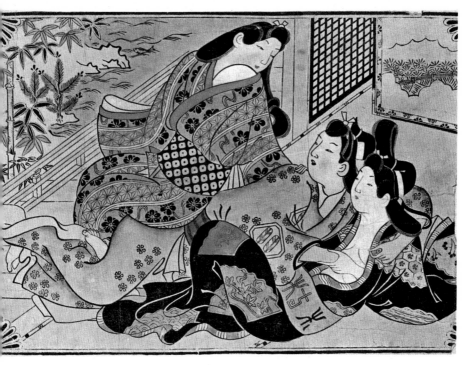

22 Sugimura. Love Scene. Mid-1680's. A young rake dallies with a courtesan, only to be interrupted by another courtesan who appears and sits on his hip. Medium-sized woodblock print with hand coloring; damaged at right.

album, and one well designed to stir romantic thoughts. The bold young man at the right spontaneously hugs his bashful sweetheart as the autumn chrysanthemums bloom beside them. It is the same setting we saw in Plate 7, but here made part of an intimate, human world quite far removed from that yet archaic scene. With Moronobu, surely, all that was "primitive" in ukiyo-e has disappeared; yet through his genius he was able to retain in full the early boldness and strength. As long as these elements remained, ukiyo-e was to thrive and find a universal audience.

Although Moronobu did not invent ukiyo-e, he did consolidate and perfect the style, and establish the Ukiyo-e school: it is not unnatural that he should be popularly called the "founder of ukiyo-e." Moronobu seems, indeed, to have been the first ukiyo-e artist to establish a true studio and

teach his methods to a generation of pupils. He was not, however, partic-
ularly favored in those pupils, and the great names of the following gen-
eration were to be men who, though taking their style from Moronobu,
never studied directly under him.

Moronobu's most notable immediate pupils included his son Moro-
fusa, together with Moroshige and Ryusen: during the late 1680's and the
1690's these men produced interesting individualized book illustrations and
a few rare prints, but none of them turned out a continuous body of work,
and they seem more like occasional artists than true professionals (Plates 19,
23, 24). Moronobu's son Morofusa returned to a trade closer to that of his

23 *(Left) Moroshige. Lovers. 1687. Detail of medium-sized book illustration.*
24 *(Below) Ryusen. Lovers with Ghost. ca. 1688. Large album plate.*

ancestors, dyeing and kimono design, after a few years as an ukiyo-e artist. This serves as a useful reminder that, however highly we honor these artists today, in their own time there was little distinction between artist and artisan, and a skilled craftsman was just as highly thought of as a worker in the "fine" arts. Art, in any event, was then so intimate a part of Japanese life that it doubtless seemed artificial to set a categorical distinction between the design of a kimono or a sword blade, a teapot or a garden, and the painting which decorated an alcove or the Buddhist sculpture that graced the family temple.

So it was that Moronobu's great tradition was taken up more by indirect pupils than by direct, and the first of these, Sugimura Jihei, seems even to have been an active competitor of Moronobu's during the 1680's. Although it would be a mistake to confuse the derivative charm of Sugimura with the original greatness of Moronobu, at his best Sugimura lends a modern, profoundly erotic flavor to his prints which is his particular contribution to ukiyo-e, and which was sometimes to be reflected more strongly in such later masters as Kiyonobu and Kiyomasu than the direct force of Moronobu's own style. It is not, of course, an unknown phenomenon in art for a pupil's "flashy" work to outshine his master's for a time. Sometimes, however, it was Sugimura's considerable weaknesses which were reflected in later artists, and in such cases his influence on ukiyo-e was not necessarily for the good.

Sugimura's finest work dates from the period of the last peak of Moronobu's fully developed style, the mid-1680's. His earliest known book illustrations appeared in 1681; yet his designs of the late 1680's and the 1690's—after Moronobu's retirement—already reveal an almost unbelievable decline. Sugimura clearly thrived on the reflection of Moronobu's greatness, and degenerated when he lost his great model.

Sugimura's prints and illustrations are remarkable in that they display a greater proportion of erotica—at least two-thirds of his work—than any other Japanese artist. He lacked the broad background of Moronobu, but he did have a flair for the depiction of lovers in intimate situations, and in this one field, at his best, he equaled Moronobu and sometimes surpassed him.

Plate 21 shows what I would judge the finest of Sugimura's "printable" prints. It is the frontispiece to an erotic album, and in the voluptuous softness of the faces and figures will be seen both the principal charm and

the essential weakness of Sugimura's style: his designs are suffused with a decadent eroticism that fascinates at first, but does not long satisfy as does the inner strength of Moronobu. Plates 10, 17, and 21 offer an interesting synopsis of the development of early ukiyo-e prints: the primitive masculinity of the first anonymous master, the inner strength of Moronobu, the soft eroticism of Sugimura.

Yet despite this "spiritual" emptiness in Sugimura's work, his charm is undeniable; indeed, in his erotica he often surpasses Moronobu, whose austere grace sometimes interferes with a basically voluptuous situation. One is sorely tempted to compare Sugimura with Utamaro, master of sensual femininity a century later (Plate 109). Yet the former artist never developed beyond the limited talent displayed in his erotica, whereas Utamaro, though perhaps equally "decadent," was a genius of many styles and moods, and often succeeded in going far beyond the limits of the erotic subject he happened to be portraying.

Plate 22, our last example of Sugimura's work, is from another album and gives a rare example of Japanese art which is both frankly erotic and yet printable even today. This print will also serve to typify an alternate type of hand coloring—which existed simultaneously with the bold orange-green mineral pigments—used from the 1670's to the 1690's. The pigments are softer water colors, reminiscent of the red prints and lacquer prints of a few decades later. In Moronobu's prints such coloring tends, I feel, to interfere with the bold black line, but to Sugimura's it adds a certain element of sensual atmosphere that is not without charm. Sugimura seldom signed his prints formally, but, probably unique among ukiyo-e artists, he loved to work his name into the kimono patterns, and thus we see here the stylized word "Sugimura" on the sash of the girl at right. In general, Sugimura's attention to kimono patterns might suggest that his early training lay in this field rather than in formal painting. (The flat pattern of pine and bamboo at the left of Plate 22 is likewise typical of Japanese kimono design.)

We have, for several reasons, chosen Sugimura to represent Moronobu's direct followers. He was the most prolific and successful of them in his own time, and the same decadent, erotic element that fascinated his contemporaries seems to make him equally popular with print collectors today. Yet it was this very deviation from Moronobu's powerful black line that was to direct the course of ukiyo-e away from linear strength and toward more

elaborate coloring. Despite the popularity of Sugimura's style in his own day, his name—like that of many seventeenth-century artist-artisans—was almost unknown until uncovered by Japanese research a few decades ago. And even today, despite his distinctive style, the unsigned work of Sugimura is often still classified as "Moronobu" in museums throughout the world.

Sugimura's success and influence may stand as a reminder that popular opinion is not always a benign influence on art. Yet ukiyo-e—at least the prints—was by its nature a popular form, far removed from any concepts of "art for art's sake" or "artistic integrity." But instead of bemoaning the influence of popular taste, we should marvel at the extremely high level maintained by ukiyo-e during its two centuries of flowering. Clearly the Japanese public demanded a high standard of quality and refinement, and the artists and publishers felt no compulsion to cheapen their works simply for some temporary gain.

GODDESS IN A KIMONO

The Kaigetsudo Painters

MORONOBU had created a sentient ideal of feminine beauty that was to illuminate ukiyo-e throughout its course. It remained for one of his followers, Kaigetsudo Ando, to make of this ideal a symbol which was eventually to represent the entire Ukiyo-e school and, abroad, the whole civilization of Old Japan.

Yet we may state without exaggeration that the only reason why the Kaigetsudo, a school of painters unsurpassed in their day, are known in the West is because one year in the 1710's they issued, quite as a sideline, two or three sets of woodblock prints. These prints, of which twenty-two designs out of a probable several dozen are now extant, are sought by collectors the world over. Today each brings thousands of dollars on the rare occasions when one appears on the market; at the time they were issued, they sold for about what a reproduction costs today.

The artistic success of the Kaigetsudo prints was not, however, a matter of chance: behind them lay the rich tradition which had been established by the master painter Kaigetsudo Ando—a tradition which, though based on colors and brush, was eminently suited to being translated to the medium of the woodblock print. The massive contours of Ando's paintings could be transferred directly to the block; masses of black and intricate but boldly patterned designs could be effectively substituted for the magnificent coloring. Often, further, suggestive colors could be applied by hand, and several of the extant Kaigetsudo prints are of the orange-print variety— black-and-white prints with bold coloring added by hand.

The present price of Kaigetsudo prints (the highest in the field) is

doubtless due, in large part, to their rarity; their remarkable qualities as prints, however, are another matter. There is no need to try to rate comparatively the courtesan prints of Moronobu, Sugimura, Kiyonobu, Kiyomasu, and Kaigetsudo; each is great in its way. Yet of all these artists, it is the Kaigetsudo alone that has become the symbol of ukiyo-e and of this golden age of Japanese culture. The Kaigetsudo prints stand independent because they are not illustrations of some scene or depictions of some famous actor in a given role. These solitary women exist for themselves alone, characteristic of, yet standing clearly apart from the world that bore them.

Having recognized these early prints as marking one of the pinnacles of ukiyo-e, we turn to the man who begot them. The prints are signed Anchi, Doshin, or Dohan, but before each name we find the inscription "Follower of Kaigetsudo." It is, indeed, the genius of Kaigetsudo Ando that stands behind each of these prints. It was he who set the style and taught the principles: without him, these prints could not have been.

Kaigetsudo Ando (traditional dates, 1671–1743), the founder of the Kaigetsudo school, was active from some time shortly after 1700 to the year 1714 when, for reasons which will be discussed later, he was forced to abandon his work and leave Edo. Ando's family name is recorded variously as Okazaki and Okazawa, and his given name as Genshichi. From his earliest period as a painter, however, he employed the given name Ando and the studio name Kaigetsudo.

Ando was an artist of Edo, living in the Suwa-cho district of Asakusa. Site of the great Kannon Temple since very early times, Asakusa was (as it is today) in a sense the epitome of Edo, and a center of the new plebeian renaissance. It had been the home of such popular heroes as Banzuiin Chobei and Sukeroku — both the Robin Hoods of their day, and still immortalized in the Kabuki theater. Asakusa had a history and a tradition; it was to be the birthplace or inspiration for much of the culture of Edo.

Asakusa had also, at its northern extremity, the Yoshiwara, famed demimonde of Edo and the haunt of the literati as well as of rakes and tourists. The Yoshiwara contained some two thousand women, including,

25 *Kaigetsudo Ando. Courtesan in Breeze. Early 1700's. Playful winds grasp at the courtesan's skirt and sash, but the girl herself remains unmoved, a Bodhisattva of the demimonde. Painting on paper; large hanging scroll.*

no doubt, some of the fairest in Japan. Our painter Ando lived somewhat more than a mile south of this quarter, directly on the main road to and from the Yoshiwara.

From a consideration of Ando's broad, majestic manner of painting — each work standing as though it were framed and set up in a shrine — it has been suggested that his early training may have been in painting *ema*, votary tablets with large pictures of horses, warriors, and such, which were contributed to temples and shrines as offerings. Ando's residence, practically next door to the famed Suwa and Komagata shrines and only a half-mile south of the great Asakusa Kannon Temple, surely lends support to this surmise. Clearly his manner of painting with thick outlines and majestic poses owes much to *ema*; but he combined this powerful style with a grace and artistic sense that was partly his own contribution and partly derived, doubtless, from the works of such predecessors as Moronobu and Kiyonobu.

At any rate it is clear that tourists, rakes, and literati passed daily in front of Ando's studio on their way to and from the Kannon Temple and the Yoshiwara. Whether he was a painter of temple *ema* or simply an aspiring painter of the genre scene, from some impulse Ando began taking as his special subject the beauties of the Yoshiwara; soon, his fame spreading, he came almost to monopolize the field of courtesan painting.

But there is something more to these paintings than a view of a courtesan; indeed, in order really to enjoy the Kaigetsudo paintings to the fullest degree, one must develop something of the Japanese love and appreciation for the kimono as a work of art. And works of art these are indeed: one has only to glance at such paintings as those reproduced in Plates 25 and 26, for example, to see that there is something more here than a simple girl; there is — shall we say — a whole culture involved in the appreciation of even one such painting. In the hands of a master such as Ando, the individual courtesan can somehow rise above the elaborateness and elegance of the kimono and impress the viewer with her sensual, human charm. With several of Ando's pupils and followers, however, the painting often stands or falls upon the beauty and originality of the robes alone.

The tremendous and almost instantaneous success of Ando's courtesan paintings marked the turning point of his artistic career. He was established as *the* painter of beautiful women in Edo; and his pre-eminence may well have been a deciding factor in the decline of the dominant Moronobu school

of painting within a decade or two after that artist's death in 1694. But in the year 1714 an event occurred that was to cut off Ando's career at its peak, to send him into desolate exile, far from the world of beauty and sophistication that he loved so well.

What happened in the First Month of 1714 was this: Ejima, one of the highest ladies of the Shogun's court—indeed, the principal lady in waiting to the reigning Shogun's mother—was caught in a flagrant love affair with the handsome Kabuki actor Ikushima Shingoro. The Lady Ejima (who was thirty-two at the time) was discovered with the actor during a visit to the theater following a pilgrimage to the Zojo Temple on behalf of the Shogun's mother. This passion that proved Ejima's undoing was not of recent origin: for some years past, forgetting her high rank, she had given herself body and soul to the actor—though her duties prevented her from meeting him as often as she might have wished. Once discovered, punishment was swift: the actor's Yamamura Theater was closed and destroyed, and all persons, high or low, connected with the scandal were either executed or peremptorily exiled to barren islands off the coast of Japan. The Lady Ejima was sentenced to banishment on the island of Tawara (but on the plea of the Shogun's mother, was actually placed in the custody of the Lord of Suruga, where she died in 1741); the actor Ikushima was exiled to Miyake Island. Among the dozens of others intimately involved in the affair we find the names of Tsugaya Zenroku, a wealthy merchant of the Suwa-cho district of Asakusa, and his neighbor Okazawa Genshichi. The former was exiled to Miyake Island, the latter to Oshima. None of the principals is known for certain ever to have returned to Edo.

The last-named townsman, Okazawa Genshichi, was—to the best of our knowledge—the painter Kaigetsudo Ando. Ando's exact relation to the Ejima-Ikushima affair is unclear, but he and several other townsmen must somehow have aided and abetted the romance. Quite possibly they had motives of profit in mind, for the Lady Ejima was one of the most influential women in the Shogun's court. Be that as it may, no townsman could but feel flattered at being asked to assist such a noble personage—whatever her designs. This romance, which would provide little more than brief fuel for the tabloids of our day, proved, in that age, the undoing of all concerned.

Although there is no record that Ando ever returned from exile, one or two paintings of his exist that may quite possibly date from a period a decade or two after the scandal. It is clear, however, that Ando never again

26 (Left) Kaigetsudo Ando. Courtesan with Long Hair. Early 1700's. Despite the beauty of the girl's face and figure, it is the outer robe that dominates the painting. The Kaigetsudo girls are often termed "stout" or "robust"; in this painting we see that the girl beneath the layers of kimono is slim and pliant, more shy and pensive than aloof. Painting on paper; large hanging scroll.

27 (Right) Kaigetsudo Doshu. Courtesan Glancing Back. 1710's. The courtesan's outer robe slips from her shoulders as she draws it together. The robe bears a formalized design of cherry blossoms in circles, and the mood is clearly that of spring. Painting on paper; large hanging scroll.

returned to the active exercise of his profession; this his several pupils continued, carrying on the master's tradition in such a faithful manner that the uninitiated viewer is likely to conclude that the paintings of the Kaigetsudo school are all the work of the same man.

This view, indeed, was that held by several of the early Western students of ukiyo-e. They had not seen more than a few of the paintings, and had no chance to discern the slight, but nevertheless distinct, differences that mark both the painting style and the calligraphy of each member of the Kaigetsudo school. In the present chapter I will try to suggest some of the distinguishing characteristics that become evident after a careful study of the different members of the school. But as in distinguishing the style, say, of Botticelli from that of his contemporary imitators, it is sometimes only an impression of quality and greatness rather than a particular twist of lip or eyebrow that makes all the difference in an attribution.

As might only be expected in the work of the founding genius of a school, the paintings of Kaigetsudo Ando reveal an originality, a strength and freshness, which is seldom mirrored with perfection in the work of even his finest pupils. At the same time, Ando's courtesans often display a certain austere yet thoughtful mien which tends to remove them from the realm of simple "pin-up girls"—that is, the objects of plainly erotic attention.

The extant works of Ando's pupils show little variation from the theme of the single standing courtesan. Such is not the case with Ando, however. Fully half a dozen of the paintings of his that have survived the earthquakes, fires, and bombings of Japan display a mastery of group genre-painting technique that goes well beyond the limited theme for which he is most famous. Among examples of Ando's versatility we might mention his extended picture scroll illustrating the Oeyama legend, his large screen paintings and his several boudoir scenes with the skilled placement of the courtesan amidst the bedding and the mosquito net—accouterments later to be widely employed by Utamaro.

Ando's women are not of one type alone. There are, on the one hand, the austere, stately figures, more goddesses than objects of sexual attention, such as that shown in Plate 25. But there is yet another girl in Ando's

28 Kaigetsudo Anchi. Standing Courtesan. 1710's. Large woodblock print.

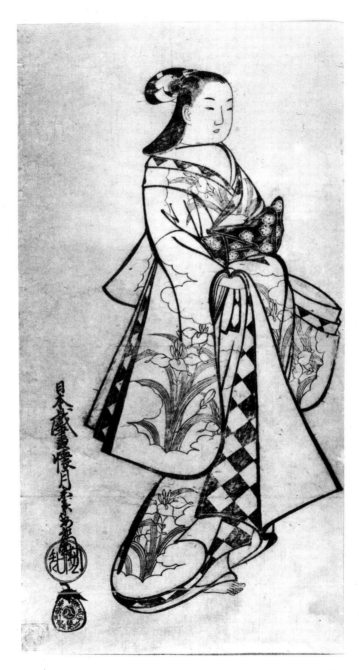

69

work, a girl much more of our own world, who may be appreciated without such great immersion in Japanese taste. We find this girl most strikingly in Plate 26. Hers is a willowy, sinuous figure which belies the weight of the fine robes wrapped about her; she stands detached, yet somehow intimate and approachable. Others of Ando's women (and those of most of his pupils) stand somewhere between these two extremes: they are more feminine than the first, less lovable than the last. Judging from numbers, however, it was the aloof, goddess-like beauty that struck the taste of the Edo connoisseurs of Ando's time, and it remained for Sukenobu, Ando's great contemporary in Kyoto, fully to exploit the theme of the more intimate "girl next door."

We have characterized the general style (or styles) of Ando. Let us next examine the work and manner of his pupils, seeing what each brought to, or lost from, the style created by the founder.

Like the other four immediate pupils of Ando, Choyodo Anchi often employed the studio name Kaigetsudo. On other occasions, however, he used the name Choyodo. Anchi is the only immediate Kaigetsudo pupil to have a studio name of his own; he is also the only pupil to derive his given name from the first syllable of Ando's name. Possibly he may have been Ando's own son, who was allowed to set up his own studio once he had acquired sufficient skill.

Anchi's characteristic style is rather more coyly erotic than that of his teacher. Whereas Ando's women can often pass as maidens or ladies of quality, Anchi's girls are clearly courtesans, lovely but at the same time somehow predatory. They seem definitely to be thinking only of themselves; most men would probably think twice before putting their love into such hands. To one degree or another, this is the feeling one gets from each of Anchi's paintings. Quite possibly it has little to do with his own character: some of the greatest rogues have painted the sweetest girls. It does, however, indicate his own taste in women: aristocratic, self-absorbed, disdainful. Anchi probably liked cats.

Anchi's prints are, it is my impression, in several ways artistically superior to his paintings. He was not, of course, a professional print designer, his few prints being but a minor experiment, probably done on some special commission. The fact is, though, that his style, somewhat too cold and unyielding for the intimacy of painting, proved eminently suited to the woodblock technique. We accept the stiffness of these "primitive" prints

as one of their charms. Under the block-cutter's knife, the sharply feline quality of Anchi's women is blunted to a certain vapid childishness. Somehow, his faults are lost in the technique of early printmaking (see Plate 28).

The women of Kaigetsudo Doshin, on the other hand, are characterized by a certain air of quiet detachment that is reminiscent of the master Ando, though lacking his depth of psychological insight. In most of Doshin's paintings the faces do not succeed in the competition for attention with the brilliant robes.

Coming to Doshin's prints, we experience quite another impression again. We still note a certain ponderousness, a tendency of the figure to weigh down the face. But in contrast to the paintings, where the blue-gray pigments used for the delicate facial features tend to recede and the brilliant reds and browns of the kimono tend to dominate, reduction of the whole to black masses and lines tends to unify the composition; these prints strike a happy balance between the kimono and the girl. Plate 29 well displays Doshin's powers as a print designer.

Kaigetsudo Doshu (Noritane) must be ranked as one of the finest of Ando's pupils. Like Ando, he did no prints, but in the best of his paintings, such as that reproduced in Plate 27, he approaches the finest work of his master. A close examination of his women will, it is true, reveal the lack of that indefinable spark of psychological insight that characterizes the best of Ando's work. Yet (though his extant works are few) Doshu seems to me the most consistently dependable of Ando's immediate pupils. In a painting such as that of Plate 27, he achieves a kind of distant, respectful intimacy that comes close to the perfection of Ando's masterpiece in Plate 26. Had Doshu's work extended to the field of prints, one feels that he, like Ando, might have rivaled Kiyomasu and Masanobu in the representation of a feminine grace that knows no boundaries of time or country.

The works of Kaigetsudo Doshiu (Norihide), the fifth member of the Kaigetsudo group, are also limited to paintings. Due to the similarity of name in its Roman form, he has usually been confused in Western studies with Doshu, noted above. Though Doshiu's extant works are few, they rank with Doshu's in their consistent excellence. His women display a detached yet withal forceful mien which places them in the lineage of Ando and Doshu, rather separate from the feline women of Anchi or the recessive, passive women of Doshin.

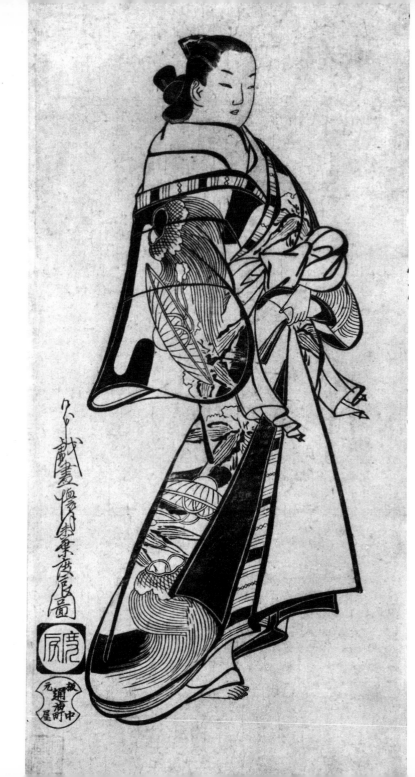

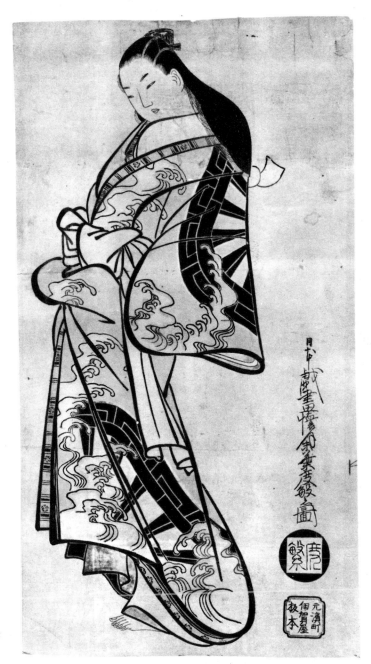

(Left) Kaigetsudo Do-
Standing Courtesan.
's. Large woodblock

(Right) Kaigetsudo
an. Standing Courtesan.
's. Large woodblock
, hand colored.

73

Kaigetsudo Dohan, the last of the immediate pupils of Ando, was the least skillful as a painter, but produced the most prints. Dohan's paintings are not particularly distinguished. They display a certain stiffness and lack of freshness and buoyancy notable even in a school where originality of pose was not the main concern.

Dohan's prints are another matter again. We possess a sufficient number of them to enable us to be critical; and indeed, the average level of Dohan's prints is below that of Anchi and Doshin in inspiration and liveliness. Having said that much, however, we must turn to Plate 30, one of the loveliest works in the whole Kaigetsudo canon. In this print the essence of the Kaigetsudo school is somehow distilled in a work by one of its lesser members. The pose itself is somewhat improbable, but to this fact we are rendered blind by the perfection of the balance. Dohan, a painter of no particular genius, here achieves greatness through simply following, in a moment of rare inspiration, the dictates of his tradition.

This ends our account of the Kaigetsudo painters as such. They were followed by a dozen or more lesser imitators, some of whom—Shigenobu, Chikanobu, Eishun—must be counted among the minor masters of the eighteenth century, but none of whom added anything remarkable to the style established by Ando.

We have made no attempt to date each of the individual painters of the Kaigetsudo school—indeed, this is impossible at the present time. Still, it is clear that Ando and his immediate pupils must have flourished about the years 1700–1725, and their imitators in the style, about 1720–1750. In all, then, the total life of the Kaigetsudo contribution to ukiyo-e would seem to have lasted about a half-century.

Yet ukiyo-e was never to be the same after the appearance of Kaigetsudo Ando. He created an overpowering ideal of feminine beauty that was to linger somewhere in the mind of every perceptive male who ever saw his work—an ideal that has since passed far beyond the seas, to men for whom the vision of these timeless, solitary figures sometimes seems more real than life itself.

FROM BOMBAST TO SERENITY

Kiyonobu and the Torii Masters

TORII KIYONOBU was an artist who took as his model the Moronobu style and learned his lesson well. A series of circumstances was to enable the new Torii style practically to dominate much of the ukiyo-e print world of the first half of the eighteenth century.

Kiyonobu had been born about 1664 in Osaka, son of Torii Kiyomoto, actor and occasional painter of the type of colorful Kabuki billboards that grace the entrances to such theaters even today—and are still painted by descendants of the Torii family. Kiyonobu followed directly in his father's artistic footsteps, but with a significant difference: the family moved to Edo in 1687, and young Kiyonobu fell immediately under the spell of Moronobu, producing his first work of book illustration later in the same year. This new combination of the dynamic, disciplined vigor of Moronobu with the bombast and hyperbole of Kabuki was to dominate not only the theatrical–art world for nearly a century, but also ukiyo-e in general for much of that period.

It is probable that Kiyonobu had undergone some brief training in ukiyo-e even before coming to Edo, no doubt under the influence of the Kyoto illustrator Yoshida Hambei. Kiyonobu's first known work, illustrated in Plate 33, already shows some of the inclinations of his style. Though the interrelation of figures is not so skillful, there is a greater emphasis on action than we customarily find in Moronobu, and each figure seems posing, as though in a play. The subject itself is a current love novel, yet the Kabuki world of Kiyonobu's upbringing has already begun to impose its peculiar conventions upon his art. Just to indicate something of the literary tastes of

75

the time, we might briefly summarize the plot of this particular novel. In it we follow the various adventures of the handsome young man Kazuma, who is loved first by a lusty Buddhist priest, but later falls in love himself with the courtesan Kosakura. As fate would have it, he kills the priest by accident, the courtesan commits suicide, and the hero delivers himself to the authorities for execution.

Throughout the 1690's Kiyonobu continued to work at the illustration of novels and plays—as well, doubtless, as assisting his father with the Kabuki billboards that were fast becoming a family monopoly. Unfortunately, hardly any of these grand paintings have survived; in Kiyonobu's book illustrations of the period, however, we note an increasing attention to dramatic values, a greater stylization of the human figures, and a mounting awareness of the differing requirements of painting and woodblock prints.

Kiyonobu's first large-scale illustrations date from the year 1700 and appear in his *Actor Book*—full-length portraits of the Edo Kabuki actors in role—and his *Courtesan Book*, an album devoted to portraits of the noted Yoshiwara beauties of the time. Plate 31 is the first picture in the *Actor Book*, and shows the leading man of Edo Kabuki, Ichikawa Danjuro, posing in the role of a heroic samurai. Note how firmly his feet are planted (his legs in the solid "inverted gourd-shape" that was to become the Torii trademark), the boldly patterned kimono with the design of a giant centipede upon the jacket, the reed cap on the actor's head, and his hand upon his enormous sword. This is the characteristic Torii figure. It derives from Moronobu, but adds so much of bombast and dramatic exaggeration that we are quite ready to concede it to be Kiyonobu's unique invention. It will form the basis of his style and of Kabuki prints for the next eighty years. Indeed, we might suggest that it even influenced Kabuki itself, for Kiyonobu's vision of the actor's art at its ultimate peak of tension must surely have helped standardize and intensify the actors' poses in an age when Kabuki was still in its formative period.

The actor Danjuro, with his family crest of concentric squares shown here above his head, was the first great consolidator of Edo Kabuki. This remarkable theatrical art has lately become internationally known, but a few words on its origins may not be amiss.

31 Kiyonobu I. Kabuki Actor. 1700. Large book illustration.

76

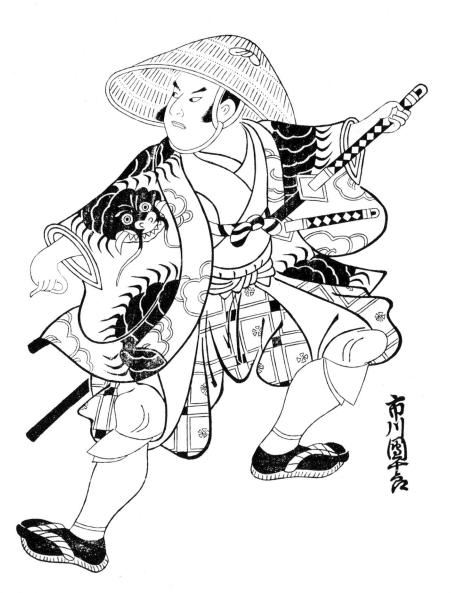

Kabuki as such began around the year 1600 when Okuni, a young Shinto priestess from the Izumo Shrine, formed a small troupe in Kyoto and performed popular dances and mimes on the east bank of the River Kamo. The actual plays were doubtless only impromptu adaptations of traditional Shinto and folk dances, but they filled a need, and Okuni's troupe gradually grew in renown; she was even summoned, from time to time, to appear in command performances before the great feudal lords. The country had but recently achieved peace after a century of civil wars, and it is not surprising that the early seventeenth century should have seen the reformation and renaissance of all kinds of amusements and popular culture which had been driven underground during the long period of conflict. Okuni, in any event, was the first to take advantage of this need, and so she is honored as the founder of Kabuki, though it need not be supposed that at the time the individual performers were considered anything more than the "disorderly characters" that the name Kabuki implied when it was first used.

Okuni's innovation was soon taken up by the courtesans of Kyoto as a means of displaying their charms—in this function differing but little from the elaborate geisha dances performed even today in Kyoto and Tokyo. The courtesans, however, not only gradually overstepped the bounds of propriety in their performances, but also tended to create public disturbances among rival males; and so the authorities finally banned all female performers from the stage in the year 1629. This prohibition was to persist for two hundred and fifty years, and proved a crucial factor in the development of the Japanese theater.

Kabuki was by now a vital part of public amusement, however, and the government ban against actresses was circumvented at first by having fair young men take all their parts—just as in Shakespeare's London. The authorities soon found that they had only exchanged one vice for another. Certain practices rather widespread among the Buddhist priests and among the samurai during the campaigns now found their natural center in the "Young-mens' Kabuki," which became, in short, a hotbed of pederasty for hire. Kabuki was by now too popular simply to be banned outright, so the authorities went one step further in an attempt to sever forever the connection between Kabuki and vice: in 1652 they proclaimed that henceforth only grown men should play the parts, and that they should shave off their handsome forelocks so there would be no doubt whatsoever of their sex.

Sex and Kabuki never did really sever relations, but the authorities seem to have realized that the popular drama formed a generally healthy outlet for frustrated ladies and mildly perverted gentlemen; thus they permitted a certain amount of vice to persist, only clamping down when, as we have seen in the Lady Ejima affair of 1714 (see Chapter III), some flagrant scandal besmirched their own sacred precincts.

Although the effect was by no means immediate, the discouragement of sex exploitation in stage performances had, by the end of the seventeenth century, resulted in a trend toward emphasis on acting ability rather than good looks, though it must be admitted that the graceful actors who specialized in female roles did their best to act like women—in all too many ways, both on stage and off. Still, the ideal of acting in general began to tend toward that kind of elaborately stylized realism which still characterizes Kabuki today.

The Genroku Era at the end of the seventeenth century proved in many ways the consolidating period of Kabuki: to the dance performances of the earliest "Okuni Kabuki" were added the simple dramas of mid–seventeenth–century Kabuki, and more advanced plots, music, and methods of staging were adapted from Japan's unique puppet drama—which was technically far more advanced than the theater of the live actors. With Genroku also came a clear cleavage between the rough, violent style of Edo Kabuki and the more romantic, polished style favored in Kyoto and Osaka. Although the Kyoto-Osaka region was to remain the literary center of Japan for some years yet, from the Genroku Period both the Kabuki and the ukiyo-e that celebrated it found their centers in Edo, where they have remained through modern times. Characteristically, ukiyo-e prints form a good barometer of the state of Kabuki at any given period, and it is no coincidence that the great Kabuki prints of Kiyonobu and Sharaku lie within the two greatest periods of Kabuki development: the beginning and the end of the eighteenth century.

Just as the Yoshiwara formed the center of the sophisticated Edo male's social life, so did the Kabuki theater constitute, in a different sense, the primary amusement of Edo womanhood. And this alone is enough to explain the huge number of actor prints produced during the eighteenth and nineteenth centuries. Indeed, in terms of buying power it might be suggested that the three thousand secluded and sexually neglected ladies–in–waiting of the Shogun's harem in Edo formed enough of a print audience alone to

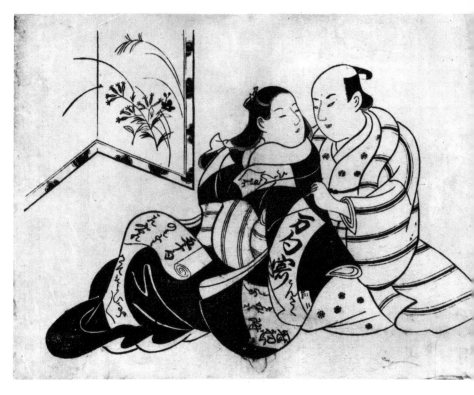

32 Kiyonobu I. Courtesan and Lover. Early 1710's. Large album plate.

support several artists and publishers. As is apparent from the famous Lady Ejima scandal, noted in the previous chapter, this enthusiasm on the part of the noble ladies sometimes went too far, but for the most part it must have been a tragically sublimated attachment for the actors that brightened their abstinent lives within the confines of Edo Castle.

Like practically everything else in Japanese life, the Kabuki theaters were strictly regulated by the feudal authorities. Edo was limited to four theaters with their troupes; when one of these was closed down because of the scandal of 1714, the number was reduced to three, and this number was not enlarged until several years after the Meiji Restoration of a century and a half later. Due to the danger of fire, performances were limited to the

daylight hours, though mirrors and other clever devices were used to achieve various special lighting effects. The basic stage was patterned on that of the classical Noh drama; this was gradually adapted to the special needs of Kabuki, in the late 1660's adding the *hanamichi* ("flower-path") — a narrow extension of the stage that stretched right through the midst of the audience to the back of the theater — and in the following century, the revolving stage.

Just as the Kabuki theaters were kept under close surveillance by the government, so was life among the troupes and the actors themselves rather strictly governed by matters of precedence and protocol — as it is even today. Obviously, no amateur Kabuki fan of an artist could be trusted to prepare the complex theatrical billboards and playbills. And so it was that the Torii clan became, from the end of the seventeenth century, the exclusive official artists of Edo Kabuki. Of course, their "exclusive rights" pertained only to official publications of the theaters, but actually, as long as the Torii artists maintained their artistic predominance, most of the popular prints (sold as souvenirs of each performance) issued from their studios as well.

Returning to Kiyonobu's first great Kabuki work, his *Actor Book* of 1700, we may note that, in a rare coincidence of life and art, the swash-buckling Danjuro, portrayed here, himself met a violent and early death in 1704 at the hands of a fellow actor. Danjuro had been the great star of Edo Kabuki, both as actor and as playwright, but his successor, Danjuro II, was to prove an even greater figure. Indeed, it is a remarkable fact that throughout Kabuki history, by careful selection, adoption, and training of sons and pupils, the style and quality of an actor's performance was perpetuated and expanded over generation after generation, so that Danjuro V (whom Sharaku would portray a century later) will carry on the traditions of his first ancestor without the least lowering of standards.

Within a few years of 1700 Kiyonobu had already developed his full powers as a printmaker, both in actor prints and in the floating world of love and courtesan prints. Plate 32 shows one of his finest album plates, part of an erotic series, with a design reminiscent of Sugimura but displaying a solidity of composition and a rich boldness of "black coloring" that was seldom to be equaled in ukiyo-e. Kiyonobu was never quite the master of kimono design that were Moronobu and Sugimura — not to mention Kai-getsudo — but the total effect of the plate is one of graceful latent power. Kiyonobu has here surpassed himself by the simple expedient of depicting

81

a kimono simple yet by its nature suited to his style. This girl is one of the boldest we will find in ukiyo-e; her features and form are clearly derived from the model of Moronobu, but strikingly display the roundness and solid power that distinguish Kiyonobu's figures. If the total effect is more of a pattern than of an erotic scene, that is one of Kiyonobu's characteristics, too.

Like most of the ukiyo-e masters, Kiyonobu was an expert in erotica—even including several pederastic series involving the "gay" actors—but the interest of his love scenes is almost never sexual or sensual; rather are they bold, sometimes crude, patterns in which the nudity of the bodies is only a part, however integral. They form a curious chapter in Japanese erotica, prints whose sexual content is largely lost in the overpowering pattern of the participants' bodies.

Kiyonobu's varied output in the first three decades of the eighteenth century includes, in addition to his basic work of Kabuki posters and bill-boards, many volumes of book illustrations and a number of strong and mas-terly actor and courtesan prints (many of them unsigned) in large format—both influencing and influenced by the Kaigetsudo artists. Kiyonobu's late works, smaller in scale and done in a more quiet, graceful manner, are often difficult to distinguish from his successor's; they will be noted subsequently. Strangely enough, the characteristic prints of the early Torii school are most often signed "Torii Kiyomasu," the name of an artist who is supposed to have been Kiyonobu's younger brother.

Kiyomasu (worked from 1696 to the early 1720's) has always represent-ed an enigma in ukiyo-e history. His first known work is shown in Plate 34; it is one of a series of book illustrations published in 1696, the year custom-arily assigned to his birth (which will show something of the reliability of traditions regarding the ukiyo-e artists' work and biography). The scene is from a love novel, and the style is clearly an imitation of Sugimura, who was just then approaching the end of his career. Indeed, Kiyomasu, far more than Kiyonobu, patterned much of his early work on Moronobu's de-cadent competitor, and he was one of several important ukiyo-e artists to do so. To this displacement of Moronobu as the model may, I suspect, be attributed something of the loss of male vigor and the lack of "seriousness of intent" that were to characterize part of the work of the Torii school.

The book illustrated in Kiyomasu's earliest known effort is another cu-rious yet typical novel of the time: it concerns the love and trials of young Iori, a disenfeoffed samurai, and Oyuri, lovely daughter of a samurai who

is murdered early in the book by a rejected suitor of the girl. During the course of the novel Oyuri is kidnapped by bandits and sold as a courtesan in the Kyoto pleasure quarter; on the occasion of a street dance in the district—the scene depicted in our illustration—the principals of the story are brought together, and vengeance, as well as happy union, is finally achieved by the lovers.

Although large signed prints by the elder Kiyonobu are rare, those by Kiyomasu are numerous, probably indicating that the older artist spent his time at the more prestigious business of painting the Kabuki billboards and designing playbills and illustrations, leaving the print field more to the younger man. Of course, at the time, this official work for the Kabuki theaters was doubtless considered the most important function of the Torii clan, and hence was left to the current head of the school. Thus, paradoxically, we now possess a great many of the popular prints of Kiyomasu, where most of the magnificent billboards and other paintings by the founder of the school have long since been lost.

Plate 35 shows one of the finest of Kiyomasu's love scenes, a large, horizontal print in black and white, with orange and pale yellow hand coloring. The scene is that perennial favorite of the ukiyo-e artists, the interior of a Yoshiwara boudoir, showing the courtesan with her lover. Here the setting is summer and the lover reclines within the mosquito netting, his robe loosely wrapped about him. The fine lines of the mosquito net are indicated by a faintly handpainted yellow pattern. In the center the majestic Yoshiwara courtesan sits with her elbow resting on a tasseled pillow and a saké cup in her hand. At the right squats the little maidservant—drawn, in one of the conventions of early ukiyo-e, like a miniature adult rather than as a child. The man's kimono is simple enough, but the maidservant's reveals a design of large plum blossoms, and the courtesan's is featured by a pattern of the lacquered *inro* cases so favored by Western collectors today. In the background a screen displays irises by a stream. The print is of the orange-print variety and is distinguished by a dramatic employment of the primitive coloring.

Overleaf 33 and 34:

(Left) Kiyonobu I. Ghostly Combat. 1687. (Right) Kiyomasu I. Street Dancers. 1696. Details of medium-sized book illustrations.

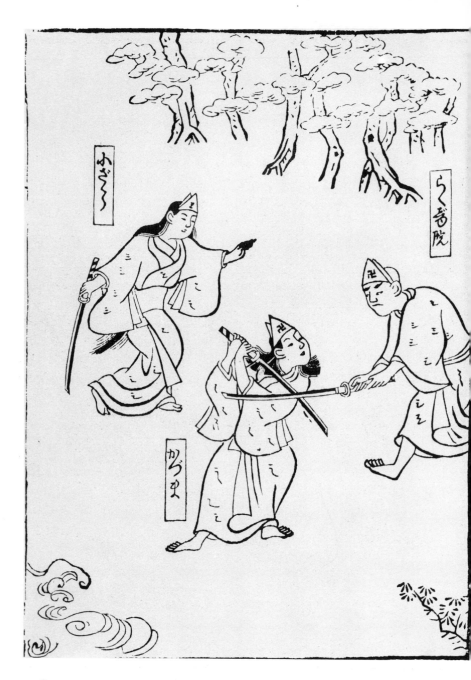

84

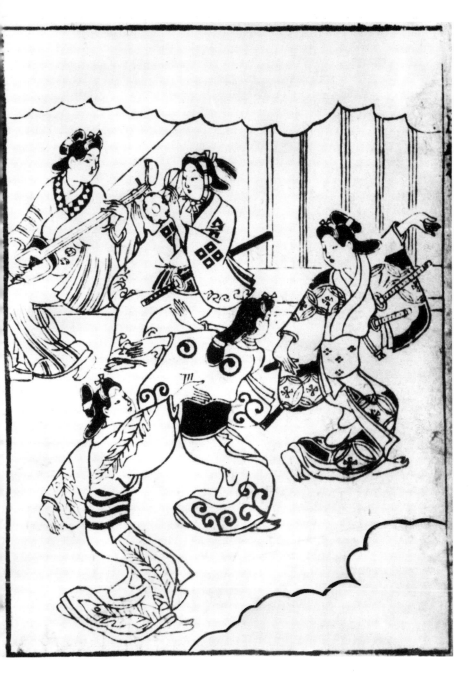

As we have noted earlier, such scenes were often frontispieces to erotic albums. The present work, however, is of a much larger size than usual, and was clearly issued as an independent print. Its buyers were doubtless the rakes or would-be rakes of the day. Since a round of such pleasures as are shown here cost at least the equivalent of a hundred dollars, these pictures may well have been bought by junior clerks and rising tradesmen as a (hopefully) temporary substitute for the real thing. They also formed an excellent souvenir for the wealthy connoisseurs whose business affairs, or distant residence from Edo, prevented them from visiting the floating world as much as they might have wished. Whatever the nature of the contemporary audience, however, the print in Plate 35 stands as a rare example of the early Torii school at its peak, exhibiting a graceful, self-possessed eroticism that pleases as much by its artistic pattern as by its subject.

In the 1710's, after nearly three decades of activity, Kiyonobu seems to have turned over part of his Kabuki work to Kiyomasu. During 1715–1716, the latter designed, for example, an impressive series of black-and-white prints featuring the great actor Danjuro II in his various roles. A similar but even more notable print is shown in Plate 36. It was originally a lacquer print, the hand coloring being accomplished with lustrous vegetable pigments, in imitation of lacquerware, with "gold dust" (actually brass) sprinkled on some of the wet pigments to give sparkle to the print. The colors are today faded and the print is just about as effective in monochrome, as shown here. The scene is from a Kabuki drama and features three well-known actors—the one at the left in the role of a blind masseur, in the center a fair young man of the nobility, and at the right a lovely girl reduced to selling picture books and prints on the streets. A potential love story is implied in the girl's amorous glance and the young man's shy response.

Aside from its considerable artistic interest, this print is notable as one of several that show how books and prints were hawked about the streets of eighteenth-century Edo, in a period when each print and book shop was its own publisher and its own retailer. The batch of prints which the girl dangles from her left hand are of the narrow lacquer-print size just coming into favor at this time, a reduced size both inexpensive and ideally suited for intimate depiction of the actors or reigning beauties of the day.

Although few early ukiyo-e dates are reliable, Kiyomasu appears to have died fairly young, probably in the early 1720's. He was not the bold

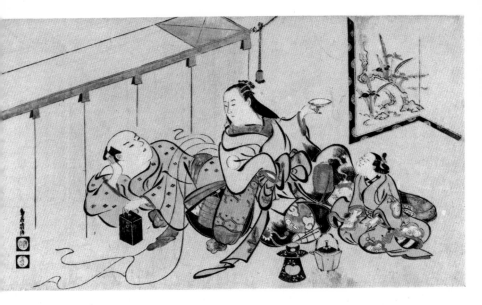

35 Kiyomasu I. Courtesan with Lover. 1710's. In a house of assignation, the lover reclines within the mosquito netting as the courtesan holds a saké cup and the little maidservant sits in attendance. Large woodblock print with hand coloring.

and startling innovator that Kiyonobu was, but he did establish an ideal of fluent grace that was to dominate the work of the Torii school for the next half-century. It was Kiyonobu who established the bold, dynamic forcefulness of the Torii school, but it was Kiyomasu who adapted that style to portraying serene beauty, whether on the stage or in the outer world.

Kiyomasu ceased work at the beginning of the 1720's, and Kiyonobu was dead by the end of the same decade. Each had trained his successor, however—sons or adopted sons. Indeed, in the late work of both artists, but particularly Kiyonobu, we may sometimes detect the hand of the pupil, and the authorship of Torii prints of the 1720's is often difficult to settle, for none of the prints bear any manifest distinction between the teacher and the pupil; they are simply signed "Kiyonobu" or "Kiyomasu," and the designations "I" and "II" are merely our modern attempts to distinguish the two generations.

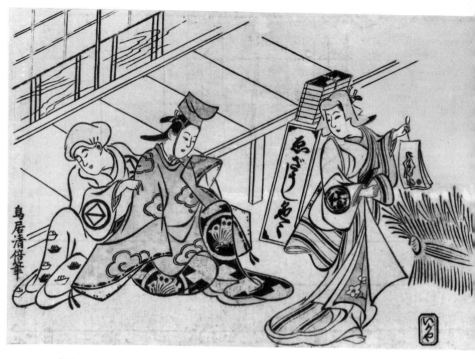

36 Kiyomasu I. Masseur, Young Nobleman, and Girl Bookseller. ca. *1717. Small woodblock print with hand coloring.*

Plate 37 depicts the fair young actor Izaburo as a youthful samurai in the midst of a stylized dance before a pine tree. He holds a fan in his right hand and grasps his long sword with his left. The wide sleeves of his outer robe and the tips of his ceremonial skirt are caught in a moment of arrested movement as he strikes a precarious but balanced pose. The print, datable from the Kabuki records as 1726, is signed "Torii Kiyonobu," and is either the finest extant work of Kiyonobu II (who worked from the 1720's to about 1760) or one of the great late works of his father. Possibly it represents a collaboration, but the signature, at least, seems that of the son.

Here, in any event, we glimpse the peak of the Torii style in its middle years: the primitive vitality of the early Kiyonobu is gone, and in its place we see the quintessence in miniature of the graceful, restrained vigor that

was Kiyomasu's contribution to his school. Still retained, however, is something of the bombast and movement of a Kabuki performance, and the print is at once part of a tableau and an idealized record of a great Kabuki dancer at the peak of his performance.

At the same time, the print is a masterpiece of the hand-colored "lacquer-print" (*urushi-e*) genre mentioned above. The vivid colors glisten and sparkle almost as on the day they were painted; the rich black pigment at the actor's shoulder and the gold dust at the lower right lend a strange depth and unity to the coloring. These same pigments sometimes resulted in garish failures, but at the hands of a master, as here, hand coloring produces effects of richness and vitality that were never to be surpassed in all the ramifications of later color printing. Whether any kimono could ever reproduce the variety of coloring we see here was not, of course, the concern of the painter: Kabuki itself knew no limitation in methods of producing an effect through color and hyperbole. Few, indeed, must be the actual pine trees which combine a trunk of pink with needles of mustard-yellow, olive-green, and red: this is clearly a pine tree of the imagination.

The last of the quartet in the direct Torii line, Kiyomasu II (who worked from the 1720's to the early 1760's), is often maligned by critics who have seen only his poorer work. Indeed, the average prints of either Kiyomasu II or Kiyonobu II are rather stereotyped, lacking in vitality or fertility of invention. Yet in perhaps a quarter of their prints they manage to rise above the confines of their own limited talents and produce work of rare grace and charm. Plate 39 shows a detail of a print typical of Kiyomasu II at his best, a standing portrait of the classical poetess and beauty Komachi, resplendent in light pigments augmented by gold dust and powdered mica, but even in monochrome its graceful ideal of feminine loveliness is striking. This is the girlish face which remained the ideal of the Torii school during all the middle years of its flourishing, and which brightens so many of the Torii prints and children's books produced in such quantity during the second quarter of the eighteenth century. It becomes difficult to point up the failures of a school when, in repeated moments of inspiration, its lesser members could create such an image as this.

We have suggested above that something of the change in ukiyo-e fashions from austere power to sensual grace may have lain in the supplanting of Moronobu by Sugimura as a basic influence. This readily apparent weakening of artistic force and originality during the 1720's and 1730's was,

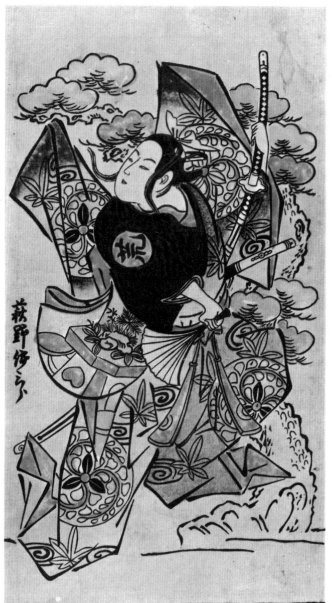

萩野伊ふ下

鳥師海 居清信筆通油町村田板元

however, indicative also of a far more profound and general trend of the times, visible in Japanese art in general, as well as in other cultural forms. It represents, on the one hand, a natural slackening of vitality after the limited but highly dynamic Japanese renaissance which began in the early seventeenth century and culminated in the Genroku Era.

At the same time, government interference must surely be blamed in part for the attenuation of this first flowering of Japanese plebeian culture. Early in his reign the eighth Tokugawa Shogun, Yoshimune (ruled 1716–1745), found both the government and the country at large in serious financial difficulties. He therefore determined to enforce an austerity program upon the nation, with a general raising of morality and a return to the "simple, austere life of former times" as the philosophical basis of the program. The curiously detailed bans and warnings which his government issued seem almost consciously aimed at killing all that was gay and creative in plebeian life. For example, these edicts of the year 1721:

> The use of gold and silver foil and metal utensils is prohibited. Large, decorated battledores and shuttlecocks are prohibited. Dolls over eight inches tall are prohibited.... The use of gold and silver coloring on toys, children's clothing, doll-stands, etc., is forbidden.
> The production of anything new in the field of books and booklets is forbidden. (However, if there be any real necessity for such, applications may be made to the office of the Magistrate, requesting instructions. For the time being, single-sheet prints, etc., may be printed, but are not to be put on public sale....)
> Such articles as the above have existed for some time, and at first their form was quite simple. But gradually methods changed and they became very elaborate and colorful, and also very expensive. Therefore do we order you to use the simple forms of earlier

37 *Kiyonobu II. Kabuki Dance. 1726. The actor Izaburo in a scene from the dance-drama* Tokiwa Genji. *Small woodblock print with hand coloring. One of a set, the left panel of which shows an actor in a female role.*

Overleaf:
38 *Kiyoshige. Warrior and Dancer. 1758. Hand-colored cover prints from volumes I and III of a children's book.*

新板

新皿屋舗月�‍晝‍記‍

上

山

days. (Of course, when these articles are for official use, the above does not apply.)

Fortunately, the Japanese townsman was too resilient and clever to receive such authoritarian trivia with anything more than lip service. Thus, in obeying something of the letter, but seldom the spirit, of these oppressive edicts, the Japanese commoners in the end succeeded in preserving their rising heritage of reborn culture. Nevertheless, the manifestations of plebeian culture could not but be adversely affected by these totalitarian ordinances, and we have, I think, a misguided, financially oppressed dictator to thank for the weakening of many popular art forms such as ukiyo-e prints during the 1720's and 1730's.

Although so far our emphasis has been placed on the members of the immediate Torii family line, there were other artists of great talent who followed the Torii style and were often direct pupils employing the family name. Among them were:

Torii Kiyotomo (worked from the 1720's to the 1740's), who was probably a late pupil of Kiyonobu I. His work greatly resembles that of his fellow pupil Kiyonobu II, both in its strong points and its weaknesses.

Torii Kiyotada (worked from the 1720's to the 1740's), who seems also to have been a pupil of the first Kiyonobu; in his fusion of the Kiyonobu and Masanobu styles he impresses one as possessing more talent than either Kiyotomo or Kiyonobu II, and it is unfortunate that so little of his work is now known.

Torii Kiyohiro (worked from the 1750's to the 1760's), who patterned his figures closely after those of Kiyomitsu and Toyonobu—artists who will be mentioned shortly—but in his over-all compositions reveals a special genius of his own.

Torii Kiyoshige (worked from the late 1720's to the early 1760's) was a late pupil of Kiyonobu I and often gives a rather stiff, angular note to his prints; his book illustrations and his large pillar prints in the Masanobu manner rank among the masterpieces of the Torii school.

We have chosen the last of these artists to represent this group, and in a form of print designed by nearly all the ukiyo-e artists of the eighteenth century but all too long neglected both in Japan and in the West. We have already mentioned the wide activity of the Torii artists in the field of illustration of children's books. These little volumes of fairy tales and legends

form one of the untouched treasures of eighteenth-century Japanese literature and art. Each book consists of one to ten small volumes of ten pages each. Every page is a block-printed illustration by a well-known ukiyo-e master, with the text (often prepared and written by the artist himself) printed in simple language above and around the figures portrayed. These small volumes formed the equivalent of today's "comic books," but their artists were the greatest masters of the popular school; despite the economical printing and paper, the great prints that bring such grand prices in world markets today can be seen on every page in embryonic form.

Although the rough paper of the illustrations renders them difficult to reproduce well, each of the covers of these little volumes boasts a miniature ukiyo-e print which is executed and printed with somewhat greater care than the text and is often itself well worth the price of the book. These "cover prints," as we shall call them, usually feature an outstanding or crucial scene from that particular volume, together with the title of the book.

Plate 38 shows two such cover prints from a three-volume novelette published in the year 1758. Though most often issued in black-and-white, these books frequently display contemporary hand coloring by skilled youthful admirers whose work is often, as here, quite the equal of the professional colorists employed by the ukiyo-e publishers. At the right we see the cover print for the first volume of the book, the young hero performing a restrained but lively Noh dance on a stage with pines in the background; at the left, in the cover print of the final volume, we discover the same hero in later life, dressed in full samurai regalia, and clad, moreover, in snow cap and rain cape, appearing beside a castle in the snow, preparing for revenge upon his enemies. Above and below each scene will be found the decorative wave design that characterizes this particular book; at the left are seen the titles and volume numbers. The interior illustrations of course feature more complex storytelling scenes than the cover prints, but they maintain the same general level of quality, which makes these little volumes surely one of the finest groups of children's books, and one of the most successful blendings of literature and art, to be found in any land.

The final major figure in the traditional Torii school is Torii Kiyomitsu (about 1735–1785), son of Kiyomasu II and nominal head of the third generation of the Torii. Kiyomitsu worked almost entirely in the period of the "red prints" (*benizuri-e*), the stage from about 1740 to 1765,

when primitive color printing had gradually replaced hand coloring. (A detailed discussion of this process is given in the next chapter.) Kiyomitsu's work is about evenly divided between Kabuki scenes and girl pictures. He produced an enormous quantity of Kabuki prints, many of them prosaic, for his was not a dynamically original talent. With prints of girls and young men he was more successful, and in this category he was one of the greatest figures of his time, sometimes even equaling Harunobu, the genius of girl prints who was just beginning his work.

Plate 40 exhibits Kiyomitsu's strength and weakness. The figure of the actor at left is skillful enough, but taken alone is typical of Kiyomitsu's Kabuki work, and hardly breathtaking. The girl at right, however, ranks among the loveliest in ukiyo-e. ("She" is, technically, a female impersonator, but in reality may be considered more a girl of the artist's imagination than the subject of a simple actor-portrait.) When the stiff form of the actor and the pliant figure of the young girl are combined, the result is one of rare beauty —a beauty, as is typical of Kiyomitsu, where the effect is unexpected, deriving from seemingly inharmonious elements.

Historically this print is of great interest, for it displays the last peak of the red prints, which were, within two or three years, to be displaced by the more colorful "brocade prints" of Harunobu. Some five blocks are employed in this print—yellow, mauve, gray, green, black—but the technique and color harmonies belong to the traditional age of ukiyo-e rather than to the new full-color palette soon to be developed by fresh artists under Harunobu's leadership.

39 (Left) Kiyomasu II. The Poetess Komachi. Late 1720's. Detail of small woodblock print with hand coloring.

Overleaf 40 and 41:
(Left) Kiyomitsu. Kabuki Scene. 1763. The actors Uzaemon and Kikunojo appear as male and female komuso, itinerant Buddhist flute players, in the drama The Flowering of East Mountain. *At the top are the actors' crests and a verse commemorating their performance. Large color print. (Right) Kiyotsune. Lovers Eloping. 1760's. A youth carries his coy sweetheart on his back as they elope—a scene derived from classical Japanese literature, but here translated into modern terms. Painting on paper; large hanging scroll.*

Kiyomitsu's greatest follower was Torii Kiyonaga, a pupil of his late years, who was to found a tradition that dominated after Harunobu's brief decade of fame; Kiyonaga will be discussed in a later chapter. Kiyomitsu's chief traditional pupil was Torii Kiyotsune (worked from the late 1750's to the 1770's), at his finest, one of the great ukiyo-e masters of naive, effeminate delicacy, in this quality sometimes surpassing Harunobu himself. Kiyotsune's prints greatly resemble those of his master, but the innocent frailty of his figures often saves them from the monotony of some of Kiyomitsu's work.

We have chosen a rare painting rather than a print by this master (Plate 41) to reveal his style and remind us also of the occasional activities of all these print artists in the more prestigious field of painting *kakemono* for the parlors of wealthy patrons. Plates 40 and 41 form, indeed, excellent examples for a comparison of the differing methods and effects of ukiyo-e prints and paintings. In the former, whatever the basic delicacy of the design, the sweep of the carver's knife has lent a wirelike sharpness to the figures, while the flat planes of the color blocks break the print's surface into clear-cut yet pleasingly harmonized patterns of color. In Kiyotsune's painting, however, the softness of the original brushstroke is fully retained and, in the original, intimately and deeply felt; further, in the soft, now oxidized hues of the boy's skirt and elsewhere, we find a depth and gradation of coloring that no woodblock could possibly match. In short, as we shall note throughout ukiyo-e, the painting and the print may exist harmoniously side by side, each form fulfilling a different function, their common effect lying in the successful depiction of an instant of profoundly moving beauty, glimpsed in these parallel mirrors of the floating world.

The subject of Kiyotsune's charming painting was a favorite of the ukiyo-e artists, the elopement of a pair of young lovers, the boy carrying off the girl on his back into the romantic future. The theme was derived, though indirectly, from various early Tosa illustrations for a brief and ingenuous chapter in the tenth-century *Tales of Ise*, which may be translated as follows:

In former times there lived a young nobleman. For several years he had courted a certain young lady without being able to make her his own. At last he succeeded in eloping with her on a pitch-black night. When they arrived at the river called Akutagawa

she asked concerning the dewdrops left upon the grass: "What are those?" But their destination was distant and the night was far advanced so he did not reply.

The thunder roared fiercely, the rain came in torrents: he put the girl inside a dilapidated storehouse, unaware of the demons [in reality, the girl's brothers]. The man then stood at the entrance, bow and quiver in hand, hoping that the night would soon end. In the meanwhile the demons had all at once devoured the young lady; and though she cried for help, he could not hear her for the rumbling of the thunderstorm.

Dawn came at last, but when he looked into the storehouse the girl who had come with him was nowhere to be found. He stamped on the ground and wept, but all to no avail:

> *"Are these white pearls*
> *or what are they?"*
> *my love asked once before.*
> *Had I but answered, "Dewdrops" and*
> *then known life's grief no more!*

This famous elopement scene had appeared in ukiyo-e even before Moronobu, and remained a favorite subject throughout the history of this popular art. The most-reproduced work on this theme, and possibly Kiyotsune's direct inspiration, was a color print by his fellow pupil in Kiyomitsu's studio, Torii Kiyohiro, which bears the humorous verse, at once romantic and realistic,

> *They sway the moorland's*
> *thousand grasses*
> *with their fervent warmth:*
> *heavy, heavy is the load of love!*

In following the fortunes of the long-lived Torii school, we have spanned some eighty years of ukiyo-e history and development, from the bold, dynamic work of Kiyonobu, spiritual successor to Moronobu, to the graceful effeminacy of Kiyomitsu and Kiyotsune, immediate precursors of Harunobu. Before turning to that remarkable artist, we must first retrace our steps to record some further significant lines of early eighteenth century ukiyo-e—Okumura Masanobu and his followers, and some little-known but nonetheless notable illustrators and painters of Kyoto and Osaka.

GRACE AND LIVELY WIT

Okumura Masanobu and Others

IF one master were chosen to demonstrate the wide range of forms in ukiyo-e, it would surely be Okumura Masanobu. This artist's long life (about 1686–1764) spans the period from the strong early black-and-white prints and the great hand-colored orange prints, through the lacquer prints, small and large, all the way down to the red prints that just precede the development of full-color printing. In addition, Masanobu worked in practically all the experimental ukiyo-e forms of the first half of the eighteenth century (and may have invented several of them): the triptych, bust portraits, Buddhist subjects, stone-rubbing prints, large perspective prints, elongated pillar prints, and the early landscape and flower-and-bird prints.

Moreover, unlike several other long-lived ukiyo-e artists, Masanobu's production is surprisingly even: from his first black-and-white prints, done in his early teens, to his last red print done in his mid-seventies, there is no flagging in that inventive genius and native wit that characterizes all his work. Two long-lived artists, Masanobu and Hokusai, could be taken to represent practically the total range of ukiyo-e in their prints; in the long run it may well be that Masanobu will be recognized as the greater genius of the two.

In Plate 42 we see the earliest known print by Masanobu, from a *Courtesan Album* published in the year 1701. Its designs are patterned after a similar work of Kiyonobu's, already mentioned, published the previous year. But although the compositions are frequently derivative, the figures are already tending to become characteristically Masanobu's: in place of

the solid power of Kiyonobu we see the beginning of that Edo wit and verve that was to characterize the best in eighteenth-century ukiyo-e, and owed its origins above all to Masanobu.

The scene of this print, the first in the series, is the entrance to the Yoshiwara: fire buckets are stacked in the background and a wealthy rake and his manservant are seen entering from the right. As was customary in the larger pleasure quarters, deep reed hats were often purchased or rented before entering; thus, faces hidden, the gallants could enjoy a modicum of anonymity—such as we find today behind dark glasses. The scene was one of the staples of ukiyo-e from its origins; indeed, this might well be considered a close-up of what the pioneer Moronobu showed us thirty years earlier in Plate 13. At the left side of the print we see the principal subject of the album, the high-ranking Yoshiwara courtesan, here accompanied by a woman who handled her affairs and appointments. The courtesan is the famous Kasugano, identified both by name and crest; she wears a kimono bearing bold patterns of giant chessmen, while her attendant, an older woman, wears a kimono of simpler floral designs, with a kerchief placed upon her hair and purse and keys dangling from her sash.

A glance at the composition of this print reveals that we are already in the presence of a master: the man's striped trousers and minutely patterned upper garment complement the wild disarray of the courtesan's bold kimono; the total composition is bound in a dramatic unity worthy of Masanobu's great preceptor Moronobu; the swifter movement of the two men with their angular bodies and even more angularly dynamic black swords is balanced by the slower but more solid progress of the vividly bedecked courtesan. If one eliminates any element—even the fire buckets or the courtesan's flower crest—the unity of the composition is destroyed. With time, and with the changing fashions of ukiyo-e, Masanobu was to modify greatly the concept of bold power that he derived from Moronobu and Kiyonobu; he was never, however, to lose his remarkable sense of balance and design, which is as readily apparent in the lovely delicacy of Plate 48, done just fifty years later, as it is in this *Courtesan Album* of 1701, designed when Masanobu was in his early teens.

Masanobu was undoubtedly the greatest Japanese master of the album, as Moronobu had been of the illustrated book. Ukiyo-e albums were, in effect, a series of horizontal prints on a given theme, folded in the middle and bound together for convenience. Moronobu had already produced

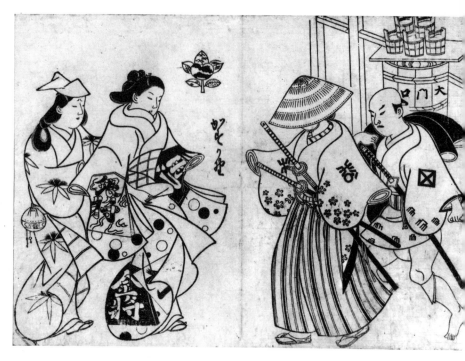

42 *Masanobu. Yoshiwara Street Scene. 1701. Large album plate.*

several such albums, erotic and otherwise, in the late 1670's and 1680's, as had Sugimura; but it was Masanobu who devoted much of his early work to that form. His *Courtesan Album* itself saw several later versions, redesigned and expanded; but his greatest albums display his more fanciful approach to the "floating world." Masanobu designed at least a dozen albums, of a dozen prints each, each devoted to witty and paradoxical approaches to the classics as seen through modern eyes: among them one will find series of parodies on the austere Noh drama, on familiar Kabuki and puppet-drama scenes, on the *Tale of Genji*, or on themes from classical Chinese and Japanese poetry or legend.

For Masanobu was, though self-taught in ukiyo-e, a literary amateur of some pretensions, pupil of the noted Edo poet and novelist Fukaku. Masanobu's skillful retelling of the *Tale of Genji* in modern terms, which he

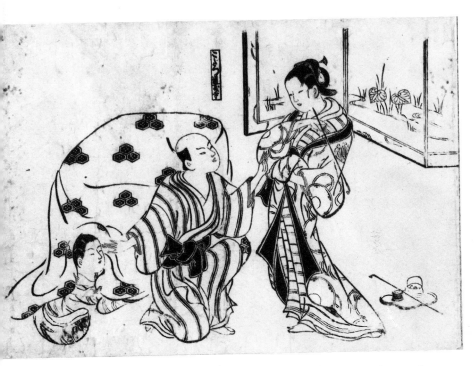

43 *Masanobu. Jealous Wife Discovers Rendezvous. 1710's. Large album plate.*

illustrated and published in three series of six volumes each around the year 1707, was one of several such literary-artistic efforts on his part. We may assume that the texts of the many children's books which he illustrated also issued from his brush. Indeed, Masanobu must be ranked with Harunobu in consistent and unified employment of literary themes in his prints. With the pioneer Moronobu, of course, literary association had been an inherent feature, for much of his work was in specific illustration of a literary volume, classical or modern; with Masanobu the literary element was at last divorced from its specific text and became an independent theme of ukiyo-e, an important development which was to lend a new depth and subtlety to the prints of the Ukiyo-e school.

Quite naturally, ukiyo-e prints are valued in the West principally for their surface beauty rather than for any adept utilization of literary asso-

ciations. Thus most of Masanobu's finest parodies will mean little to the modern viewer unless accompanied by several paragraphs of commentary; and then the spontaneous effect will have been lost in the verbiage. For example, Plate 43, one of Masanobu's finest parodies, shows a jealous wife advancing threateningly at right, her apologetic husband cowering in the center, and to the left, partially hidden under a *kotatsu* (quilted brazier), the husband's youthful paramour. Alone, it is an amusing scene, but when we look at the title the picture becomes even more richly humorous. It is entitled "*Kotatsu Dojoji*," the second word being the name of a temple and the title of a famous Noh play in which an amorous maiden, spurned by a handsome Buddhist priest, chases him into the bronze bell of a temple, then in her rage transforms herself into a dragon, wraps her coils around the bell and burns the scornful priest to a crisp. Here, instead of a great temple bell, we have an ordinary household brazier, in which a frightened girl (possibly the family maid) huddles in an attempt to hide; and, the fury of a betrayed wife being what it is, we have no doubt that the young girl is in somewhat the same danger that the legendary priest was. In addition to this classical allusion, we may be sure that the connoisseurs of Masanobu's day would not have failed to remember the artist's most immediate inspiration, a novel by Saikaku—published some thirty years earlier but reissued several times in Edo with illustrations by Moronobu—in which the hero is successfully hidden under a brazier by his courtesan-paramour when she is unexpectedly visited by a wealthy patron.

Granting, then, that there is much in Masanobu's literary albums that will be obscure to the casual art lover, there is also a great deal that can be appreciated for its beauty of line and figure alone. There are also several albums less complex in their allusions, devoted more simply to daily incidents in the lives of the courtesans. Plate 45 shows a picture from one such album, a scene of courtesans at leisure, playing with some dolls—newly bought, doubtless, for the Girl's Festival of spring. This was a holiday, still celebrated, on which even grown women and courtesans, in memory of happier childhood days, participated in "playing house" with elaborately be-decked retinues of dolls, ranging from representations of the Imperial family on down to servants and entertainers. At the left the courtesan's young maid-servant holds a small doll, while beside her the middle-aged attendant manipulates a mechanical puppet representing a one-man marionette show; on the floor are two smaller dolls. At right, almost imperceptibly dominating

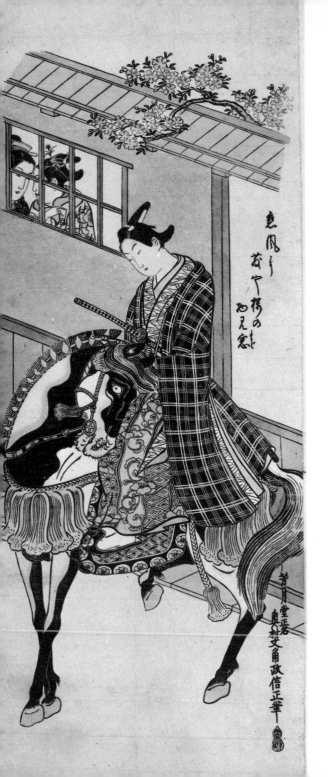

44 *Masanobu.* *Young Samurai on Horseback.* *Mid-1740's. Through the window two girls peek admiringly at the gaily accoutered young man; the verse reads, "In Love's zephyr, cherry blossoms fall, beside a picture window." Large woodblock print with hand coloring.*

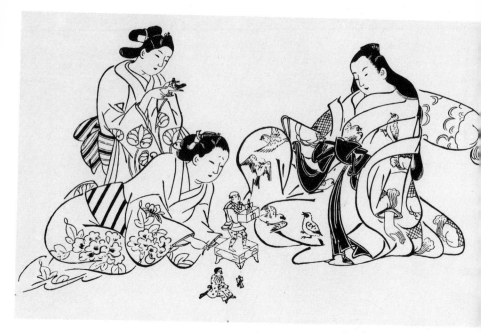

45 *Masanobu. Courtesans with Dolls. 1710's. Large album plate.*

the design, sits the high-ranking courtesan herself, resplendent in a robe of sparrow designs and tasseled pillows, while her own half-tied sash and the pillow at her back indicate she has but recently aroused herself from bed. Watching the childish play of her attendants, she seems to be bemusedly detached. As is always to be found among the great ukiyo-e masters, there is a clear composition *in beauty* as well as in design: the two plainer faces and figures in the left half of the print are perfectly balanced by the single lovely face and languorous form of the reigning beauty, and no further background or color is required to complete the album sheet—one that stands today among the dozens of casual masterpieces issued yearly by this facile master.

Masanobu's black-and-white albums range through the whole first half of his career, from the early 1700's to the 1730's; his picture books and illustrated novels continued to be produced in numbers almost to the end of his days. Simultaneously with his early albums Masanobu began designing large prints of girls and courtesans, often in the form of hand-colored orange

prints which, at their best, rank with the Kaigetsudo beauties in power and grace, and sometimes excel them in the native wit displayed. In the 1720's Masanobu succeeded in opening his own publishing house in Edo, both in order to increase his control over the final results of his designs and, no doubt, to retain the lion's share of the profits from his popularity, which had hitherto gone to his various publishers. (By the late 1730's Masanobu's son Okumura Genroku seems to have taken over the actual operation of the publishing concern, leaving his father free for his artistic concerns.)

It was just at this time that the fashion was changing (partly under government influence) from the large orange prints and medium-sized album plates to the smaller and more intimate lacquer prints, about twelve by six inches in size. This easily handled format was to dominate Masanobu's print production during his first two decades as his own publisher, and in it he

46 Masanobu. Courtesan with Lover. 1710's. Large album plate, hand colored.

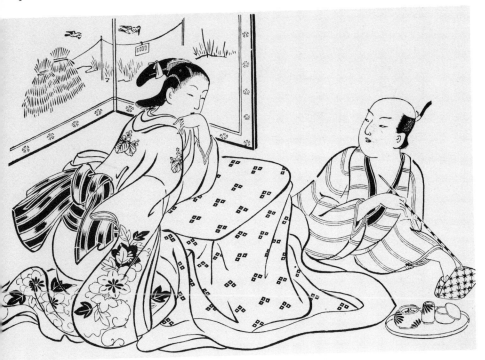

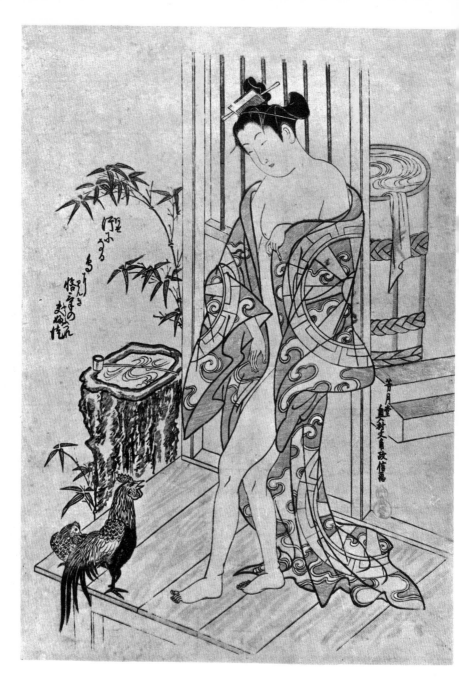

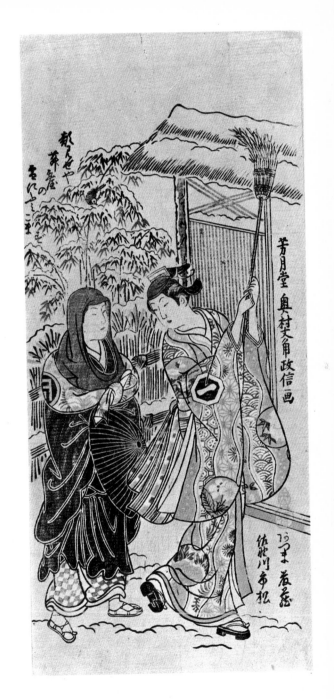

7 (Left) Masanobu. Cour-
san after Bath. 1750's. As the
alf-dressed courtesan comes
ut onto the porch from the bath
hamber, she is confronted by
cock and hen. Medium-sized
olor print.

8 (Right) Masanobu. Ka-
uki Scene. 1751. At left the
oted actor Ichimatsu, in the
ole of the priest Nichiren, ap-
roaches the maiden Tamazusa,
layed by Fujizo; the latter is
rushing snow off her gate with
a broom. Small color print.

was to create an impressive percentage of the minor masterpieces of all ukiyo-e.

In tune with the taste of the times, Masanobu, like his contemporaries the Torii masters, often took current Kabuki dramas as his theme; his small and warmly intimate lacquer prints of the actors form a pleasant contrast to the more conventionalized pictures of the Torii artists. Unlike many of his contemporaries, however, Masanobu searched far and wide for themes, and many of his best prints depict non-Kabuki subjects—scenes from classical and modern literature and legend, birds and animals, landscapes, girls and courtesans, and depictions of the festivals and events that constituted the fascinating street scenes of Edo. He also experimented with the curious "stone-rubbing prints" (*ishizuri-e*), in which the lines are shown in reverse, white against a rough black background, in the manner of Chinese stone rubbings.

By the year 1740 print fashions had once again changed, and larger prints were back in style. Masanobu, always a pioneer in such trends, led the field from the outset. Not only did he design some of the finest of the new actor and courtesan prints, but he also began experimenting with Western-style perspective, producing a number of excellent prints—usually featuring grand interior scenes in horizontal format—in which the receding lines are made to correspond to Western, rather than Oriental, perspective. The effect of these seems oddly quaint to us today, but they were a startling innovation to Masanobu's contemporaries. The greatest of Masanobu's large lacquer prints were, however, his vertical prints featuring figures of actors and girls, together with such varied compositions as we see in Plate 44.

With the Kaigetsudo masters, and the Masanobu of Plate 44, the Japanese print achieves a magnificence of coloring and dimensions which places it on a competitive level with the rich *kakemono* paintings and even with the smaller Western oil paintings (not, of course, that one would wish to compare such dissimilar genres). By the same token, such prints lose the intimacy of the smaller designs and become principally objects for exhibition, either (as they were in the eighteenth century) mounted in place of a *kakemono* painting, or in a museum today. Due to the rarity of these big *kakemono* prints they now command the highest prices of all ukiyo-e prints; so far as the individual collector goes, however, one wonders if he can get as much personal pleasure out of these impressive showpieces as from the little poem cards at a tenth the price. Be that as it may, the grand *kakemono*

prints flourished particularly during the Kaigetsudo period around the 1710's, during the 1740's with Masanobu and his contemporaries, and, briefly, in the landscapes of Hokusai and Hiroshige a century later. They were never to usurp the central place of the smaller prints, but they do constitute a noteworthy and magnificent attempt on the part of the popular artists to exceed the normal limits of the print format.

Around the year 1740, at exactly the same time that the large lacquer prints were coming into vogue, Masanobu began experimenting with—and perhaps helped to invent—the first real "color prints."

Our account has dealt with ukiyo-e *prints* from the early masterpiece of Plate 10; yet in the subsequent eighty years of its development the Japanese print had depended entirely upon hand coloring for its hues. Not that color printing was unknown in the Far East: it had been practiced on a limited scale in China, and in Japan several different colors had been employed with success as early as 1627 in an illustrated arithmetic text, and in 1644 in a seven-volume almanac. Yet these were to prove scattered experiments, repeated in subsequent years only for special works, such as poetry collections in limited editions. Most probably early color-printing methods were troublesome and expensive, as yet unsuited to mass production.

By the 1720's, however, public demand for more color had reached the point where the varied hand coloring of a print like Plate 37 must surely have cost more than the original print itself. By the late 1730's artist-publishers such as Masanobu and Shigenaga (to be noted shortly) had perfected the technique of easy color registry, and the way was now paved for the mass production of pictures color-printed in several hues.

The actual method of printing was as follows. The artist submitted the completed design in black and white on thin paper. This was pasted, face down, on a smooth slab of hardwood such as catalpa or cherry. An artisan then carved and gouged away the portions of the woodblock which were not to be printed, leaving only the fine outlines of the original sketch. This block was now inked, fine absorbent Japanese paper laid upon it and vigorously rubbed with a hard round pad called a *baren*. The resulting impression in black on white paper was the "ink print" (*sumizuri-e*), the basis of all Japanese printing and ukiyo-e prints and the backbone even of the full-color prints. During the early decades of ukiyo-e this print was often sold as it was, simply for its rich black-and-white effect; or, hand colored by artisans, it became the vivid, primitive orange print, or the more rich

and varied lacquer print of the late 1710's and after. In order to produce true color prints, however, another stage was required.

For the color prints of the 1740's and following, after the initial black-and-white "key block" was prepared, the artist was given several copies of the black-and-white impression, on which he marked his suggestions for color printing. Due to the expenses involved in a small edition for a yet limited audience, early color prints (1740-1765), featured a very restricted range of colors, usually the basic red and green that had characterized ukiyo-e from the beginning. Sometimes yellow, blue, or gray were added or substituted, and by the late 1750's three or four colors were achieved, both

49 Masanobu. Kabuki Scene. 1719. In the spring rain a "lady samurai" visits the Kyoto villa of a stylish poet. A maidservant wields a large umbrella, and in his cottage the poet smokes his long pipe while a blind minstrel plays the samisen. Painting on silk; small hanging scroll.

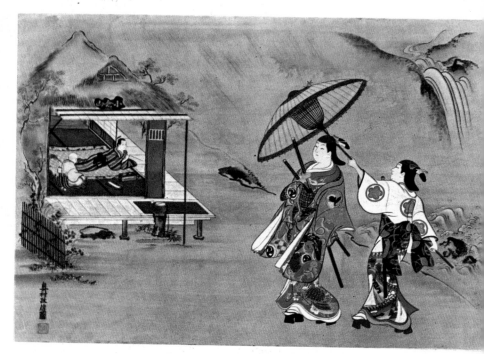

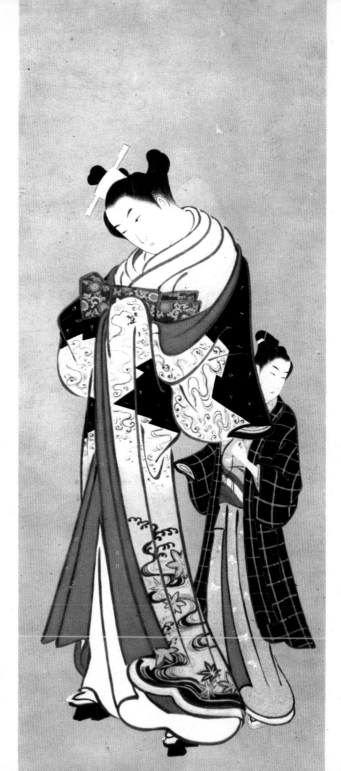

by the employment of a full complement of blocks or by overprinting two colors to produce a third.

The artist thus noted each of the areas to receive a given color. In Plate 48, for example, the green areas could either be marked in that color or simply with the word "green"; more often, one proof sheet was reserved for each color, and any addition on that sheet would imply "green." The same was done for the red (a fugitive vegetable color now usually faded to pink; since this was the characteristic color of these prints, they are termed "red prints," *benizuri-e*). In effect, then, Plate 48 may be visualized in four stages, the fine white paper, the jet-black outlines, the green patterns, and the vermilion patterns. Combined, these simple elements were to produce some of the loveliest of Japanese prints.

Plate 48 has been cited as exemplifying the technique of early color printing, but it deserves further appraisal as one of Masanobu's quiet masterpieces in this genre. The print is not so striking as many in this book, yet in such firm but gentle lines and colors as we see here lie some of the most satisfying experiences in ukiyo-e. The plate represents a Kabuki scene, but, as always, the dynamic, primitive force of the stage is never allowed to intrude in Masanobu's theatrical prints: he seeks a refined ideal of beauty that bears little relation either to the bombast and exaggeration of Edo Kabuki or to the hurly-burly of the Edo streets. And, quite incidentally, this print reminds one again of the importance of the Japanese kimono in ukiyo-e: try to imagine these figures in any other garb.

As though all these achievements were not enough, Masanobu was also a master of ukiyo-e painting, an example of which appears in Plate 49. Even the hand-colored prints were necessarily limited in the strength of the colors the artist or artisan could employ, for too-vivid hues might obscure the lines of the wood block. In his paintings, however, Masanobu could give full expression to his love for color, and Plate 49 is one of the most visually brilliant, gemlike paintings in Japanese art. It also gives us some insight into Masanobu's training, for though he was doubtless self-taught in the ukiyo-e style, the skillfully realized fence, trees, roof, cascades, and waves show strong influence from the traditional Kano school, reminiscent, indeed, of the work of Masanobu's great early contemporary Kano Tsunenobu. Of course, Masanobu may have been self-taught in this respect, just as he was in ukiyo-e; but certainly he ranks with Moronobu in his masterful blending of the "floating world" with the traditional styles. Despite his evident skill,

116

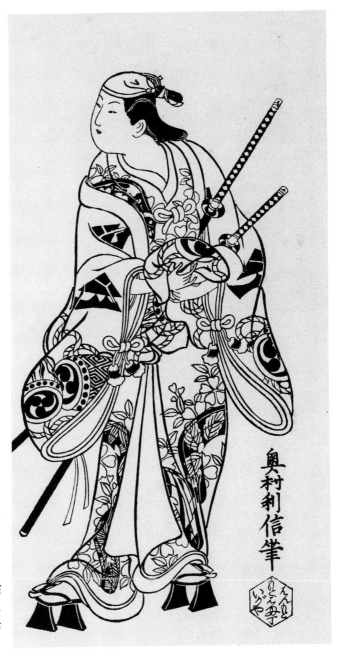

51 Toshinobu. Kabuki
Actor as Female Samurai.
1719. Small woodblock
print, hand colored.

however, Masanobu's extant paintings are relatively few in number, and they are largely devoted to Kabuki subjects. Doubtless his wide activities as a print designer, artistic innovator, and publisher kept him from devoting more time to this less commercial (albeit well-paid) side of ukiyo-e.

In spite of his towering place in eighteenth-century ukiyo-e—savior and renovator, indeed, of the form after the death of the early Torii masters—Masanobu established no important school of his own. Most of his contemporaries learned and (as he himself often complained) copied from him; but Masanobu was himself so great and long-lived that no line of pupils was really needed to perpetuate his style. Only one major artist, Okumura Toshinobu (worked from about 1717 to the 1740's), seems to have studied directly with him. Toshinobu, who may have been Masanobu's adopted son, specialized in small, intimate lacquer prints featuring one or two figures of actors or girls. This was a field in which Masanobu himself excelled during the middle decades of his career, and it is saying much for Toshinobu's genius when we record that he often equaled his master in this one limited field.

Plate 51 shows a good example of Toshinobu's polished charm, in a hand-colored lacquer print which retains its balanced harmony in black-and-white as well. Note how the delicate poise of the actor's body balances so nicely the jutting, angular swords, and how the luxurious kimono flows over all. The actor and role are, by coincidence, the same that Masanobu had portrayed in Plate 49, and the painting and the print offer interesting comparison.

Toshinobu's small prints constitute one of the minor glories of ukiyo-e, and provide an example of how a talented pupil can sometimes equal his master by assiduous practice of a more limited discipline. One of ukiyo-e's minor riddles, incidentally, is why Toshinobu's prints were often issued by publishers other than his teacher. Quite possibly Masanobu the publisher had his hands full simply with his own prolific output. Equally likely, however, was a desire on the part of a teacher that his pupil should benefit

52 Shigenaga. Landscape with Figures. 1720's. Peasants on a mountain trail near Kyoto. Late Snow at Mt. Hira, *one print of a series on the famous* Eight Views of Lake Biwa. *Small woodblock print with hand coloring.*

from outside "editorial guidance" and, now that he had completed his basic training, make a name for himself in the world, away from the shadow of his master's great name.

Contemporary with Masanobu, and influenced by him, were several other artists of considerable talent whose work deserves mention. Hanekawa Chincho (about 1679–1754) produced few prints, but all of distinction; he is famous among ukiyo-e artists for being of samurai stock and working at his artistic calling only when the spirit moved him. Allied in style to Chincho is Kondo Kiyoharu (worked from the early 1700's to the 1730's), who likewise produced few prints that are still extant, but a number of graceful children's books and illustrated novels. Workers in the later Masanobu style include a number of lesser figures, among them "Mangetsudo"—notable as having deftly pirated several of Masanobu's finest designs during the late 1740's, and possibly the *nom de plume* of a publisher rather than an individual artist; and Furuyama Moromasa, who was nominally a follower of Moronobu (and possibly the son of Moroshige) but worked principally in the late Masanobu manner (Plate 50).

Although we have cited Masanobu as the great innovator and renovator of the Japanese print in the first half of the eighteenth century, one other artist remains to be noted who, though not possessed of Masanobu's overpowering genius, contributed nearly equally to the progress of ukiyo-e during this difficult transition period from hand painting to color printing.

To Nishimura Shigenaga (about 1695–1756) has been attributed the invention, or at least the development, of most of the new forms of ukiyo-e that he and Masanobu exploited so charmingly: perspective prints, the triptych form, stone-rubbing prints, blue prints, and the seminude. Like Masanobu, he produced important prints of birds and flowers, actors, and courtesans. One of his most significant innovations, however, was the type of landscape-with-figures that we see in Plate 52. In this print, which features subdued hand coloring, we find the beginning of the landscape as a separate form in ukiyo-e. A century divides Shigenaga and Hiroshige, but the latter owes more than is usually thought to this pioneer of ukiyo-e landscape.

Plate 52 is significant in several ways: it is one of a series of eight prints

53 Shigenaga. Boys in Lion Dance. Early 1750's. Small color print, one panel of a triptych.

celebrating the famous views of Lake Biwa (near Kyoto), and helped popularize a format that was to persist throughout ukiyo-e. Shigenaga's prints of famous places were both caused by, and helped to encourage, the trend toward travel to famous places, which had been spreading since the seventeenth century in a country where travel abroad was forbidden by law. Shigenaga's cramped little figures will doubtless never be counted among the great beauties of ukiyo-e, but they do possess a rustic charm. He was, it must be added, a master of girl prints too, his best work in this genre ranking with those of Masanobu and the Torii, while his prints of children are among the treasures of this genus (Plate 53). Nevertheless, it must be admitted that many of Shigenaga's prints belong among the "period pieces" of the school, and their charm is more of an era than of the universal kind that appeals to the average Western connoisseur. Yet though he lacked Masanobu's powerful genius, Shigenaga's partially formulated ideal of art did not die with him, for he was one of the greatest of all ukiyo-e teachers: such masters as Shigenobu, Toyonobu, and Harunobu received their basic training in his studio, and went on to create some of the glories of Japanese art.

Nishimura Shigenobu, perhaps Shigenaga's earliest pupil, remains a kind of phantom in ukiyo-e history. Clever scholars have tried to claim that his name is simply the one taken initially by Ishikawa Toyonobu, but this seems doubtful. Shigenobu worked principally in the 1730's and early 1740's, specializing in small lacquer prints of actors and courtesans which, at their best, are among the minor masterpieces of this genre.

One final master to be mentioned in relation to this group is Ishikawa Toyonobu (1711–1785). He was a pupil of Shigenaga, but also learned much from Masanobu's style; there is a certain grand impassivity to his figures that suggests Kaigetsudo influence as well. Critics vary in their attitude toward Toyonobu, some ranking him very high. However, his prints are generally lacking in variety and a certain human touch that many of us seek in art—a quality which may be found in the best of even the impassive Kaigetsudo girls.

54 Toyonobu. Courtesan after Bath. 1750's. A courtesan comes from her summer bath with fan in hand; she is greeted by a little maidservant with a cup of green tea. Medium-sized color print.

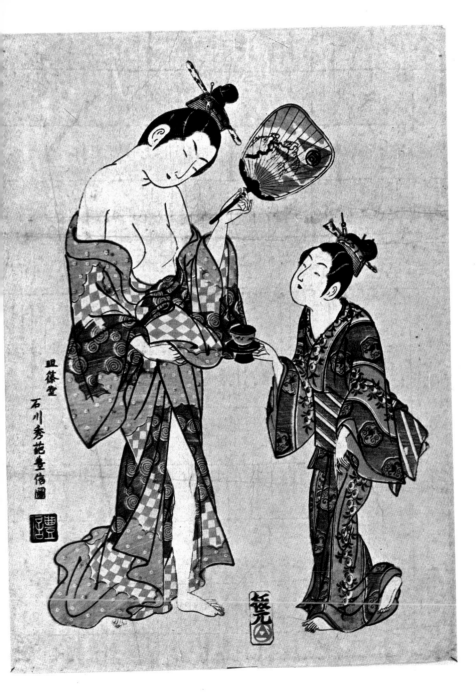

Like Masanobu, Toyonobu created an impressive number of large lacquer prints of actors and standing girls during the 1740's. He was also one of the pioneers of color printing during this and the ensuing decade, but gradually gave up his ukiyo-e work with the ascendancy of his fellow pupil Harunobu in the 1760's. Toyonobu produced one notable pupil himself, Ishikawa Toyomasa—possibly his son—who during the 1770's designed some of the most charming of ukiyo-e prints depicting children at play.

Plate 54 shows Toyonobu at his best. The subject offers more variety than is customary with Toyonobu, and the seminude was an innovation in which he excelled. Before him, Shigenaga, Masanobu, and Kiyohiro had each experimented briefly with the nude, but it was not to prove a lasting trend in premodern Japanese art, being usually employed, as here, for its mildly suggestive eroticism rather than as any such glorification of the human form as we find in Greek art. Nevertheless, whatever the motives for its exploitation, the occasional nudes and seminudes of these artists (and later, Kiyomitsu, Kiyonaga, Utamaro) form an unusual bypath of ukiyo-e; by this device ukiyo-e might well have managed to escape from the domination of the kimono in depicting female beauty—had Japanese lovers of feminine beauty but followed the artists' leads! This Toyonobu plate is notable also as among the last of the "primitive" color prints, and shows what a wealth of color could be suggested simply by the use of two color blocks plus black.

With the graceful, faultlessly designed color prints of Masanobu, Shigenaga, Toyonobu, and such late Torii masters as Kiyomitsu and Kiyotsune, ukiyo-e was now ready to proceed to its technical and spiritual culmination under Harunobu. First, however, one more chapter remains to be written in the cause of early eighteenth century ukiyo-e, a chapter in which we shall seek the neglected charms of the Kyoto artists, and find in Sukenobu and Choshun much of the key to the dreamlike grace and color that were to enrich the later prints.

BEAUTIES IN THE SHADE

Some Eighteenth–Century Painters and Illustrators

ALTHOUGH ukiyo-e had its origins in the Kyoto scrolls and screens described in Chapter I, the popular prints were primarily a product of the eastern boom-town Edo, and indeed, the term "Edo pictures" is used even today in Kyoto to refer to ukiyo-e in its period of full development. Yet though we transferred our attention rather abruptly from the Kyoto ukiyo-e paintings of Plates 4 and 5 to the early Edo paintings and prints of Plates 8 and 10, we did note in passing such transitional works as the "Courtesan and Courtier" of Plate 7, caught, as it were, between two worlds. As a matter of fact, quite often in early ukiyo-e it was highly trained Kyoto artists who first led the way, only to be surpassed later by the less convention-bound masters of Edo.

Throughout most of the Edo Period the popular prints of Edo failed to make much of an impression on the art lovers of Kyoto and Osaka. These connoisseurs preferred paintings first of all, and of the less expensive printed matter, they favored (at least until the nineteenth century) the convenient and comprehensive picture books over the prints, which were more decorative but also far more limited in scope.

Aside from a number of early Buddhist treatises privately published by the great monasteries, the first important *printed* illustrated books were those that appeared in Kyoto at the beginning of the seventeenth century. Initially they were devoted to "reprints" of the classics, but gradually fresh authors began to appear and give expression to the tastes and ideals of the new age. These new books of novels and tales concerned themselves primarily with love and secondarily with travel and practical information. The

love novels were at first only pale modernized reflections of the classics, but by the mid-seventeenth century, just as ukiyo-e itself was reaching its first maturity, the affairs of the commoners and the life of the great cities began to replace the courtiers and samurai as the principal matter of creative literature. Indeed, it is surprising (though logical enough, for the audience was the same) how closely Japanese popular literature and ukiyo-e coincide throughout their histories. Ideals of romance, too, were suffering a change, and the high-born heroines of the earlier novels were replaced by the new heroine of the age, the courtesan, and gradually by geisha entertainers and ordinary girls and women of the cities as well.

The early illustrations were either classically dull or primitively crude; the latter type are interesting in one respect, however, for as we noted earlier, they were often hand colored by artisans in the same combination of orange and green that we saw in Plate 10, the first ukiyo-e print. These hand-colored "orange-green books" flourished all through the period from the 1610's to the 1650's, when the technique was transferred to the newly devised prints.

Though the early ukiyo-e paintings are seldom dated, the new spirit of ukiyo-e can be traced very accurately, year by year, in the illustrated books of Kyoto: the fresh concern with the depicting of daily life and customs appears in the books as early as the 1620's, but it was not until the midcentury that a new, truly ukiyo-e style developed to do it justice. At least three major illustrators worked in Kyoto during the 1650's and 1660's, but unfortunately none of their names is known, and their work was done mainly in the form of block-printed book illustrations, about eight by six inches in size, so that they have been neglected by collectors and scholars alike. Nonetheless, they constitute the true pioneers of printed ukiyo-e, and it was through their work that early Edo masters acquired their basic training (Plate 9).

The earliest Kyoto ukiyo-e illustrator known to us by name is Yoshida Hambei—a pupil of one of the above masters and an early contemporary of Moronobu—who worked from about 1664 to 1690. During this period it is no exaggeration to state that Hambei truly dominated book illustration in both Kyoto and Osaka—the acknowledged literary centers of Japan at the time. The sum of Hambei's work during this long period must come to well over one hundred books, with a total of several thousand separate illustrations. He ranks, indeed, with Moronobu, Sukenobu, and Hokusai as the most prolific Japanese illustrator.

Yet Hambei does not, even in the single field of illustration, quite rank

among the great masters of ukiyo-e. His illustrations are consistently adroit and well thought out, but clearly the work of a talented master rather than of an artistic genius. Probably Hambei's most impressive work is his *Ladies' Encyclopedia* of 1687, containing, in one of its volumes, a series of twenty-two standing portraits of girls modeling rich kimonos. Had these but been issued as single prints and in a larger size, I do not doubt that connoisseurs would today consider Hambei to be on a level with such masters as Sugimura, the Kaigetsudo, or Toyonobu. As it is, his name is known only to specialists.

Rather than use such a nicely posed series to represent Hambei's work, we have chosen a curious illustration (Plate 55) prepared for an erotic dictionary of the following year. It illustrates the entry under the term "sex madness": the townsman in the center has wrapped his arms around the nymphet of his choice and is kicking angrily at an older woman who is attempting to interfere. The unconcerned face and posture of the young girl provide a peaceful contrast to the other agitated figures. The stolid matron, the self-centered townsman, the lovely, impassive girl are all typical of Hambei's figures, which varied surprisingly little during the three decades of his career.

Hambei's work has been immortalized in Japan less for its intrinsic interest than for the fact that he illustrated many of the books of Japan's famed novelist Saikaku, who wrote primarily during the period of Hambei's greatest activity, the 1680's. Fully ten of Saikaku's works boast abundant illustrations by Hambei, and some ten others have illustrations by the two anonymous pupils who succeeded Hambei after his death or retirement around 1690.

Interestingly enough, some of the most engaging illustrations of the late seventeenth century derive from the brush of Saikaku himself, who as an amateur illustrated about ten books by himself and his friends, particularly during the 1680's. Saikaku's illustrations offer an interesting example of the realization of an artistic ideal in the face of inadequate formal training. Despite the occasional amateurish distortions of his illustrations, Saikaku often succeeds in conveying a lively realism of stylish beauty which is rare in Hambei and other contemporary professionals. He imbues his figures with a sentient power that often helps to make up for his technical defects.

The following decade of the 1690's represents, both in Kyoto and Edo, one of the low points of ukiyo-e, the direct pupils of Hambei and Moronobu either dying out or failing to live up to their traditions. It was not until

55 Hambei. *Man Attacking Young Girl. Kyoto, 1688. Medium-sized book illustration.*

56 *(Facing) Yoshikiyo. Courtesan Playing Samisen. Kyoto, early 1700's. Medium-sized woodblock print, hand colored; damaged.*

around the year 1700 that, in Edo, such indirect followers of Moronobu as Kiyonobu and Masanobu bestirred themselves to save the cause of an invaluable yet nearly moribund art. In Kyoto, too, this year marks the rise of new figures in the ukiyo-e field, men who, though followers of Hambei, were to incorporate something of the Edo vigor in their works.

One of the first of these artists was Omori Yoshikiyo, who illustrated some twenty books during the years 1703 to 1716 and, a rare thing among

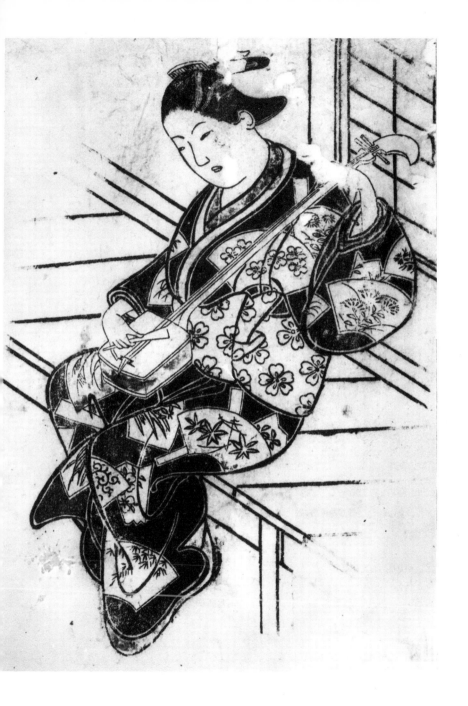

the Kyoto illustrators, designed several large albums of courtesan prints in a manner reminiscent of his Edo contemporary Masanobu. Yoshikiyo's best-known work in the album format is a pictorial guide to Kyoto, published in a series of fifteen albums in the year 1704. Far more unusual, however, among the Kyoto artists is the large hand-colored orange print shown in Plate 56, unsigned and damaged, but in Yoshikiyo's characteristic manner· It dates from very near the beginning of the eighteenth century, and is reminiscent of the styles of Kiyonobu and the Kaigetsudo, both of whom were only commencing their full-scale work at this period. This type of early Kyoto print is excessively rare, however, and it is difficult to determine just who influenced whom, though the strong influence of Edo ukiyo-e on Yoshikiyo certainly forms the unique feature of his style among the Kyoto artists. At any rate, the print form did not appeal strongly to the traditional tastes of Kyoto, and Yoshikiyo's other work is entirely in the form of books and, rarely, albums, with one or two paintings also extant to attest to his considerable skill in that quite different medium.

The dominant figure in eighteenth-century Kyoto illustration was Yoshikiyo's long-lived contemporary Nishikawa Sukenobu (1671–1751). Sukenobu's prolific output exceeds even that of Hambei or Moronobu, totaling some two hundred books with many thousands of illustrations, and maintaining a remarkably even level of quality and grace.

Like several of the greatest ukiyo-e figures, Sukenobu had undergone extensive early training under noted masters of the traditional Kano and Tosa schools, only turning to the popular art in his late twenties, around the year 1698. His life work was divided between his miniature illustrations for the novels and other books of the time and his picture books, in which the illustrations predominate, with only a minimum of verse or other supplementary text.

Sukenobu's picture books cover a wide variety of subjects, from contemporary events, amusements, and festivals to the tales and legends of antiquity. His perpetual theme, however, whatever his immediate subject, is the grace and beauty of Japanese girlhood, a theme which he never tired of depicting, and which few connoisseurs have ever tired of contemplating. There is a remarkable uniformity to Sukenobu's huge output, and I dare say every collector has had the experience, at an auction or bookstore, of falling under the spell of a Sukenobu volume, only, upon bringing it home, to find that he possessed it already! Sukenobu is the only artist I know whose

work shows so little apparent variety yet never falls into monotony or becomes repetitious.

Like most of the ukiyo-e artists, Sukenobu designed erotica on commission from the publishers, and it is in this genre that we find several of his rare albums, i.e., series of large prints bound together. Plate 57 shows a leaf from an early album of the year 1711. A rake is depicted dallying with a young girl of the pleasure quarter while, at the left, an older courtesan serves him saké and other delicacies. The nymphet at right turns away from the man's embrace either in shyness, distaste, or, more probably, simply because she is too young to understand or appreciate sexual advances. This was, however, a necessary part of the education of a courtesan's young attendant, who would herself become a full-fledged courtesan at the age of sixteen or seventeen.

In common with most of Sukenobu's erotica, the faces and figures in this print are less delicate than the childish, dreamlike visages of his finest work; indeed, this is a phenomenon seen in many of the ukiyo-e artists, who could not but be insensibly influenced by the voluptuous and wordly nature of their subject matter when they executed erotica. One should note, however, the unique quality of the kimono patterns, and particularly that of the young girl, which features stylized cobwebs at top, Chinese latticework on the sash, and various flower, wave, and geometrical patterns on the skirt. Sukenobu's skill at kimono design was, indeed, so great that he was often hired to do patterns for the great dyers of Kyoto, center of Japanese textile art; he was even commissioned to produce many volumes of printed designs for the reference of the kimono-makers.

Sukenobu's finest work lay, however, in his dozens of volumes of graceful illustrations depicting the daily life and amusements of the women of Kyoto. Plate 58 shows one such design, the frontispiece to a volume of calligraphy models for girls. The central figure is a lovely maiden of the upper classes, strolling with her maidservant in the spring under cherry blossoms. The girl is reading the verse on a narrow poem card hung on the already overburdened branch of a venerable cherry tree. The maiden's raven hair flows down the back of her elaborately styled robes, which feature patterns of waves and sea shells; the simpler kimono of her attendant shows a sprightly design of plovers and ocean wavelets. No scene could typify better the refined, halcyon pastimes of old Kyoto, a world today fast disappearing, yet preserved for eternity in the gentle pictures of Sukenobu.

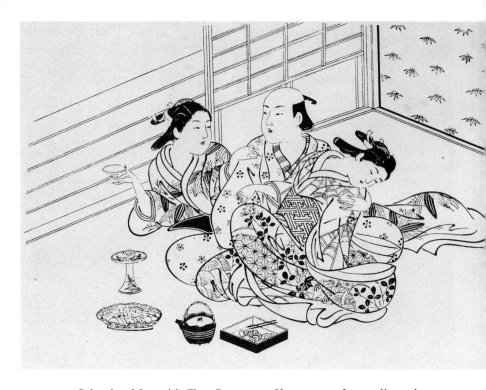

57 Sukenobu. Man with Two Courtesans. Kyoto, 1711. Large album plate.

58 (Facing) Sukenobu. Girls under Cherry Blossoms. Kyoto, 1733. Large book illustration.

Although it is a little-known phase of his work, Sukenobu was also a master painter in the ukiyo-e style, an example of which we see in Plate 59. The scene depicted is of particular interest, for it shows the visit made by a mother to introduce her newborn baby to the local Shinto deities and to appeal for their divine protection throughout the child's life. This ceremony was customarily performed when the baby was exactly one month old. In the center of the picture we see the mother, a well-to-do lady of the middle classes, wearing her outer robe as a shawl over her head. The child is carried by his nurse, and reaches out his little hand for the sacred rattle flourished by the young Shinto priestess, who stands within the shrine dressed in immaculate robes. Accompanying the party are two chattering maidservants

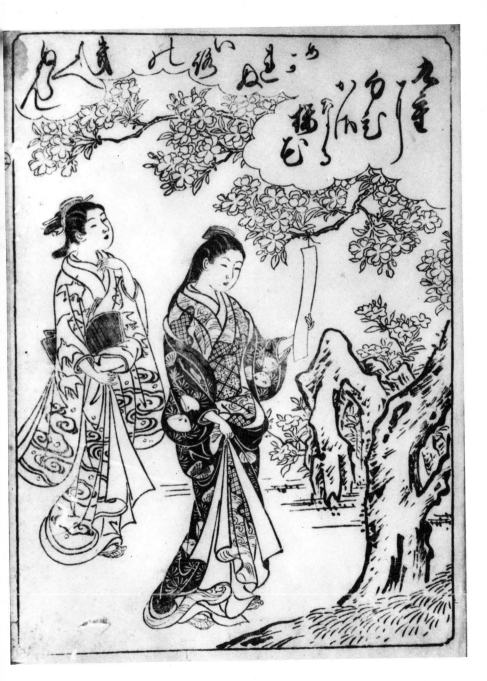

133

and a little boy—short sword stuck in his sash—probably the baby's brother. At the left are seen the paraphernalia of the Shinto rites, saké flasks on stands and a sacred wand with paper streamers below. The picture is again one typifying the ancient capital at peace, and the rich kimonos and varied attitudes of the women, together with the solemn but kindly pose of the young priestess, combine to form a gently memorable record of Sukenobu's ideal of life and beauty.

Sukenobu's subdued conception of lovely, unobtrusive grace, perhaps closer to actual Japanese womanhood than that of any other artist, was to wield a far greater influence on ukiyo-e than one might have imagined. Of Sukenobu's contemporaries few failed to absorb something of his quiet loveliness, and in the great Harunobu, Sukenobu found a noble follower who was to adapt his ideal and raise it to the very pinnacle of art.

Like many another ukiyo-e master, Sukenobu was not too richly favored in his direct pupils: his son Suketada, and Sukeyo, possibly his daughter, continued his tradition faithfully but without notable talent. Other Kyoto-Osaka illustrators such as Hasegawa Mitsunobu, Shimokobe Shusui, Kitao Tatsunobu, and the painters of the Kawamata school, Tsuneyuki and Tsunemasa, adapted his style to their own talents and produced charming though derivative work (Plate 60). In Edo, Yamazaki Ryu (worked from the early 1700's to the 1730's), one of the few important women painters in Japanese history, combined the Moronobu and Sukenobu styles to create some of the most graceful paintings ever to be seen in the eastern capital (Plate 61).

Of Sukenobu's direct pupils, the greatest was probably Ooka Michinobu, a shadowy Osaka painter who designed several illustrated books during the 1720's and 1730's. Michinobu was at his best in his rare paintings of women, and in this field almost equals his master. Plates 62 and 63 show details from Michinobu's most extensive work, a long scroll depicting life on the streets and in the houses of the pleasure quarter. Though both in residence and style an artist of the Kyoto-Osaka region, in this scroll Michinobu has, curiously enough, chosen the Edo Yoshiwara as his theme, and depicts it with great skill, though his girls clearly smack more of Kyoto's traditional grace than of the more racy stylishness of Edo. Possibly the scroll was painted as a souvenir of a trip to Edo, commissioned by some Osaka millionaire who harbored fond memories of its distant pleasures.

The subject of Plate 62 is the procession of a famous courtesan as it

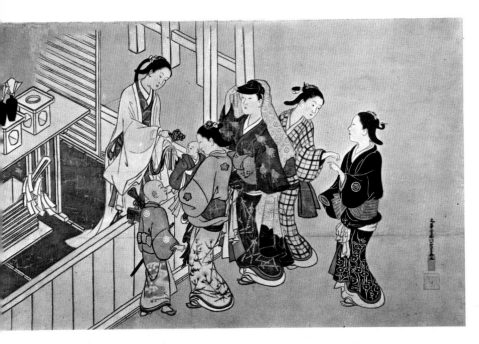

59 Sukenobu. Shrine Scene. 1730's. The women of a wealthy family present a baby for initiation at a Shinto shrine. Painting on paper; medium-sized panel.

moves through the streets of the Yoshiwara—a ceremony frankly intended to display the courtesan's charms to prospective patrons, and one which is still occasionally performed in the old capital, Kyoto. At the head of the procession is the young courtesan herself, bedecked in the finest of kimonos, her outer robe worn casually off her shoulders and her sash tied jauntily in front. Like the courtesans of Sukenobu, she seems but a child performing in some pageant, and it is difficult to imagine her in the more sordid aspects of her enforced profession. Yet she had already been sold into this life before the age of ten by impoverished parents, so that she herself was at least free from the stain of moral sanction—was, indeed, considered a model of filial piety to have thus given herself to preserve her family's fortunes.

The young courtesan is followed by the somewhat older girl who customarily acted as her attendant and substituted for her when she was busy. Behind them a manservant shades the pair with a giant parasol bearing

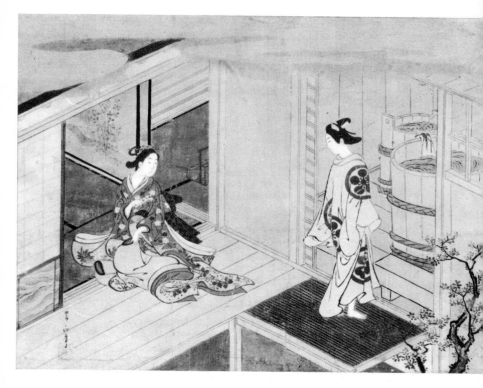

60 *Tsunemasa. Girl with Love Letter, and Young Man Entering Bath. 1740's.*
Painting in colors on paper; small hanging scroll; after a book illustration by Sukenobu.
61 *(Facing) Miss Ryu. Girl Walking with Maidservant. 1720's. Painting in*
colors on silk; detail of medium-sized hanging scroll.

the girl's crest. The courtesan's two little attendants (themselves destined to
the same career) follow, engaged in childish conversation, and the group is
completed by the older woman whose job it was to handle the courtesan's
affairs and who also appears in Plate 42. At the upper left an older woman
of the quarter views the procession, and to the right two lesser courtesans
are seen entering the Yoshiwara gate.

The brilliant coloring of this scroll is remarkably well preserved, and in
the varied patterns of the kimonos will be seen some of the finest miniature
detailwork of ukiyo-e. Note particularly the color balance of the central

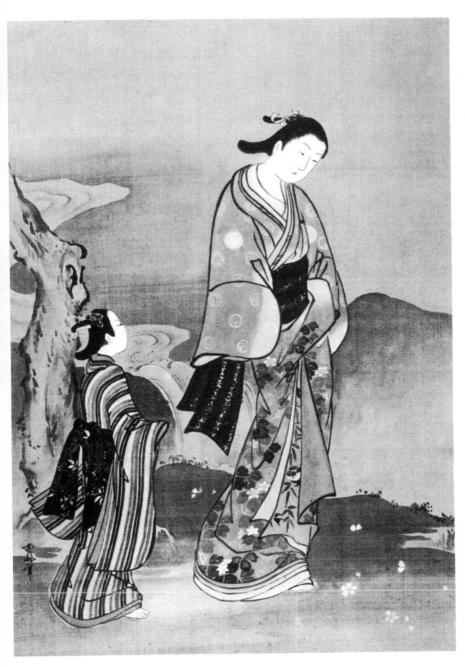

group, the stripe-clad servingman forming a pivot on which balance the brightly gowned front and rear figures, while the two children balance the second courtesan and the tilt of the parasol moves the whole procession on its way to the next scene of the scroll. For it should be remembered that the best of these long scrolls were not meant to be merely a group of static tableaux, but rather a series of kaleidoscopic views aimed at giving a total impression of life. Among the other characteristically poignant scenes of this remarkable scroll may be mentioned the one that shows a pensive courtesan reclining alone on her bedding late at night, strumming a tune on the samisen as her little attendant sleeps exhausted on the floor, the courtesan's outer robe thrown over her slim form (Plate 63); and again, the final scene of the scroll, wherein a little maidservant washes her hands in a quiet evening garden as the silhouette of a turbulent party is reflected dimly on the paper doors behind her.

This, then, is Michinobu, a painter you will fail to find mentioned in any art book, but typical of the lovely surprises that lie in wait for the persistent searcher among old Japanese art.

But as though this were not enough, we have another surprise, Miyagawa Choshun, a rare genius of Edo who painted ukiyo-e all his long life but is hardly given more than passing mention in any book on the subject. For, as we have already noted in relation to the Kaigetsudo, it is the readily available prints that have always interested Western collectors; and scholars and critics who have never been to Japan have had to follow the collectors' leads, for they have had little access to the treasures of ukiyo-e painting, and, moreover, perhaps feared their studies might lack an appreciative audience. Be that as it may, in my opinion there are few greater, and no more greatly neglected, ukiyo-e artists than Choshun, and I submit Plate 64 as partial evidence.

Choshun (1683–1753) devoted nearly half a century to ukiyo-e painting and founded an important Edo school, yet neither he nor his pupils are known to have designed a single print. This artist acquired a firm groundwork in Japanese painting under Kano and Tosa teachers, but it was the ukiyo-e style and subjects that proved his real love, and Moronobu, his real mentor. Both in line and coloring Choshun's paintings are reminiscent of Moronobu's, but with an added element of the statuesque that derives from the Kaigetsudo. There is a softness, however, a remarkable quality of warm femininity to Choshun's girls that is uniquely his own; and though we may

62 Michinobu. *Yoshiwara Procession.* *1730's.* A young courtesan and her retinue promenade through the licensed quarter. Section of a long hand scroll on paper.

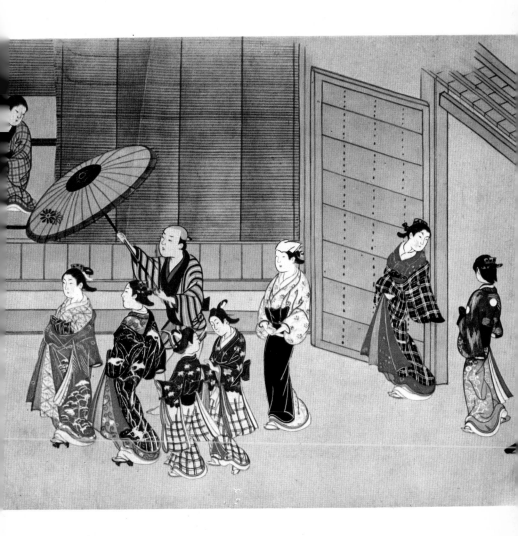

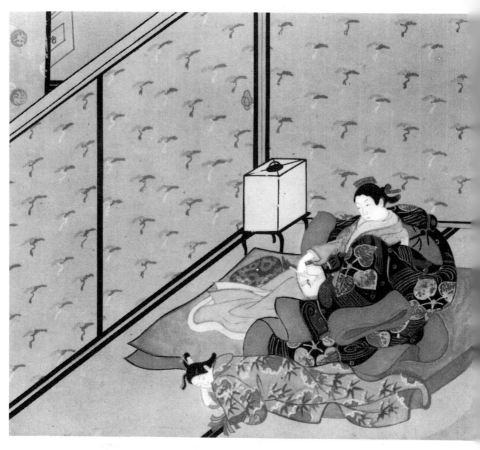

63 *Michinobu. Courtesan with Sleeping Maidservant. 1730's. Detail of a long hand
scroll in colors on paper.*

speak of influences upon him, in the end his is one of the most uniquely in-
dividual styles in ukiyo-e, and in coloring he may well take first rank among
all.

More than any other artist except the Kaigetsudo, Choshun's subject
was preeminently girls and women; you will rarely find a male figure in his
pictures. Plate 64 ranks among the masterpieces of ukiyo-e; it depicts a
seated Yoshiwara courtesan, luxuriously enveloping herself in the scent of

rare incense, which is seen escaping upward in a faint vapor from her bosom. The implements of incense burning (a highly refined art and pastime in Old Japan) are seen at her feet, and in the background is placed a screen painted in the Kano manner. The scene is one of complete sensuality, the girl lost in a dream of voluptuous pleasure; yet we find not the least hint of crudity or decadence, only a rarely intimate glimpse into a feminine absorption in the senses. The pose and atmosphere are almost orgasmic, but there is no self-indulgence here, only an all-pervading voluptuousness somehow reminiscent of Correggio. Of Japanese painters Choshun must surely rank as the master of the female sensual, as Moronobu does of the creature sentient.

Choshun was rather fortunate in his pupils: Miyagawa Choki, possibly his son (and no relation to the later print artist Choki), sometimes equaled Choshun's portrayals of soft catlike femininity, and in his group compositions went a step beyond the more limited subject matter of his master (Plate 65). Other notable pupils were Issho and Shunsui; the latter is best known as the teacher of the master Shunsho, whose elegant paintings (Plate 87) will be a subject for later discussion, and who in turn taught the great Hokusai, among others. Thus was Choshun's remarkable tradition of warm color and subdued grace to flavor ukiyo-e painting until its demise over a century after his own passing.

Among other notable Edo painters in the first half of the eighteenth century the following may be mentioned only in passing. Tamura Suio, whose poised style reflects the dual influence of Sugimura and Choshun; Ogawa Haryu (Haritsu), the most famous lacquerware designer of his age, who executed a number of lovely girl paintings partly as a hobby; Hozumi Kogyu, whose angelic, graceful figures lie somewhere between the beauties of Choshun and Harunobu—together with a host of Kaigetsudo followers and imitators, and such noteworthy but anonymous figures as the minor master illustrated in Plate 67.

Though his work lies outside the scope of this book, Hanabusa Itcho (1652–1724) must also be cited as a brilliantly original Kano-trained painter who devoted his life to witty representations of much the same genre world as did ukiyo-e, but in a style and manner never quite a part of the ukiyo-e tradition. Itcho sired a host of followers, and the work of his school forms a fascinating byroad which winds its way for over a century between the Kano and ukiyo-e styles.

In closing our discussion of these neglected eighteenth-century masters,

a final place must be set aside for Sukenobu's principal successor among the Kyoto-Osaka illustrators and painters, Tsukioka Settei (1710–1786). At first a student of the Kano school, Settei soon achieved his forte in a unique combination of the Moronobu and Sukenobu styles, an attempt to unite the force of the one with the grace of the other. The amalgamation was achieved admirably, though there is little question that Settei lacked the genius of either of his preceptors.

Settei's work covers a large number of book illustrations and paintings, particularly of classical Japanese subjects handled partly in the ukiyo-e manner. In this respect Settei's work, like that of Sukenobu, well reflects the tastes of Kyoto and Osaka, where the Imperial Court, and court culture in general, were still the principal objects of veneration and interest; quite the opposite was true in Edo, where the courtesans and actors—principal subjects of ukiyo-e throughout the seventeenth and eighteenth centuries—were all the rage. Settei was also one of the principal creators of erotica in western Japan, and Plate 66 shows a detail from one of his encyclopedias of sex. A geisha and her lover are depicted in an embrace in which the swirl and beauty of the kimonos almost obscure the figures. One amusing story, probably true, about Settei has come down to us: During the late 1760's part of Kyoto was laid waste by a great conflagration, but one lone storehouse remained strangely untouched by the fire. Upon opening it, a box of Settei's erotic pictures was found inside. From this time forward the price of Settei's erotica is said to have risen tenfold, since the male citizens of Kyoto sought them out as a pleasurable kind of fire insurance.

The school of painting founded by Settei flourished, and his influence was felt likewise throughout the later history of Kyoto-Osaka illustration. Perhaps the finest of his pupils were his own sons, Sessai and Sekkei. Sessai, in particular, excelled in his paintings of girls and courtesans, which are rather freer and less conventionalized than those of his father. Plate 68 is an example of Sessai at his best: he retains the typical face and peculiar concept of beauty developed by his father, but succeeds at the same time in delineating an impressive ideal of young womanhood which, while not so universal

64 Choshun. Seated Courtesan. 1720's. Alone in her boudoir, a courtesan surrenders herself to the warm fragrance of an incense burner. Painting on silk; medium-sized hanging scroll.

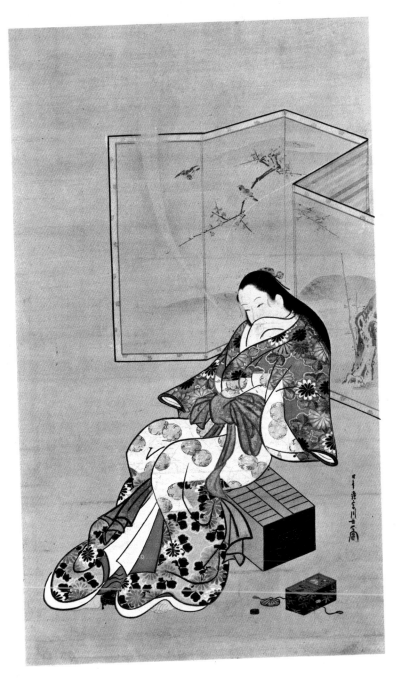

143

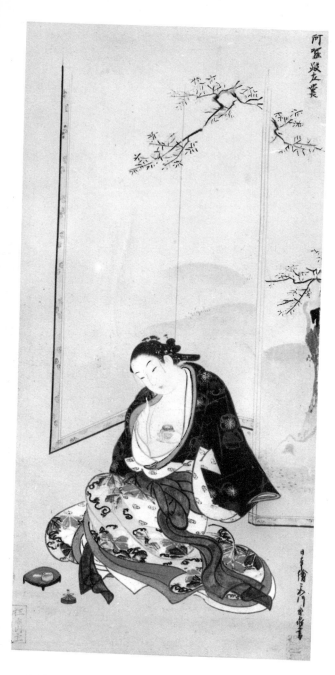

144

65 *(Facing) Miyagawa Choki. Courtesan with Incense Burner. 1730's. Painting in colors on paper; medium-sized hanging scroll; after a painting by Choshun (see Plate 64).*

66 *Settei. Geisha with Lover. Kyoto, 1740's. Detail of large book illustration.*

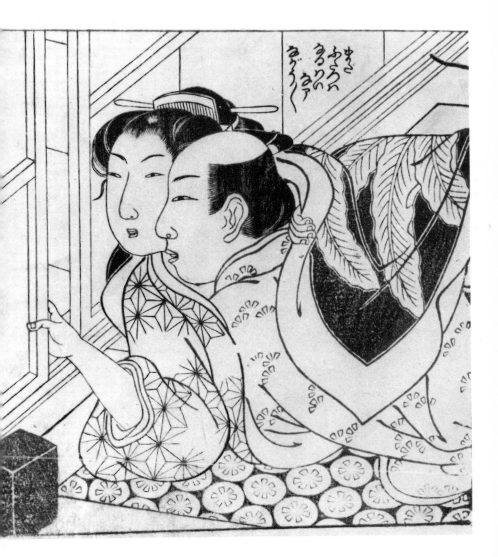

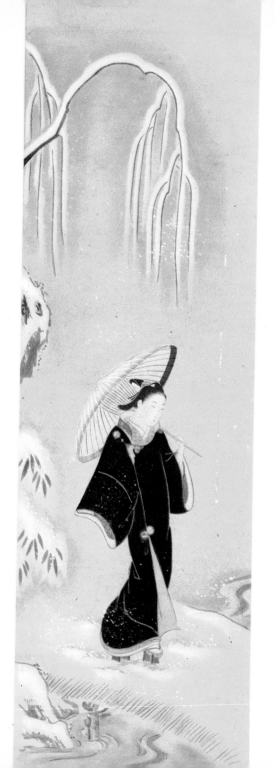

67　(Left) Anonymous. *Young Man in Snow. Early 1760's.* A young man crosses a small bridge in the snow. Though close in style to the work of such late Torii artists as Kiyonobu II, this may well be by a Kyoto follower of Sukenobu. A few years later the same figure will march into the prints of Harunobu. Painting on paper; medium-sized hanging scroll.

68　(Right) Sessai. *Courtesan with Fan. 1780's.* A sumptuously dressed courtesan with coiffure in an archaic style reminiscent of that in Plate 5. Painting on paper; medium-sized hanging scroll.

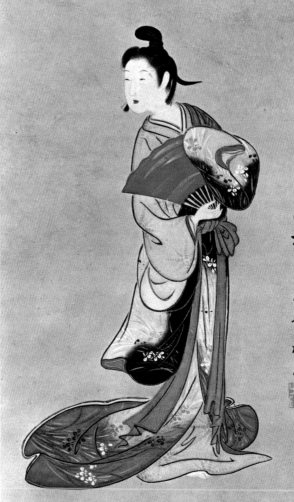

as the work of the Edo ukiyo-e masters, is still acceptable to Western tastes. Compared to such real geniuses of ukiyo-e painting as Sukenobu and Choshun, Sessai's handling of kimono design and other details can hardly be termed adroit, but his very faults lend a certain rustic charm to his works, which offer a sometimes welcome relief from the perfection of his betters.

Settei and Sessai have been cited as typical of the painters who satisfied the tastes of the well-to-do Kyoto and Osaka citizenry during the very period that Edo ukiyo-e was making the tremendous advances which were to earn it world-wide renown. It is just as well to recall, as we consider the coming golden period of ukiyo-e prints, that a fair majority of Japanese art lovers preferred their floating-world pictures to have a close and persisting link with the traditional outlook and styles of the past. A lack of immediate appreciation has, of course, been the fate of fresh new art in other societies as well. As the golden fire of Harunobu's genius swept the Edo horizon in the brief decade to come, there were many, even among Japanese connoisseurs, who never noticed him—were not, indeed, to recognize the flame of his genius until well over a century later, after enthusiastic foreigners had succumbed to his bewitchment and carried away most of his pictures to their own far shores.

THE FLEETING DREAM

Harunobu, Koryusai, Buncho

A misguided Shogun's whims had reduced the scale and grandeur of Japanese prints in the 1720's; the free and easy, often corrupt government of another administrator, Tanuma Okitsugu, went hand in hand with a new flourishing of the print—beginning in the mid-1760's—which was to surpass in color and variety anything seen before. To Harunobu went the early leadership of this artistic revolution, and to the brief six years of his ascent belong some of the greatest glories of ukiyo-e.

Suzuki Harunobu (about 1725–1770) is said to have been a pupil of the pioneer innovator Shigenaga, but their relationship is by no means clear. Certainly the strongest influence in the work of Harunobu's maturity is that of the Kyoto master Sukenobu, together with that of Kiyomitsu, Toyonobu, and the Kawamata school of ukiyo-e painters. Harunobu also shows evidence of Kano training and, both in his coloring and his ideal of frail femininity, something of the manner of such sixteenth-century Chinese genre masters as Ch'iu Ying and T'ang Yin.

Harunobu's early work of the 1750's consists of deft adaptations of the styles of these predecessors. In particular, his early prints, whether their subject be actors or girls, show the obvious influence, both in design and coloring, of the late Torii masters Kiyomitsu and Kiyotsune. Strangely enough, within a decade these artists were themselves to be imitating Harunobu's fully developed style. Yet Harunobu might possibly have remained the potentially great but obscure designer of his first decade of work had not a fortunate chain of circumstances thrust him into a new style, a new technique, a whole new art. What happened was this:

149

For some years well-to-do connoisseurs and amateur poets in Edo had tended to form clubs and cliques for the appreciation and publication of each other's verses and ideas. Among these groups—even acting as their leaders—were several wealthy samurai who, typical of the age, were concerned more with aesthetic culture than with the military arts of their ancestors. Around the year 1764 the interests of these groups—like those of their Chinese predecessors—came to be directed toward the realm of contemporary art, and to ukiyo-e in particular. On some impulse the various groups decided to concentrate their dilettante efforts upon the production of unusual New Year's and greeting cards for the coming year, and Harunobu, both on the basis of personal contacts and from the quality of his own literate, refined style, was chosen as the professional guide and executor of the amateur efforts of the groups.

These New Year's cards served, it should be explained, a dual purpose. Calendar publication was at this time a strictly controlled monopolistic enterprise, a field denied to the general publishers. Yet the Japanese lunar calendar was so arranged that the months were either short (twenty-nine days) or long (thirty days); if one but knew which months of the year were short or long, other calculations were relatively simple. Thus these "calendar prints," as they are often called, contrived to work the numbers of the long or short months unobtrusively into the design of the picture; and the ingenuity with which this was done, together with the artistic and technical quality of the print itself, governed its success in the friendly competitions— held at regular intervals throughout the year—of these highly critical amateurs.

Although Toyonobu and one or two other ukiyo-e artists are known to have designed a few calendar prints at this time, Harunobu was, in effect, the acknowledged master, and produced a considerable number of prints in this medium, particularly for the years 1765 and 1766.

Several features are remarkable in the calendar prints. First, only the finest materials were employed. Thitherto the popular prints had most often been published rather inexpensively on thin, strong paper with ordinary pigments. Now, however, the wealthy aesthetes had only the finest paper,

69 Harunobu. Boy Water-Vendor. 1765. One of the boys who roamed Edo selling fresh water for use in the tea ceremony. Small color print.

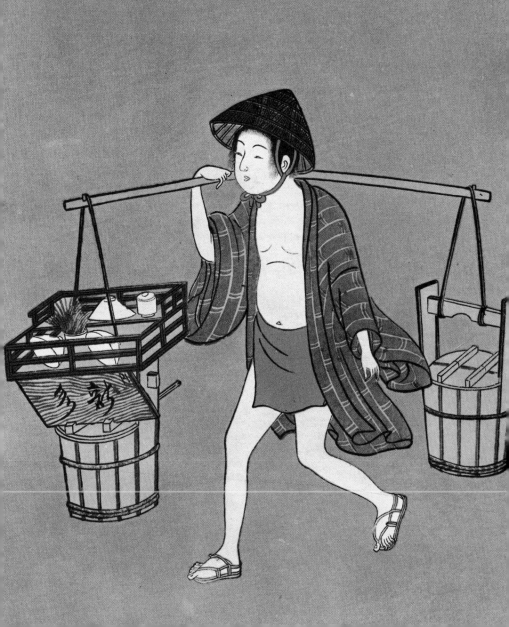

colors, and techniques used, and the cost of Harunobu's new "brocade prints" (*nishiki-e*), as they came to be called from their variegated colors, was just about ten times that of the red prints that he himself had designed in his youth.

By the same token, no expense was spared in the development of new techniques in printing. Thus, where formerly catalpa wood had most often been used for the blocks, now the finer cherry wood was employed. Not only were more expensive colors used, but the new prints now featured a thicker pigment, a striving for the opaque rather than the transparent, a return to the quality of coloring found in the early orange prints, but now with a full range of colors, and all benefiting from the uniformity of outline, tone, and color surface which was achieved through the medium of the wood-block. Most important of all, with expense and time now no consideration, the number of blocks was increased to as many as were needed for the most effective distribution of varied colors, as many as ten blocks even being employed for some of the first experiments of 1764–1765.

The fact that full-color printing could have been thus evolved in the space of a few months would seem to make it clear that the techniques were ready and only awaiting the financial backing necessary to put them into practice. Indeed, Plate 40, done only a year or two earlier by Kiyomitsu, already shows much of the technique that was to make Harunobu world-famous. The print lacks only the somewhat more brilliant, opaque coloring to qualify as a brocade print.

The third notable feature of these refined, personalized greeting cards was that they nearly always bore the name of the amateur who commissioned them, but often omitted that of the artist. This has led to all sorts of controversies among ukiyo-e scholars, but the fact seems to be simply that the signature, for example, "By Kyosen" (the samurai leader of the largest club), on such a print signifies that he commissioned it for distribution among his friends, and most probably suggested the idea and even the design to be used. But the final painting which was carved on the woodblocks came from Harunobu's anonymous brush. This fact can be readily proved by an examination of the successive versions of a print: the first and finest impression is always the limited edition done for the connoisseur who signed the print; in the later commercial editions the connoisseur's name is removed and that of the artist, Harunobu, added. Further, the calendar marks are also removed, as being out of date by this time, and the print is sold to the general

public simply for Harunobu's lovely picture. Of course, this phenomenon applies principally to the calendar prints and other series commissioned for the years 1765–1766. Once Harunobu was established as the new master of ukiyo-e, most of his prints were issued directly by the publisher, often bearing the artist's name from the beginning, and evidently attempting in quality of printing to equal the standards set by the pioneer amateurs. Interestingly enough, however, a great many of Harunobu's prints are unsigned throughout his career; whether they were done on special commission or whether his style was simply thought inimitable is not known; since a publisher's seal is also seldom seen, it may be that the connoisseurs of the time considered such additions as marring the pristine beauty of the print. Again, some of Harunobu's most luxurious prints were originally issued in series of two to eight prints, in which case the paper wrapper (now usually lost) bore the name of the series, the publisher, and the artist.

Conversely, some of the early calendar prints bear the name not only of the patron and the artist, but also of the engraver and the printer as well. The latter's names are often to be found recorded in the colophons to illustrated books. But in the prints these skilled artisans, who contributed so much to the success of a print, received published recognition only briefly now and again in the mid-nineteenth century when another even more luxurious form of ukiyo-e greeting card came into vogue.

It may be well to review here the stages and agents that went into the production of a Japanese color print; for though the artist, given paper, paints, and a brush, could go on to produce a painting singlehanded, both the production and the success of a print depended upon many factors beyond the artist's control. The situation might, indeed, be likened to that of the sculptor who must delegate the casting of his statue to a specialist in that field.

The first agent was, of course, the connoisseur or publisher who commissioned the work, most often suggested the subject, and sometimes even

Overleaf 70 and 71:

(Left) Harunobu. Girl on Night Pilgrimage. Late 1760's. A girl visits a Shinto shrine in a driving rain. The pilgrimage is doubtless related to some love affair. Small color print. (Right) Harunobu. Girl Plucking Irises. Late 1760's. Detail of small color print.

153

specified the design. He also provided the capital and the tasteful direction and control upon which the quality and details of the project often depended. Second came the artist, who worked out the final design—the physical expression of the idea, if you like—and imbued it with whatever artistic value the print was to have. Third were the engraver and the printer, each of whom often maintained his own workshop, independent of the publishers, and upon whose skill depended the technical excellence of the final result.

72 (Facing) Harunobu. Girl Boarding Boat. Late 1760's. Small color print.
73 Harunobu. Classical Courtesan in Boat. Late 1760's. Small color print.

There is some confusion among critics regarding the actual place of the artist in the printmaking process. But whatever his technical indebtedness to publisher, patron, engraver, and printer, he is still the only artist in the group, and without him there is no print worth printing.

Although there is no need to belittle Western art in order to glorify our subject, it must be pointed out that the woodblock print, and more parti- curlary the color print was technically and aesthetically further advanced in Japan than anywhere else. The European wood engravers, from the early Germans through Thomas Bewick, could have done justice perhaps to the pre-Moronobu primitives; but beginning with the late seventeenth-century Japanese woodblock prints, a peak was reached, and sustained, which was never to be achieved in the West. This fact was already noted by the first Americans to visit and write about Japan, members of the Perry expedition of 1852–1854, one of whom wrote of a print by Hiroshige (still alive and active at the time):

> The chief point of interest in this illustration, considered in an artistic sense, is, that, apart from its being a successful specimen of printing in colors—a process, by the way, quite modern among ourselves—there is a breadth and vigor of outline compared with which much of our own drawing appears feeble, and, above all things, undecided.

Many of the early Harunobu calendar prints are remarkable more for cleverness than artistic appeal. Though they represent some of the technical peaks of color printing, the artist's true genius was, naturally enough, ham- pered by the dictation of subject and treatment, and we sense this lack of freedom in the somewhat stiff lines and formalized treatment of the figures.

A notable exception is the print reproduced in Plate 69, which marks the beginning of Harunobu's maturity as a free artist. The calendar numbers (2, 3, 5, 6, 8, 10) are concealed adroitly enough in the calligraphy above the pail at left, but the print stands as a masterpiece quite independent of

74 *Harunobu. Courtesan with Attendants. Late 1760's. A Yoshiwara courtesan in all her splendor, pipe in hand, stands on a veranda as her maidservants play with a dog. Small color print.*

158

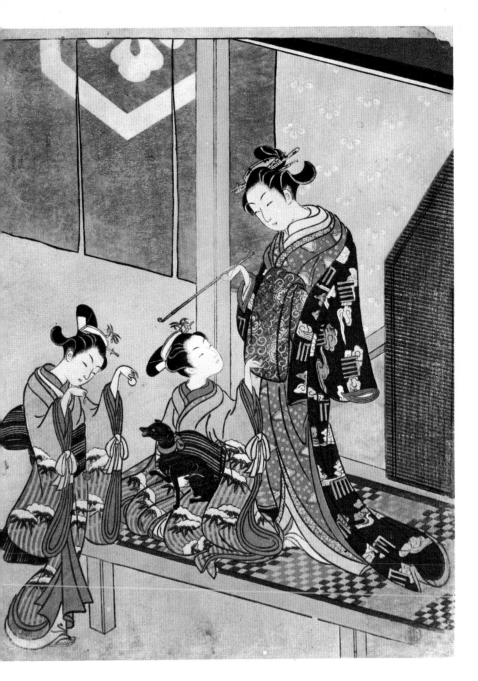

159

its original function. (Note, incidentally, that in this, the second impression for general sale, signatures of designer, artist, and engraver have been removed, though the unobtrusive calendar markings have been allowed to remain.)

To some critics Harunobu's subjects all seem like children; in this case, however, the subject is an actual child, one of the young boys who used to trudge about the streets of Edo selling pure well-water for use in making tea. The boy carries his wares balanced on the end of a pole, the bucket at left bearing the implements of the tea ceremony. He is clad only in a red loincloth and a purple *happi*-coat, with a straw hat to keep off the summer sun. This is all simple enough, but, in the first sign of Harunobu's characteristic genius, the boy is surrounded by a remarkable pink background that suffuses the entire print and serves, in some inexplicable manner, to complete and unify the whole picture. Atmospheric background, indeed, was to be a characteristic innovation of Harunobu's art. Before him, Moronobu, Sugimura, and Sukenobu had employed such to a limited degree, but never, of course, with the advantage of the rich color harmonies that Harunobu had at his disposal. Yet Harunobu was not only the pioneer of colorful background as integral atmosphere, he was also to be the greatest exponent of it that we are to find in all ukiyo-e. Harunobu made particularly effective use of the *tsubushi* technique shown here, the whole background in a wash of one color—opaque pink, blue, gray, or black; this technique was to be closely imitated by later artists, but, somehow, never with the same startling effect of this bold but gentle pioneer.

Harunobu was unique not only in color but in subject matter as well. Glancing at the work of Harunobu's predecessors shown here, you will find much powerful or charming work, but a certain limitation in subject matter. Somewhere in their scores of picture books Moronobu and Sukenobu had, of course, treated practically every subject of Japanese life; but it remained for Harunobu to immortalize the ordinary world of daily life in the print. And here, too, no later artist was quite to equal him. He set the new ideal both in color and in subject, but was himself the only artist fully to achieve it. In art, it would seem that individual genius is far more important than laws of progress and evolution.

75 Harunobu. Hotel Maid Pulling in Traveler. Late 1760's. Small color print.

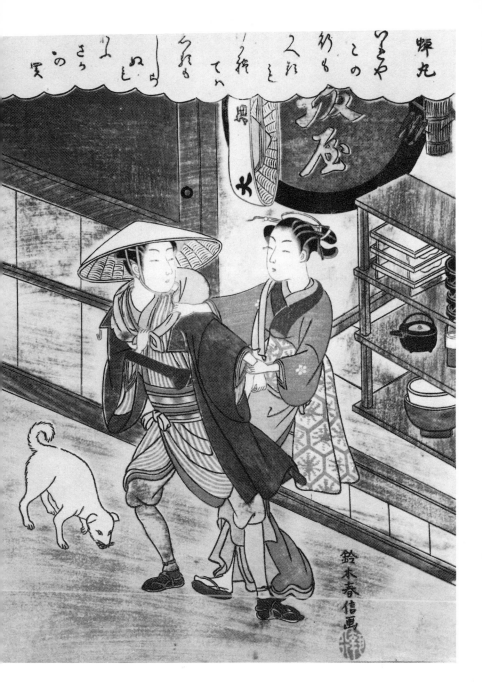

Although Harunobu is most apt to be thought of as an idealist, one cannot neglect to note the realistic nature and background of his work. The age in which he lived was one where the very laxity and corruption of the supposedly austere feudal government gave a touch of satirical realism to the outlook of the common man as well as to that of literature and art. Thus ukiyo-e came to deal more with the everyday world, and more realistically, rather than simply with the pleasure quarter and the theater—themselves almost a world of make-believe. The new emphasis on coloring, too, might well be interpreted as representing a striving for greater physical and emotional realism, depicting things nearer to the way they actually were—or, at any rate, the way they were imagined to be. In any event, the formal, the conventional, the stylized, were gradually being replaced by forms which, though still refashioned in the mold of art, were far nearer to the actual world.

With the print of Plate 70 we come to Harunobu's special province, in which he excelled all other Japanese artists: eternal girlhood in unusual and poetic settings. Harunobu's girls bear the closest spiritual affinities to Sukenobu, and derive physically from Kiyomitsu. Yet in the end they are Harunobu's alone, surpassing, in their own special world, the work of any other artist.

The setting of this print could well evoke horror: a girl's midnight pilgrimage to a Shinto shrine in the midst of driving rain and storm; her umbrella is shattered, her lantern nearly extinguished; dark cypress trees rustle wildly in the background, not another soul is in sight. Yet there is no horror here, nor in any of Harunobu's prints, only beauty. Try, if you are yourself an artist, to recreate this design of bold *torii*, slim girl in blown kimono, paper lantern and broken umbrella, post fence and four straight trees: can anyone rearrange this complexity into a more perfect composition, much less evoke the magic mood expressed here?

The more moving the art, the less one feels tempted to describe details. Note, however, Harunobu's mastery of kimono design and at the same time his refusal to let the kimono dominate the print, as was so often the case with his predecessors. Note also the flawless placement of the complex colors, red, blue, yellow, purple, green, several browns, several grays, and the black; also, on the paper lantern, the method of gauffrage, or embossing, used often by Harunobu to lend texture to white surfaces. We may well be grateful to the artisans who effected full-color printing, if but for this one print alone.

Let us take a closer look at Harunobu's idealized, ageless girl, this time in Plate 71. Here we have a detail of the central figure in a larger print. This girl is perhaps a trifle younger, at any rate a bit more innocent of the ways of the world. She stoops under an umbrella in the spring rain to pluck with frail hand a stalk of iris flowers at the waterside. It is difficult to imagine, even in Japan, actually viewing a scene of ingenuous beauty so perfect; yet it must be an unfeeling reader indeed that is not captured by this dream and longs to possess something of it. This detail also serves as an excellent example of Harunobu's coloring at its best (and it is almost invariably fine), particularly effective when printed without black outlines, as in the pattern on the girl's kimono, the gradation on the earthen bank, the purple blossoms of the iris.

It must be admitted, however, that Plate 71 represents more sweetness but less art than the masterpiece of Plate 70. It is cited not only for its lovely girl and coloring, but to illustrate the uniformly high standard of Harunobu's prints. There are not more than a half-dozen Harunobus that can rank with Plate 70, but several hundred minor masterworks compete with Plate 71 for the collector's eye. And the artist made well over a hundred such prints per year during the final six years of his foreshortened life.

While Harunobu's principal forte consisted in opening new vistas to the beauty of delicate girlhood in all walks of life, he was the master, as well, of lovely scenes depicting mother and child and children in general. (In addition to the water boy in Plate 69, Plate 78 by Harunobu's follower Koryusai may well be cited as representing Harunobu's gentle, playful style in this genre.) His later prints reveal some of the loveliest erotica in the world, as well as enchanting prints of the famous local beauties of the day, Osen and Ofuji. This was a period when the beauty of the everyday world was at last coming into its own, and lovely girls of the local shops were appreciated as much as the Yoshiwara belles. Earlier writers on Harunobu have tried to invent some strange romance between Harunobu and the lovely Osen, but it seems most likely that he simply chose her as an earthly representative of his feminine ideal, and was not as much in love with her as he was with beauty in general.

The belles of the Yoshiwara were not unknown to Harunobu, however, and he immortalized them in a number of prints, particularly during his later years, of which Plate 74 is one of the finest. Harunobu's courtesans — like those of Sukenobu and Michinobu before him — seem like some gentle

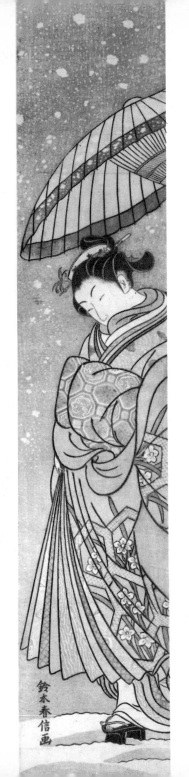

76 (Left) Harunobu. Courtesan in Snow. 1765. Large color print.

77 (Right) Koryusai. Girls with Young Priest. Early 1770's. Small color print.

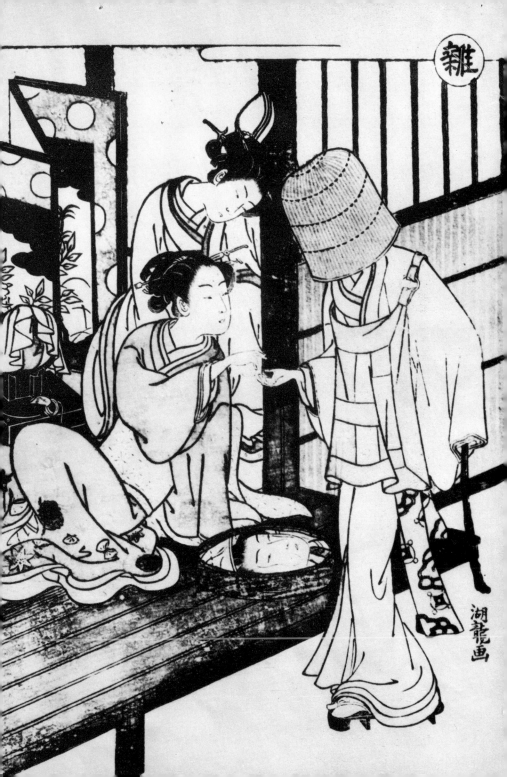

maidens dressed for a masquerade; the slight hardness of features noticeable in this print is more characteristic of one facet of Harunobu's work than of his approach to the Yoshiwara.

The scene is again, characteristically, one of everyday life, the courtesan standing on the veranda of her establishment, a long pipe in her hand, while her two little maidservants play with a black dog. Typical of Harunobu's late work, the design and the colors are a bit crowded, but in their details there could hardly be anything lovelier. Note particularly the design of bamboo trunks and leaves covered with snow, on the little girls' dresses; this was one of Harunobu's favorite and happiest devices, as is the checkered pattern on the veranda and the use of the bold door curtain as background.

Such prints represent Harunobu toward the end of his brief career, but we would be the last to say that he had "worked himself out." True, in the space of six brief years before his death in 1770, he had designed some seven hundred wonderful prints which attest both to his prolific production and his popularity: he literally dominated ukiyo-e during those years. But though Harunobu had perhaps come close to exhausting the possibilities of that miniature vision of beauty he had described so extensively and so well, the new age of the 1770's was to reveal new dimensions of ukiyo-e—and Harunobu could well have expanded with his medium. He himself was, in his final year or two, one of the first to forsake the poem-card size and re-employ the larger print formats that were to dominate ukiyo-e for the coming century. But alas, Harunobu died suddenly in his forties, only a half-dozen years after finding his true style. For some, it is pleasant to think that he passed on still in his prime, his vision of beauty unimpaired. I personally think that, had he lived, his vision would have changed and taken on new forms, perhaps (as with his own successors Koryusai and Kiyonaga) less lovely, but still a firm impetus to the cause of ukiyo-e—a delicate form ever in danger of lapsing into decadence.

Harunobu's vision represented an idealism, but always as a means to true reality, the real as it should be but seldom is. Analyzed scientifically, his girls doubtless seem almost all alike; yet every print is different: it is

78 Koryusai. Boys Playing on Ox. Early 1770's. In a parody on a classical theme, three young oxherds gambol on a complaisant ox, playing flutes and stealing flowers. One of twelve prints representing the signs of the Zodiac. Small color print.

the total atmosphere that changes, and with it the creatures that live and breathe within its frame.

Though in several ways Harunobu represents the highest pinnacle achieved in the Japanese print, his direct influence on the ukiyo-e world, all-powerful during its peak, persisted in full force for only a few years after the artist's death. Adroit imitators such as Harushige (Shiba Kokan), Yoshinobu, Masunobu, worked only in the brief gap caused by his death; greater masters like Koryusai, Shigemasa, Shunsho, and Kiyonaga soon escaped from his strong influence; Kiyomitsu and Kiyotsune, though established masters before his advent, became indirect disciples during his period of full maturity. But Harunobu's dream was too personal a one to form a permanent school; it depended too much upon the atmosphere that only the genius of Harunobu could engender. Thus, to all intents and purposes, his art, one of the most perfect realizations of an ideal that the world has seen, died with him.

Although his imitators were legion, Harunobu's principal direct pupil was his friend Isoda Koryusai, a former samurai living in Edo. Koryusai seems to have been trained first in the Kano style of painting, turning to ukiyo-e in the mid-1760's, shortly after Harunobu's rise to fame. His work extends from the popular prints of this period to his more aristocratic ukiyo-e paintings of the 1780's.

Koryusai's prints rarely succeed in evoking the dreamlike genius of Harunobu, but at his best, in the late 1760's and early 1770's, he does sometimes come close to equaling his teacher. Unfortunately, however, Koryusai proved deficient in the inventiveness that might have made him a great master. Often, upon inquiry into one of his more striking designs, one finds that it is derived from a Harunobu print.

Such is the case with the charming print in Plate 78. Probably designed soon after Harunobu's untimely death in 1770, it is doubtless modeled on a print by the older master showing a similar herd-boy playing a flute on oxback, with a small companion walking to one side. Yet once Koryusai's source of inspiration is granted, it must be conceded that he has produced an entirely new print, and one quite removed in spirit from the more rarefied work of his master. For Koryusai's genius was more earthy, and his boys are more real boys than Harunobu's. This tendency toward realism is doubtless Koryusai's principal point of divergence from Harunobu; at its

best it results, as here, in a feeling of intimacy with real life. At its least successful the effect is one of grossness and awkward verisimilitude.

Realism was a tendency which was to characterize ukiyo-e in the 1770's and the following years; had he lived, Harunobu could hardly have resisted its influence. In this sense the prints of Koryusai provide some hint of the direction in which Harunobu's work might have gone. Koryusai is also notable for the development of a style of rich, decorative coloring, unique with him, and especially for his (or his printer's) reintroduction of the opaque orange (red lead) which had characterized the hand–colored orange prints of several generations earlier. Plate 78 reveals something of the characteristically rich Koryusai coloring, which contributes so much to the success of his prints.

Although Harunobu had produced a number of adroit works in such lesser-known media as the pillar print, erotica, flower-and-bird prints, and ukiyo-e paintings, it was his pupil who fully explored the possibilities of these forms. In particular, Koryusai deserves praise as the master of the pillar print, a difficult, elongated form about twenty-eight by five inches in size, made to be displayed on the narrow supporting pillars of a Japanese home. Due to their odd shape, pillar prints do not conveniently fit into book format, but a glance at the Harunobu of Plate 76 will reveal the basic pattern of vertical composition, which could be narrowed to only one-sixth of the height and still retain its essential features. Indeed, the format often resulted in a heightening of dramatic effect due to the severe "cropping" involved. And of course the form made possible a print suitable for use as a hanging scroll at a fraction of the price of the full-width *kakemono* prints like the one in Plate 44. (It is just possible that such long, narrow formats may gradually have influenced the artistic fashion for attenuated human figures as well.)

The special feature of the pillar prints, then, was the employment of the dramatic close-up, on "wide screen," as it were. (There were also horizontal pillar prints, but these were employed principally for erotica.) It is doubtless the impressive size of the figures, and the affinities with the grand dimensions of Western painting, that have made the pillar prints popular among collectors. However, as an expression of intimate beauty they can seldom compete with the more easily handled conventional sizes, for an ukiyo-e print is most effective viewed at arm's length, not from afar.

Oddly enough, Koryusai's most original contribution to ukiyo-e probably lay in the field of erotic prints. Here his relation to his master is very

much like that of Sugimura to Moronobu nearly a century earlier. Where Koryusai's style was sometimes gross in its attempts at depicting the dream world of Harunobu, in the field of sexual art he excelled, expressing a colorful vitality in which his work is frequently more effective even than Harunobu's. In color and line, in the creation of the total atmosphere of physical love, I rather doubt that the best of Koryusai's erotic color prints are surpassed in Japanese art; and that would place him rather high internationally, too, for few peoples have ever pursued the cult of artistic erotica so assiduously as the Japanese. (For a subdued example, see Plate 80.)

Koryusai was also one of the first print masters to produce flower-and-bird pictures in any quantity (there had been notable early experiments by Moronobu, Kiyomasu, Shigenaga, Harunobu). This was a set form in traditional Far Eastern painting and, despite the limits suggested by the name, included a wide range of subjects in which a close-up of plants or flowers, with accompanying birds, insects, or animals, was featured.

Plate 79 shows a sample of Koryusai in this genre, a rather unobtrusive example, but one of the most charming of all. Seven fat puppies are seen drowsing beside narcissus; in the background are stylized clouds and the sketchily drawn thatched roof of a shelter. It is difficult to imagine puppies remaining still for so long, but one of the leaves will be seen to have leaned over to rest on the back of the dark puppy—perhaps half wilted by the heat of his plump, furry body.

The most renowned works of Koryusai's later years are his extended series of large prints featuring courtesans with their attendants. The best of these are effective compositions and impressive prints, but one finds it hard to love them. Gone is Harunobu's happy influence: these prints feature the tendency toward sharp but somewhat gross realism, the impassivity and spiritual emptiness that was to plague much of late ukiyo-e figure work. The relatively large format (fifteen by ten inches), used also briefly by Harunobu in his last years, was to predominate in the final century of ukiyo-e, and the consequent loss in intimacy was to flavor the whole mood of prints after the passing of Harunobu.

79 *Koryusai. Puppies. Early 1770's. Seven plump puppies rest beneath narcissus, probably parodying some such classical theme as the Chinese* Seven Sages of the Bamboo Grove *or the Japanese* Seven Gods of Fortune. *Small color print.*

We conclude this chapter with one of the most disturbing and fasci-
nating artists in all ukiyo-e, Ippitsusai Buncho, who worked during the
period of Harunobu's prime and during the decade after that master's death
in 1770. Buncho's greatness lies in his original and eminently personal ap-
proach to the dreamlike ideal that Harunobu had created for his age. To
this surface lyricism Buncho adds an acrid realism that may owe something
to his contemporary Shunsho, but is more reminiscent of the Sharaku of
two decades later. If lyricism and biting realism seem mutually antagonistic,
nevertheless in their mixture lies the essence of Buncho's peculiar charm.

Buncho is sometimes called an "artist's artist," perhaps to explain the
fact that he is seldom appreciated before long and careful study. There is
always something awkward about him, however, something brilliant but
untutored, as well as something that is best expressed in the Japanese term
shibui: astringent, not cloying, unfathomable. His best-known work is his
Kabuki prints, one or two actors in some conventional pose, but shrouded
by the color and mystery inherent in his artistic vision. Plate 81 shows two
such actors in the roles of ill-starred lovers. They stand before a flower bed,
under an umbrella in the spring rain. The man looks ominously to the left,
the girl looks fondly at her lover. In the quality of his coloring Buncho is
indebted to Harunobu, but ranks almost as his equal; Buncho's more re-
strained colors well suit his remarkable style. The print offers a suspended
moment of intense drama, but the exact meaning is nowhere expressed in
so many words. Buncho brings to the bombast of Kabuki the restrained mys-
tery of the Noh drama.

His output was tremendous, but Buncho nevertheless matches Haru-
nobu in splendid evenness of output. Though his actor prints have made his
name, Buncho's greatest individual works sometimes depict girls or courte-
sans with their lovers, and Plate 82 is among the finest of all. The small,
nearly square print was a format made popular by Harunobu, and the
bold use of orange was also Koryusai's forte. But in the curious restraint of
a potentially violent love scene Buncho evokes an oddly haunting mood;
the forms remind us of Harunobu, but all the sweetness is gone. The burn-
ing fires of love are left half smoldering: the courtesan greets her eager lover
half turned away; the little attendant grasps his sleeve and looks elsewhere.

80 Koryusai. Girl Dreaming of Her Seduction. Early 1770's. Small color print.

81 (Left) Buncho. Kabuki Scene. 1770. Two actors in the roles of the tragic lovers Ochiyo and Hambei in the drama Yoi-goshin. Small color print.

82 (Right) Buncho. Yoshi-wara Scene. ca. 1770. A peak in gay-quarter atmosphere, this print shows a famous Yoshi-wara courtesan, Morokoshi, half coyly and half apprehen-sively greeting her secret lover. The little maidservant watches for intruders, and the lover wears a scarf over his head to conceal his identity from pass-ers-by. One of a series of thirty-six small color prints of Yoshiwara courtesans.

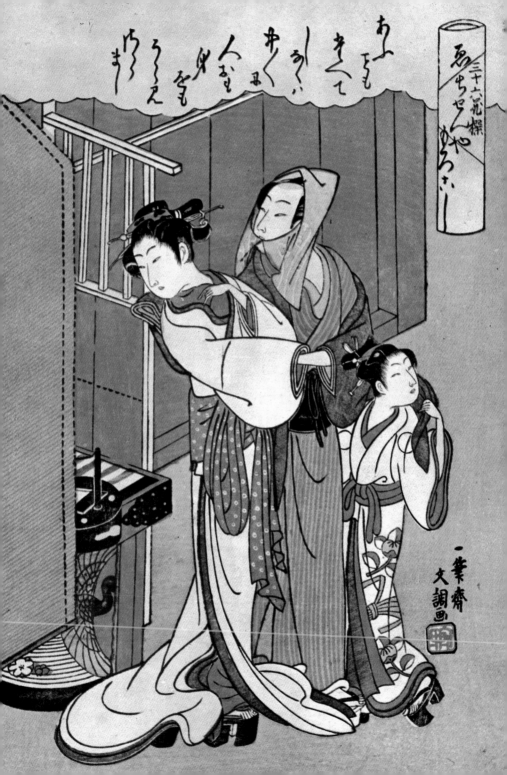

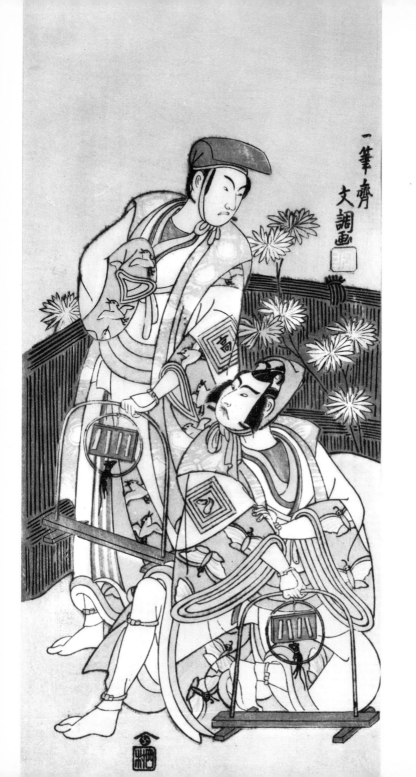

The lover, face partly concealed by scarf, half embraces his sweetheart. But everything is restrained, almost nonchalant: there will be time later for love's consummation; the artist, by concealing love's overt emotions, delineates a lasting picture of passion all the more impressive for its control.

We may end our eulogy of Buncho by noting that he has not always been praised without reserve. The nervous, haunting brilliance of his work led one perceptive critic (Arthur Davison Ficke) to imagine "an intangible spiritual abnormality" about him. Perhaps so, but it is a quality similar to that which compels us in Memling, Grünewald, El Greco.

Harunobu, Koryusai, Buncho: three happier geniuses have seldom coincided. One immediately visualizes brilliant opaque color and a newly created dreamlike vision that ukiyo-e was seldom to capture so well. In the company of these three artists one might well spend a lifetime, oblivious of the clamor and commotion of the outside world. They saw a dream, shaped it, and liking what they had made, lived in it. One envies them.

83 Buncho. Kabuki Actors with Fox Traps. 1770. Small color print.

REALISM AND
THE WORLD OF KABUKI

Shunsho and Sharaku

LIKE ukiyo-e, Kabuki suffered from the repressive govern-
ment edicts of the second quarter of the eighteenth century—as well as
from the excessive popularity of the puppet theater. It was not until the
1760's that a great theatrical revival renewed the vigor of the living stage.
From this period to the end of the century was to prove the second golden
age of Kabuki, one in which most of the elements of the art were developed
and refined as we know it today. Now, too, appeared many of the great
actors who are remembered to this day, and without whom the art could
never have survived.

Kabuki was the mind and the heart of the Edoite, and Katsukawa
Shunsho was its artist par excellence. Shunsho (1726–1793) had studied in
the studio of Katsukawa Shunsui, an adept painter of women and a pupil
of the master Choshun, whose work is shown in Plate 64. Shunsho thus had a
firm groundwork in the principles of ukiyo-e painting; moreover, he pos-
sessed an original, realistic view of the stage which was to distinguish his
work almost as soon as he turned to the production of popular prints in the

*84 Shunsho. Lovers in Flight. Early 1770's. The love-hero Narihira hides in a
moor with his sweetheart, as pursuers search for them with torches. At the top of the
print appears the verse translated on page 184. One of a series of small color prints,
based on the classical Tales of Ise, issued both as single prints and in album format.*

178

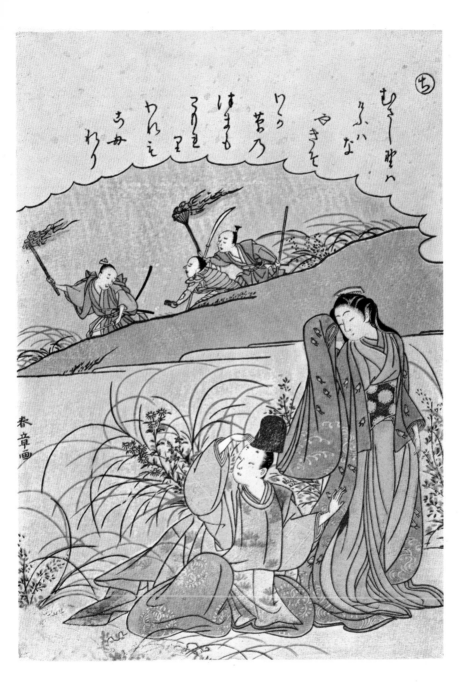

mid-1760's. This period was, it will be remembered, the time of Harunobu's full ascendancy, and Shunsho, too, could not help but be influenced by that master. Indeed, for a few years his style followed closely that of Harunobu; but by the time of the latter's death in 1770, Shunsho had already shaken free and commenced the long line of realistic Kabuki portraits that was to make his name.

Shunsho's art represented a basic revolt from the formalism of the Torii school of Kabuki specialists. Their prints were at bottom generalized depictions, highly stylized billboards to attract the crowd with their bold line and color. Unless labeled, it was difficult to tell one actor from another in a Torii print. In other words, they chose as their subject the role, not the individual actor in that role. That the results were effective may hardly be denied, for the pageantry and bombast of Kabuki made it peculiarly suited to such representation.

But realism was commencing its dominance of the new age, and the late Torii actor prints had lost the stylized power of their forerunners, being reduced to delicate tableaux bearing little relation to the dramatic nature of Kabuki. With Shunsho, theatergoers for the first time were able to recognize the features and the special artistic idiosyncrasies of their favorite performers; the individual actor was suddenly brought to life by his brush. Shunsho's success with the Kabuki fans was thus both natural and immediate, and his portrayals of living actors as actually seen on the stage led the way toward the realism that was to characterize the final quarter of the eighteenth century.

A first glance at the set of prints in Plate 85 will hardly suffice to make Shunsho's contribution clear. For he has retained the flat perspective, the formalized pose and costume of the theater, and there could be nothing more "Japanese" than these prints. Compare, however, the traditional Torii approach of but a decade earlier in Plate 40, for example, and you will see how much closer Shunsho has come, even in his early work, to portraying individual actors rather than idealized types. The full development of psychological portraiture in ukiyo-e had to wait another two decades until the appearance of Sharaku and Utamaro; but in the genius of Shunsho it found its experimental beginnings.

Shunsho's relationship to Buncho, the other great Kabuki artist of his day, has yet to be explained satisfactorily. The usual claim that Shunsho greatly influenced Buncho seems doubtful; I think, rather, that they both

simply developed at first in Harunobu's shadow, and by the time they achieved their own styles of depicting Kabuki, had mutually influenced each other. Interestingly enough, the two collaborated on a remarkable series of actor portraits published in book form in 1770, in which they both already reveal the styles that were to distinguish their careers. Of the two, Buncho's was probably the greater genius, but his style was so personal that it practically died with him. Shunsho's perfect art, however, could be understood by all, and he proved one of the greatest teachers in ukiyo-e—not the least of his pupils being Hokusai. Plates 81 and 85 offer a good basis for a comparison of Buncho and Shunsho: the former, arresting, formal, profound, and vaguely awkward; the latter, a master of portraiture and composition, but so perfect as to seem monotonous at times. In any event, Buncho and Shunsho mark a dual pinnacle of Kabuki art, one that was never really to be surpassed.

Much of Shunsho's glory lies in his use of remarkable coloring. He adapted the rich palette of Harunobu to the dramatic needs of Kabuki, and made particularly effective use of strong black, brown, orange. His versatility is often forgotten, but it forms one of his major claims to artistic greatness. His studies of the massive *sumo* wrestlers are certainly the finest in ukiyo-e, and even such great pupils of his as Hokusai never excelled him in this genre (compare Plate 123). Shunsho also designed powerful warrior prints, haunting courtesan portraits, colorful rustic scenes, and illustrated numerous books, including some extraordinarily sedate erotica.

To represent Shunsho in a non-Kabuki subject we have chosen Plate 84, one of a series of charming prints illustrating the classic *Tales of Ise*, which also provides the subject matter for Plates 3, 7, and 41. The scene illustrated here is perhaps the most dramatic and famous in the whole novel, and the brief poetic episode may be translated in full.

There was in times of old a man who, abducting the daughter of a certain person, fled with her into the Moor of Musashi. But in his flight he was considered a thief, and was forthwith arrested by the Governor of the Province. Now at the time of the flight he had left the girl concealed within a thicket. One group of those who followed, saying, "There is a thief hiding within this moor," was about to put the torch to it. Whereupon the girl in consternation pleaded,

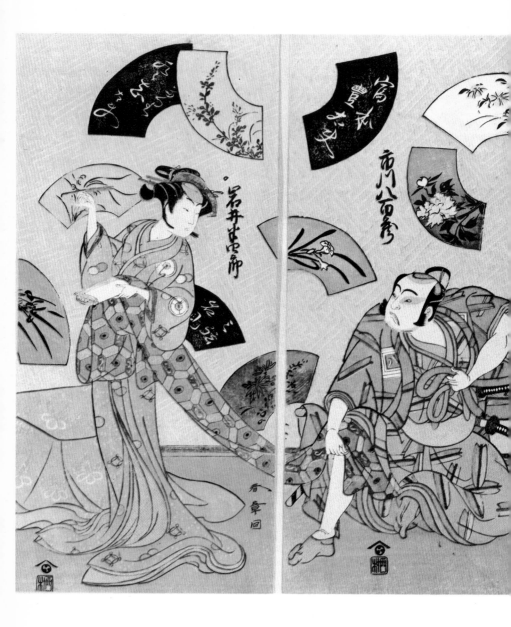

85 *Shunsho. Kabuki Scene. 1772.
The actors Hanshiro, Yaozo, and
Monnosuke appear as courtesan.
samurai, and the latter's younger
brother, in a tableau from the Soga
play* Dawn Booklet. *The samu-
rai holds fast to the sashes of the
young people, whom he has evident-
ly caught in a rendezvous. A set of
three small color prints designed to
be viewed together or separately.*

O burn ye not
this Moor
of Musashi today!
My young love is concealed within the grass:
and so am I.

Thus did she recite, and hearing this, they captured the girl, and led the two back together.

Here again it is Shunsho's coloring that moves us most, the flowers and grasses being possibly the most effective elements of all. As is common in ukiyo-e interpretations of the classics, the styles are mixed: only the hero is dressed in ninth-century costume; the girl and the pursuers follow more modern dress.

Yet another major aspect of Shunsho's versatility remains to be noted, and that is his painting. Skill in traditional painting techniques lay at the base of Shunsho's sustained success as a print designer and, like Moronobu, Koryusai, and Eishi, he devoted most of his final years to this more exacting and prestigious profession. (It should not, however, be assumed that all the great print artists were fine painters. Harunobu and Buncho, though among the true geniuses of the print, were only mediocre painters.) Shunsho has always been considered one of the principal figures in ukiyo-e painting, and in his own time there was even a saying, "A Shunsho painting is worth a thousand pieces of gold." (That is to say, "worth its weight in gold"—only more so.)

Plate 87 shows something of the characteristic flavor of Shunsho's work in ukiyo-e painting, so different from his prints. The scene is one of a well-to-do household, the women and maids engaged in airing books, scrolls, and clothing after the rainy season has passed. Though the scene is one from daily life, there is a luxurious flavor, an opulence to the painting that reveals as much the tastes of the wealthy persons by whom it was commissioned as it does the painter's own style. Such paintings were made to be viewed at leisure and in detail; we miss here the dramatic impact of the print, but are given instead a rich and intimate view of details to be savored at length. The painting was originally one of a series, each panel featuring a month or season of the year, and was probably mounted on a screen as part of the decoration of a Japanese parlor. The lack of dramatic

勝川春常画

86 Shunjo. Kabuki Scene.
1780. Small color print; one
panel of a series.

concentration in such a work is thus purposeful, designed to form a restful and harmonious union with the other paintings of the series.

This luxurious painting presents, at any rate, a sharp contrast with the multitude of prints Shunsho made for his Kabuki fans; and it is somehow gratifying to think of him as able to retire in his old age from the frenetic hubbub of the print publishers and their public, and to apply himself to leisurely painting, secure in the knowledge that a painting of his was "worth a thousand pieces of gold."

Shunsho's eminence as a teacher has already been alluded to; from his studio came such great names as Shunko, Shun-ei, Shuncho, and Shunro (Hokusai). The last two artists will receive separate treatment later, but the first pair followed directly in their master's footsteps as artists of Kabuki, and will be discussed here.

There has been a tendency of late to praise Shunko and Shun-ei at Shunsho's expense. Certainly it is true that their Kabuki work is sometimes more striking than his, and may often seem more appealing because formally less perfect. But after a careful study of Shunsho, one must ask concerning his pupils: "What new elements did they contribute to his style? Are they great creative geniuses in their own right?" To these questions my own answer must be a tentative no, and I have accordingly devoted much of the available space to displaying the breadth of the master.

That is not to say that Shunko and Shun-ei (as well, indeed, as Shunjo [Plate 86], Shundo, Shunzan, Shuntei [Plate 92] and other pupils) did not do much of interest. Shunko (1743–1812) ranks first among Shunsho's pupils who devoted their work to the theater, and his finest Kabuki prints equal those of his master. Shunko's work (see Plate 88) extends from the early 1770's through his final years; in the late 1780's his right arm became paralyzed but, switching to his left hand, he continued on to produce the type of large actor heads which were one of his main contributions to ukiyo-e. He also excelled in prints of wrestlers, of which the work of his fellow pupil Hokusai in Plate 123 may again serve as typical. Shun-ei (about 1762–1819), another major pupil of Shunsho's, contributes a modern touch to the Katsukawa school, as well as a pronounced element of facial exaggeration which adds to the individuality and dramatic force of his actor prints, but in lesser hands was to lead to the decline of figure work in the nineteenth century. Sharaku and, most of all, Toyokuni, were among those influenced by Shun-ei's style—which is, to me, most appealing when least bombastic (Plate 91).

186

*Shunsho. Girls Airing
s. Mid-1780's. The
er rainy season has end-
nd the women of the
hold air out books and
s. His mother watches
the little boy hands
lumes to the girl drying
on a line. On the ver-
, two women spread out
es, and one becomes
ed in reading. In the
n, bamboo flourishes,
p above a cuckoo darts
Painting on silk;
panel, probably de-
from a set of screens
he months or seasons
e year.*

187

At the commencement of the century, Torii Kiyonobu had opened the path to the artistic Kabuki print, and his style dominated this world for nearly seventy years. Shunsho replaced the Torii formalized art with a new, realistic vision of the actor as individual, which held sway for three decades. Then, for only ten brief months in the years 1794–1795, appeared a haunting, ephemeral genius who was to bring Kabuki portraiture to its culmination. This was Sharaku.

Toshusai Sharaku represents the extreme example of the prevailing obscurity regarding the lives of the masters of ukiyo-e. His contemporaries mention him but briefly in passing: "Sharaku designed portraits of the Kabuki actors, but in attempting to achieve an extreme of realism he drew people as they are not, and was thus not long in demand, ceasing his work within a year or two." "He was a Noh actor in the service of the Lord of Awa.... In his brushstrokes there is power and elegance worthy of note." And that is about all we know of Sharaku's life and identity even today, after decades of research both in Japan and abroad.

In this respect, at least, the simple lover of art has an advantage over the critic and scholar, for he need only concern himself with "knowing what he likes"; and Sharaku has been a favorite of print collectors almost since the first rediscovery of ukiyo-e in the late nineteenth century.

If there is any dominating element in Japanese art, it is certainly the force of tradition. However great and original the artist, we can always trace quite clearly his origins, his indebtedness to earlier masters, whether Japanese, Chinese, or Western. Whatever his native genius, we can generally identify a good part of his style as being derivative, and we judge him almost as much for his mastery of the traditional styles as we do for his original contribution to his school.

Sharaku represents the exception, probably the most extreme one in Far Eastern art. His art seems to spring forth fully formed at birth, and only toward the end of his brief, frenzied career does he decline enough in inventiveness to reveal the influence of the style (Shunsho and his group) that should have been his logical model. I find it difficult to admit, however, that miracles can occur in an artist's stylistic development; whatever his native genius, whatever the skilled guidance provided by his publisher, the

88 Shunko. Kabuki Actors in Dance. 1781. Small color print.

great Tsutaya Juzaburo, Sharaku's tremendous, evenly balanced output cannot be explained as the sudden inspiration of an untrained amateur. Attempts to identify Sharaku with other contemporary artists (for example, Maruyama Okyo and Kabukido Enkyo; and even Choki has struck me as a fascinating if wild hypothesis) have so far proved abortive, but I have a strong suspicion that somewhere in the vast mass of uncatalogued eighteenth-century Japanese paintings and prints the key will someday be found. One print, datable as 1799, has already come to light to confuse the issue, as have one or two dated fan paintings, which would suggest either that Sharaku did occasional later work or that another of the men who employed that *nom de plume* also dabbled in art. In short, though Sharaku's career remains the greatest single mystery in ukiyo-e history, I believe it to be a mystery with a clear and logical explanation—whether or not such is discovered in our own lifetime.

In point of fact, we can discern certain general contemporary influences in Sharaku's work, though they contribute a far smaller percentage to his total effect than in the case of any other ukiyo-e artist. Sharaku's Kabuki figure compositions, for example, owe a good deal to Buncho, Shunsho, and early Hokusai, and his large heads and close-up portraits, to Shunko and Shun-ei. The psychological element in his portraiture may have been stimulated by Utamaro's intuitive probing of female vanity, as were some of the technical effects employed in his prints. The strong flavor of realism and near caricature which forms the basis of Sharaku's style perhaps owes more than is generally suspected to Western art, particularly as introduced into Japan by such students of things Occidental as the painters Hiraga Gennai, Shiba Kokan, and Maruyama Okyo. Certainly Sharaku is the least conventional, the least Japanese of any major ukiyo-e artist. It is no coincidence that he should be among the most highly praised artists in the West, while in his own day he was considered "outlandish," unpoetical, and inartistic.

Sharaku's extant prints and designs total at least a hundred and sixty; being largely pictures of specific Kabuki performances, they may be exactly identified. They date almost entirely from the middle of the year 1794 to

89 *Sharaku. Kabuki Actors. 1794. The actors Konozo and Wadaemon shown in minor roles from the drama* A Traveler's Tale of Revenge. *Medium-sized color print.*

190

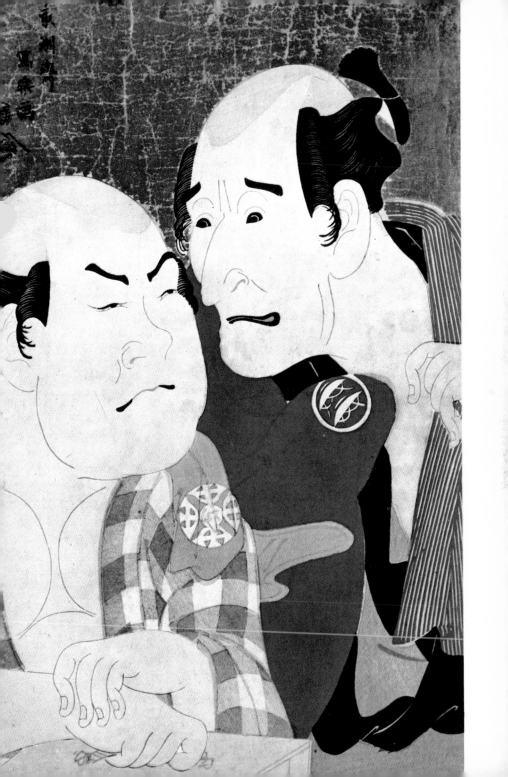

the beginning of 1795, a total artistic lifetime of but ten months. Despite the brevity of Sharaku's artistic life, his prints fall into a general pattern of change such as we are accustomed to witnessing during a decade or more in the work of a more ordinary artist.

During his "first period," the Fifth Month of 1794, Sharaku issued some twenty-eight medium-sized prints, principally bust portraits such as those shown in Plates 89 and 90. These works constitute his most famous, his most lovely or powerful prints. It is at this period that we feel the mystery of Sharaku most strongly: whatever his genius, could he have translated direct observation, however astute, into such remarkably designed and accurately executed Kabuki prints without either formal art training or long familiarity with the popular theater? To me, at least, this seems impossible.

In his "second period," the Seventh and Eighth Months of 1794, Sharaku issued some forty-six prints and drawings, comprised of medium-sized designs showing pairs of full-length figures, and smaller prints of single figures, all viewed from a unique angle, as though seen from the audience, from a position slightly below the stage. Plates 93 and 94 are typical of his masterworks of this period, which features dynamic group compositions that are among the most effective in all Kabuki art.

Sharaku's "third" and final period encompasses some eighty-six medium and small prints and designs issued in the Ninth Month of 1794 and the first month or two of 1795. There are several bust portraits, but the majority are full length, with a few *sumo* wrestling prints, miscellaneous subjects, paintings, and unpublished designs also extant. This final half of his career cannot but prove a disappointment to the Sharaku enthusiast; for in it we find a general decline in quality, a tendency toward mannerism rather than fresh creativity. From the inspired stylization of Sharaku's earlier work we come to a strong element of caricature and cartoonlike exaggeration, hardly ever constituting great art. For the first time, also, we note the use of complex backgrounds, which fail, however, to make up for the decline in the quality of figure work. Sharaku's design is still competent, but he hardly ever shows that flash of perceptive genius that characterized a good majority of his earlier works. At his finest, it is true, even now he equals the late work of Shunsho and his pupils, as well as the best of Toyokuni and Kunimasa; but nothing better can be said of him in this period—a genius who in his prime just a few months earlier had almost seemed capable of sweeping ukiyo-e off its very foundations.

What happened to Sharaku in these final months? Quite possibly he simply worked himself out, as far as this limited genre was concerned, and had no opportunity to expand into other fields of ukiyo-e; perhaps overwork and illness sapped his energies. We will probably never be able to answer this puzzle—any more than we can explain Sharaku's sudden appearance on the Edo horizon. All we do know is that he lived a rich and full artistic life in a space of but ten months, and then disappeared from view as suddenly as he had appeared, leaving a body of masterworks that was hardly to be understood until a full century later.

Though not lacking in romantic elements, Sharaku's prints represented a culmination of the early realistic movement. He depicted an ideal of Kabuki impressionism, his portrayals fusing the dramatic role and the individual actor; yet, beyond that, they display a depth of psychological insight quite lacking in the surface realism and external beauty of his predecessors Buncho and Shunsho. But psychological perception was seldom to be the forte of Japanese art—which excelled, rather, in design, style, color, and surface appeal. Thus Sharaku is the least Japanese of the ukiyo-e artists in his mental attitude, and as portraits or as Kabuki interpretations, his prints must have seemed as "outlandish" to his contemporaries as they do to the uninitiated Western viewer today—though in quite different ways. It is thus small wonder that the playgoers of his time did not vociferously demand more of the same; the wonder is, rather, that he should have survived so long in such a predominantly popular art form as ukiyo-e prints.

Whoever Sharaku may have been, we clearly owe his artistic career to one man, his publisher Tsutaya Juzaburo. Tsutaya as an individual was the greatest of the print publishers, and discovered and supported such varied talents as Utamaro, Choki, Kyoden, and many others. Toward Sharaku's work, however, Tsutaya clearly felt some attraction that exceeded even his usual devotion to ukiyo-e prints—a "commercial" art that customarily surpassed much of the "fine" art of the times. Sharaku's one-hundred-and-fifty-odd prints were published entirely by Tsutaya, and included many issued in expensive and luxurious format. But although Sharaku's style was evidently admired by a few connoisseurs of the time, even a great publisher could not create popular taste, and thus the weak public reception may well have had as much to do with Sharaku's artistic decline as anything else.

In a sense, Sharaku's work thus represents a kind of *anti*-ukiyo-e, an unconscious attempt to create an *avant-garde* within an essentially popular

and commercial (in the better sense of the word) form. The new elements of sharp realism and the direct vision of psychological caricature which Sharaku introduced were basically opposed to the colorful and highly stylized nature of ukiyo-e. For a full expression—and reception—of his true genius Sharaku appeared not only in the wrong age but in the wrong country. In the lands of Holbein, Hogarth, Goya, and Daumier, one suspects he might have found more perfect mediums, more receptive audiences for his special light. Sharaku is the one ukiyo-e artist who, despite the characteristically Japanese nature of his subject matter, would seem to belong less to his own time and country than to the world.

But though he was condemned or dismissed by the Edo populace, Sharaku's actual influence on ukiyo-e portraiture and the depiction of Kabuki was to prove considerable. He had minor imitators such as Enkyo, Shuntei, and the Osaka artists Ryukosai and Shokosai, but his most important followers were Toyokuni and Kunimasa—to be discussed in a later chapter—together with Shun-ei, the very artist who had helped form something of Sharaku's own basic pattern of design. Particularly in Toyokuni and his followers, a gradually widening misinterpretation of Sharaku's semicaricaturistic style spread through nineteenth-century Kabuki depiction, producing some works of interest but also many horrors. None of this was Sharaku's fault, of course. He himself simply had a startling vision of the Kabuki actor as an all-too-human individual, and recorded this vision with rare technical skill and simple but striking color effects.

It was no fault of Shunsho and Sharaku that the very realism which distinguished their work was, in the end, to help kill ukiyo-e. They were pioneers in a unique style, recording a fresh, colorful, and probing view of theatrical art—a vision which suddenly brought the stage alive on paper, and makes the Kabuki of that age as real for us as anything on the stages of the world today.

90 Sharaku. Actor as Courtesan. 1794. Yonezaburo as the virtuous courtesan Shosho, from the drama A Traveler's Tale of Revenge. Medium-sized color print.

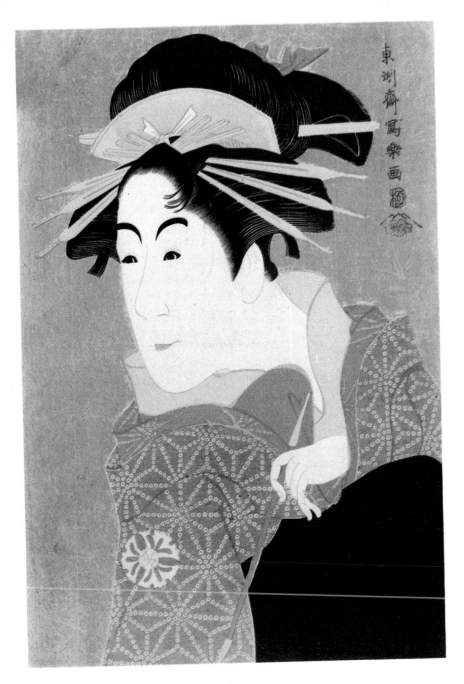

195

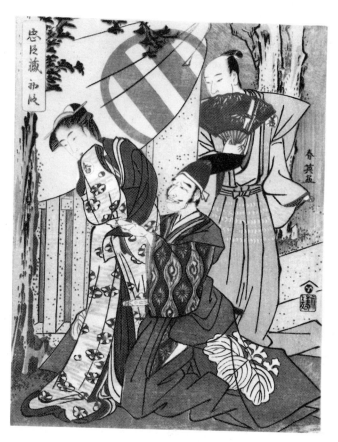

91 Shun-ei. Attempted Seduction Scene, Chushingura. *Late 1780's. Small color print; one of a series.*

92 (Facing) Shuntei. Juvenile Kabuki Actors. 1801. Medium-sized color print.

Overleaf 93 and 94:

(Left) Sharaku. Kabuki Actors. 1794. The actors Hangoro and Yaozo pose as priest and villainous samurai in a climactic moment from the drama The Courtesan's Three Parasols. *(Right) Sharaku. Kabuki Scene. 1794. In the same drama, the actor Sojuro as samurai and Kikunojo as courtesan. Both medium-sized color prints.*

196

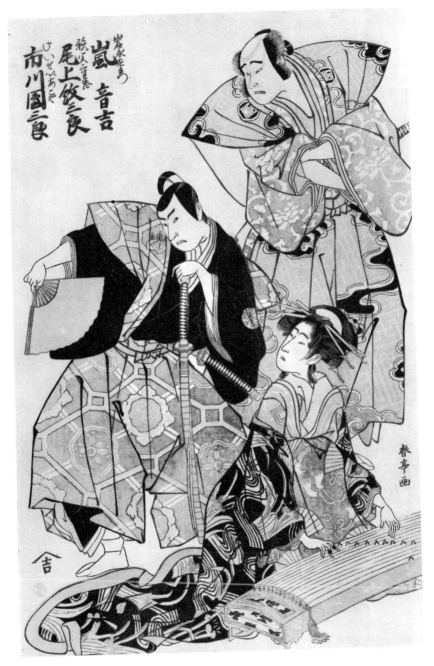

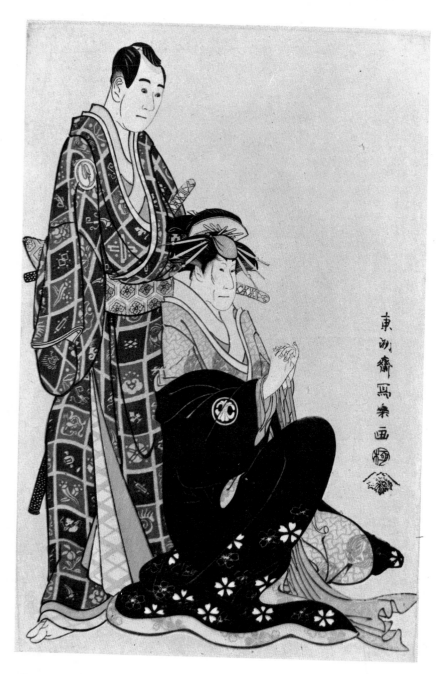

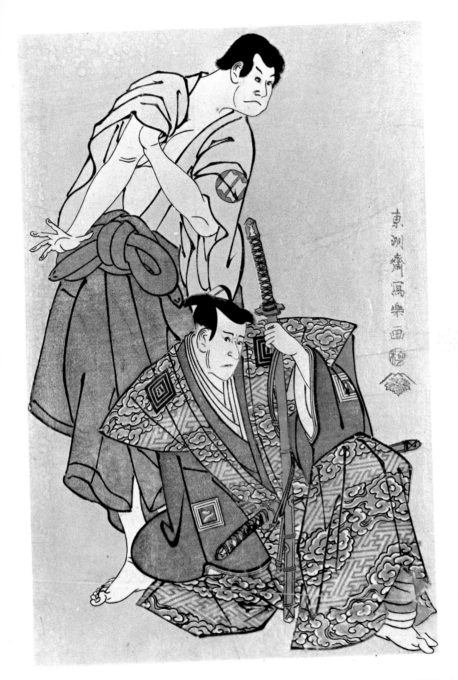

199

Chapter IX

LOVELY GIRLS

The Golden Age of Ukiyo-e

BEAUTIFUL women were ever at the center of ukiyo-e ideals. In Japan at the time of Harunobu and the generation that followed, feminine beauty received perhaps the greatest tribute that it has ever known. At the same time, the new age of the 1770's and 1780's was accompanied by a gradual change in ideals, from the frail delicacy of Harunobu to the more robust, this-worldly beauty of the later Koryusai and Shigemasa. This trend reached its peak in Kiyonaga and Shuncho—only to be replaced in the 1790's by another unreal ideal, the slim and overelongated beauties of Utamaro and Eishi. Such action and counteraction form almost the rule in ukiyo-e, as, of course, in the contemporary taste that comprised its foundation. (Before this, in the beginnings of ukiyo-e Moronobu had established the fashion of the robust female form; this had been continued by Kiyonobu and Kaigetsudo, modifying and attenuating itself gradually until Harunobu created a new extreme of idealized frailty. After Eishi, again, with the nineteenth century there was a return to the more solid female figure, a style that dominated to the end of ukiyo-e.)

The years immediately after the death of Harunobu saw the gradual development of this new ideal of robust womanhood; and this was settled by the year 1776, when Shunsho and Shigemasa published their famous book of colored illustrations, *Collected Beauties of the Green-houses*. Shunsho we have discussed in the previous chapter; his collaborator Shigemasa was to prove one of the major forces in directing the destinies of ukiyo-e through this little-understood transition period.

Kitao Shigemasa (1739–1820), son of an Edo publisher, may possibly

have received preliminary training under some obscure Kano painter, but appears largely to have been self-taught. Throughout his career he was an expert and careful draftsman, greatly respected by his contemporaries as an "artist's artist." Shigemasa's early experiments in ukiyo-e date from the red-print period and are frequently after the manner of Kiyomitsu. His first characteristic prints, however, appeared in the late 1760's, featuring a style somewhat between Harunobu and Shunsho, but pointing the direction in which all future ukiyo-e figure work was to tend.

Plate 95 shows a landscape by Shigemasa from this early period. The scene is Nippori, just north of Edo, a spot famous for its scenic view as well as for the teahouse-beauty Osen. Unlike Harunobu's usual representations of the spot, however, Shigemasa's print is a straight, draftsmanlike land-scape-with-figures, and follows in the tradition of Shigenaga's earlier land-scapes, such as the one in Plate 52. The extreme popularity of such topographical prints may be hard for us to comprehend unless we recall that the Japanese have always been great sightseers and travelers, and that these prints constituted the picture postcards and tourist photographs of the day. The fresh and lovely coloring, at any rate, saves the print from any apparent dullness, and those not attracted by the geographical details can readily disregard the text printed in the conventionalized clouds at the top.

Shigemasa's greatest contribution to the Japanese print lay, however, in a rare series depicting groups of geisha (these were entertainers, dancers, musicians—quite separate from the courtesans), one of the finest of which is shown in Plate 96. The style is vaguely reminiscent of Harunobu and Koryusai, but there is a freshness of concept that stems from neither, a filling out of forms and a sense of tight group composition that helped to set the style for the coming generation. The print shows well the transition point in the changing ideal of womanhood; Harunobu's delicacy still remains, but the dream of beauty has come closer to the forms of real life.

Overleaf 95 and 96:

(Left) Shigemasa. Scene at Nippori. Early 1770's. Festive visitors to the shrine at Nippori, north of Edo. One of a series of twenty-four small color prints of Edo scenes, later published in book format. (Right) Shigemasa. Geisha with Attendant. Late 1770's. At the right, two geisha, proceeding to the evening's entertainment, are followed by an attendant carrying their samisen in a box. Medium-sized color print.

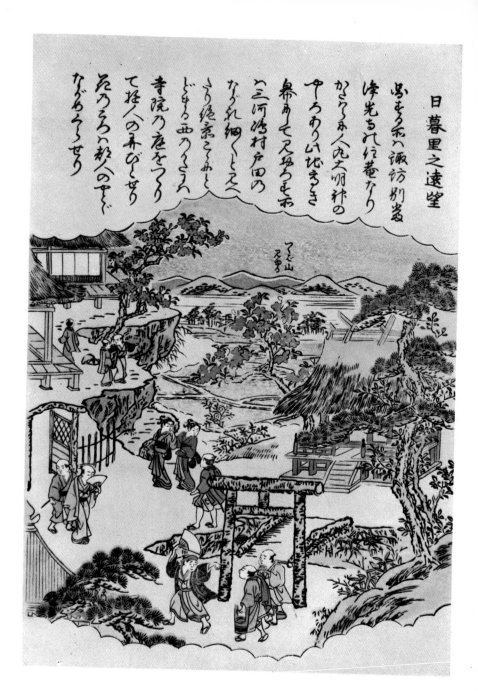

日暮里之遠望

當寺ハ新ハ諏訪別當

海光寺と号行菴なり

かたわ人丸大明神の

中ろあり山地ちき

帝あって尺境るもお

ハ三河修村戸田の

なるれ細くとえ

さり絶家こてみと

しどもの西のくるハ

寺院乃庭をつり

て程人の弄びくせり

花のうろハ秋の中に

ながるろくせり

つくど山
石碑

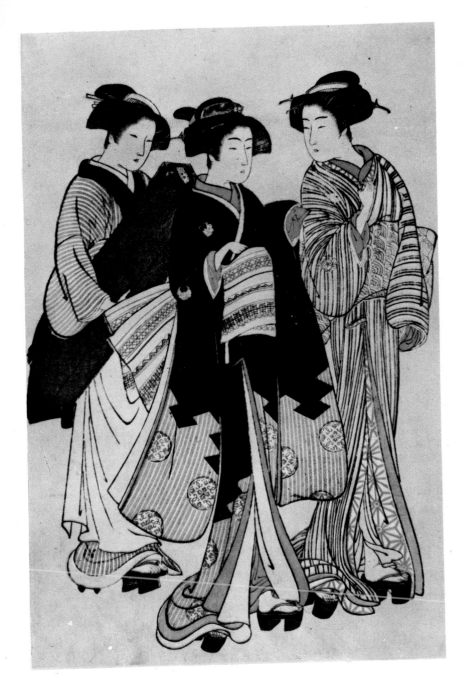

These striking geisha prints by Shigemasa represent the great new development in figure work after Harunobu: increasingly massive forms with broad and effective grouping of opaque color patterns. Yet for reasons incomprehensible to us today, Shigemasa preferred the more miniature work of book illustration. Thus he never followed through after producing examples of a magnificent figure style that could well have dominated ukiyo-e for the rest of the century (and in a sense did, though more through the prints of such followers as Kiyonaga than in the work of Shigemasa himself).

Besides being a fine artist in his own right, Shigemasa, like his good friend Shunsho, was one of the great teachers of his age, and his pupils have eclipsed him in fame, if not in native genius: Kyoden (Kitao Masanobu), Masayoshi, Shumman, together with such unofficial followers as Utamaro and Hokusai.

The most precocious of Shigemasa's several brilliant pupils was a young man named Kyoden, who entered Shigemasa's studio in his early teens and eventually received the artist name of "Kitao Masanobu." (Though the spellings in Japanese are quite different, in romanized form it is impossible to distinguish this "Masanobu" from the great pioneer of that name; hence we shall employ the name Kyoden here, which the artist used on much of his work anyway.) Kyoden (1761–1816) was already producing remarkable work by his late teens, especially in the combined genre of picture novels, which he wrote and illustrated himself. Eventually his popular and critical success as a novelist was to take him almost entirely away from the print field, though he continued to produce witty ukiyo-e paintings in his characteristic style throughout most of his career.

Kyoden's most famous work is undoubtedly his magnificent courtesan album, designed and published in 1782–1784, one leaf of which is reproduced in Plate 97. Originally published as separate sheets, the album features seven plates devoted to strikingly original, candid scenes of Yoshiwara courtesans at leisure, accompanied by verses in the girls' own handwriting. In the plates of this album we find, in a giant format twice the size of an ordinary print, an intricacy of coloring and design hardly seen before in ukiyo-e. They may truly be called brocade prints. The basic design of the prints is almost overpowered by the elaborate technique, yet the series remains one of the landmarks in the development of the Japanese color print. The faces and figures derive directly from Kyoden's teacher Shigemasa; but the forms have somehow become solidified and elongated in the interval· between the prints

shown in Plates 96 and 97. It is rather doubtful that even such masters as Shigemasa, Kyoden, and Kiyonaga could have inaugurated such a radical change in ideals of beauty; yet certainly they (like our modern illustrators and fashion photographers) did much to effect its rapid acceptance by the populace.

From the time of his graduation from Shigemasa's studio Kyoden seems to have been closely associated with that famous publisher and patron, Tsutaya Juzaburo, whom we have already mentioned in relation to Sharaku. Possibly it was under Tsutaya's advice that, only a decade after his first masterpieces, Kyoden gave up his part-time work in the prints to devote himself to the evidently more satisfying and lucrative field of literature and occasional book illustrations. Though Kyoden might well have developed into an artist to rival the great Kiyonaga, we may not, out of overabsorption in the print world, consider his loss to art a great tragedy; for Kyoden's name brightens one of the most fascinating chapters in Japanese literature, and he ranks as one of the major literary humorists and satirists of his time.

A less striking figure than Kyoden, his fellow pupil Kitao Masayoshi (1764-1824) nevertheless ranks close to him in importance. Masayoshi was a master of several styles, both ukiyo-e and neo-Kano, and a precursor of Hokusai in his numerous colorful sketchbooks, wherein, however, he specialized in strong, impressionistic renderings rather than detail and draftsmanship.

Although ukiyo-e never declined in its apparent charms, in the 1770's it was clearly waiting for some bold master to lead it to new heights, to resuscitate and expand it as had Moronobu, Masanobu, and Harunobu for their generations. This great creative effort was provided by Kiyonaga, an artist perhaps, however, more important as an innovator and consolidator than as a personal creator of beauty—though some critics eschew such distinctions and place him at the very pinnacle of ukiyo-e.

Torii Kiyonaga (1752-1815), son of an Edo bookseller, was a leading pupil of Kiyomitsu's, last of the great figures in the traditional Torii line. Kiyonaga succeeded his master as head of the Torii family, and much of his work was thus devoted to depicting Kabuki, an outstanding example of which we see in Plate 98. This print comes, it will be recalled, well before the time of the great Sharaku (discussed in the previous chapter), whose acrid realism was to revolutionize Kabuki prints. Yet if we compare Kiyonaga's print with the work of his master Kiyomitsu (Plate 40), for example,

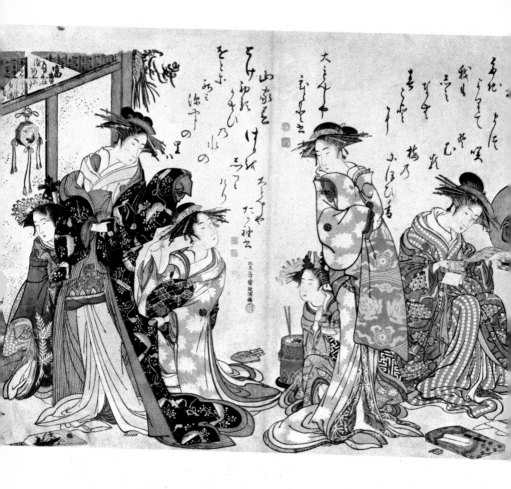

97 *Kyoden (Kitao Masanobu). Courtesans at Leisure.* ca. *1783. The Yoshiwara courtesans Tagasode and Hitomoto in regal splendor, surrounded by attendants. One of a series of seven large color prints of noted beauties of the Yoshiwara, together with verses in their own calligraphy, later issued in album format.*

98 *(Facing) Kiyonaga. Kabuki Scene. 1784. The hero Sukeroku strikes an attitude of defiance in the Yoshiwara, parasol in hand, sword and flute stuck in sash, and flanked by a wine-seller and a courtesan's maidservant. Medium-sized color print.*

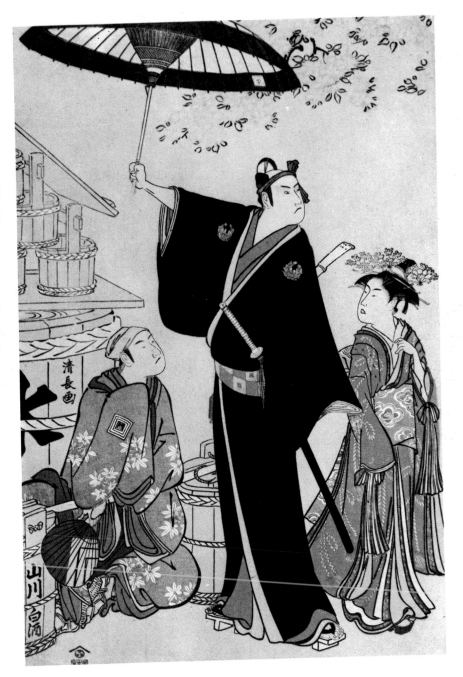

207

we will perceive a revolution in the depiction of Kabuki as important as that produced by Sharaku. The total effect is one of realism rather than idealism, of an actual Kabuki performance on a real stage. It is difficult to imagine what the work of Sharaku might have been without this intermediate revolution.

The scene depicted in Plate 98 is one of the favorites in all Kabuki, the hero Sukeroku parading through the Yoshiwara at cherry-blossom time. He is shown here, parasol in hand, sword and flute stuck in his sash, striking a pose of defiance toward corrupt authority. For Sukeroku is the Japanese Robin Hood, a seventeenth-century figure who had come to stand for the spirit of heroic independence in the midst of a feudal organization which denied all human rights.

Besides the new realism of design and setting, we see in this print most of the other characteristics of Kiyonaga's style. Although indebted to the later Koryusai manner and to Shigemasa, by the late 1770's Kiyonaga was already part of, and soon after leading, the movement toward grand figures and greater naturalism of treatment. Kiyonaga represents, indeed, the culmination of this trend, and was extravagantly praised by the earlier "morality school" of Western critics for "his inherited loftiness of aim and nobility of taste" (von Seidlitz), as well as for his "large-limbed, wholesome, magnificently normal figures as the symbols of his magnificently normal mind" (Ficke). This is all doubtless very true (though one wonders how these critics would have explained Kiyonaga's abundant erotica), but does not necessarily make us *love* the artist. Indeed, for all his perfection, there is a certain perfect dullness about much of Kiyonaga's work, and one may well find oneself turning in relief from his persistent perfection — to such less impeccable but more human contemporaries as Choki, Utamaro, and even Shuncho.

Following the general trend of the times, Kiyonaga discarded the lovely exaggeration and idealism of the earlier artists and strove above all for naturalism in his figures, producing an effect of healthy proportioning which has been aptly compared with the achievements of Greek art. But if there was a gain here in surface accuracy, it does not necessarily mean that Kiyonaga produced greater prints than the earlier artists. For what he gained in naturalism he lost in stylization; his figures have become realistic dolls positioned in real space, the backgrounds most often carefully delineated, the compositions impeccable; but they are certainly less individ-

ualized than the figure prints of, say, Masanobu or Harunobu. One most often is impressed by the composition or the coloring, while remaining cool to the individuals portrayed. Such is the case with Plate 98, which is rather typical of Kiyonaga's middle period in this respect.

With Plates 99 and 100, however, Kiyonaga in his final maturity achieves a rare vision of personal, feminine beauty seldom surpassed in ukiyo-e. These plates date from near the end of his career as a print artist, when he was, perhaps, at last awakened to the importance of that personal spark of animation by such of his followers as Utamaro.

Though this is not so true of Plates 99 and 100—rather exceptional works for this artist—one unexpected effect of Kiyonaga's naturalism is often a greater "masculinity" to his portraits. The frail, dreamlike grace of the Harunobu period is gone; and, conversely, Kiyonaga's men are sometimes more attractive than his women—who, in their excess of naturalism, frequently appear almost desexed. (Perhaps it was this element that so attracted the Victorians to Kiyonaga?) This feature even carries over into Kiyonaga's erotica, where one is most often likely to be interested more by the perfect compositions and lovely coloring than by the curious activities displayed.

For all that he excelled in the representation of stylish young men, statuesque girls, and courtesans against broad and fully realized backgrounds of Edo, Kiyonaga was the head of the Torii school, and eventually had to give up the prints to devote himself exclusively to theatrical posters and the training of Kiyomitsu's grandson as his successor. That Kiyonaga was then truly in his prime we may discern from the masterpiece of Plate 100, published shortly after his official retirement from the print world.

Though we cannot agree with the critics who have acclaimed Kiyonaga as the summit and culmination of all ukiyo-e, that is not to deny his key place in the crucial decade of the 1780's. He invented a new manner of depicting Kabuki realistically, presented a fresh concept of background integration, was one of the great masters of ukiyo-e composition, the first to perfect the unified diptych and triptych, and a fine painter as well. Above all, it was Kiyonaga who decisively formed the style that was to dominate figure prints for a century to come. But he was a giant whose ideal was to be realized perhaps as much in the work of his followers as in his own prints.

Kiyonaga's greatest direct follower was not truly a pupil of his but a

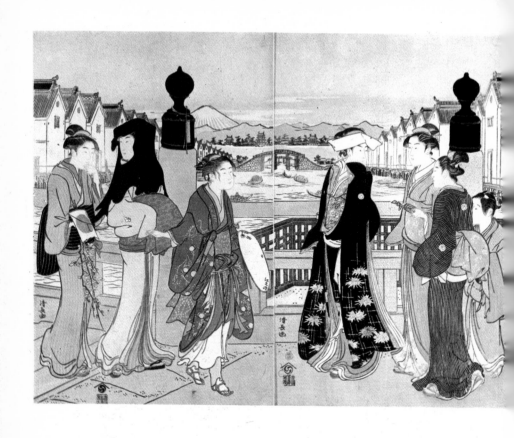

99 Kiyonaga. New Year's Scene at Nihombashi. Mid-1780's. At left, a maid-servant, a matron, and a girl returning from a pilgrimage; at right, a maiden of quality accompanied by two maidservants and a boy. Beyond the bridge are warehouses, Edo Castle, and Mt. Fuji. A diptych consisting of two medium-sized color prints.

100 (Facing) Kiyonaga. Girls Walking. Early 1790's. Two maidens followed by an attendant carrying a potted plant. One of a series on women's customs. Medium-sized color print.

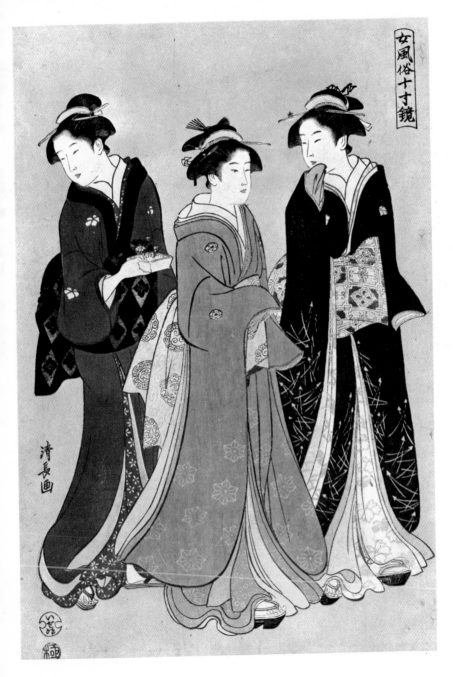

清長画

convert from the Shunsho school. This was Katsukawa Shuncho, who worked from the late 1770's to the end of the century.

Though much indebted to his master Shunsho for his perfect color harmonies, Shuncho found his ideal in the work of Kiyonaga at its peak and seldom deviated from that style. We are accustomed to judging artists according to their originality, and by this standard Shuncho must be relegated to second rank. His actual prints, however, are often quite the equal of Kiyonaga's. They lack the latter's magnificence of concept, but possess a peculiar ethereal quality seldom found in Kiyonaga, and a luminous harmony of coloring that is unsurpassed in ukiyo-e.

Shuncho followed Kiyonaga's manner with a brilliance which, though imitative, frequently charms us more than the greater genius of the teacher. There is, moreover, often a haunting mystery to Shuncho's women, an element unfortunately lacking in Kiyonaga's suave creations. Like Kiyonaga, Shuncho was a master of such difficult forms as the vertical pillar print, the diptych, and the triptych; we represent him, in Plates 101 and 103, with prints each of which probably formed one panel of a set, but which are nevertheless lovely and independent creations in themselves.

Another pupil of Shunsho's who later made Kiyonaga his model was Shunzan, a talented artist who never, however, rose to the achievements of Shuncho in this manner.

One of the most striking figures of this period is Kubo Shumman (1757–1820), who studied with Shigemasa but was particularly influenced by Kiyonaga—though in his mastery of subdued coloring and complex patterns we may perceive the influence of Shunsho and Shuncho as well. If anything, Shumman at his rare best represents an improvement over his ultimate model, Kiyonaga, and this principally through the evocative quality of atmosphere.

This is well displayed in Plate 102, one of a series of six consecutive prints showing scenes of the "Six Tamagawas"—a group of geographically unrelated Japanese rivers each bearing the same name, Jewel River. Besides revealing that subtlety of mood and atmosphere so seldom achieved by his contemporaries, Shumman's print shows his characteristically subdued coloring, in which pale greens and grays pervade the scene, more dominant colors being purposely excluded.

Shumman belongs to that group of fine artists, including Shigemasa and Kyoden, whose prints are scarce because their main efforts were di-

rected rather to book illustration or literature. Shumman, for example, besides his extensive career in the field of ukiyo-e painting, was a gifted writer of light verse, and devoted much of his artistic efforts to the rare gift prints (*surimono*) and illustrated albums which specialized in collecting such verses for publication.

The brief career of Kiyonaga's son and pupil Kiyomasa may be cited here, in passing, as one of the minor tragedies of feudal convention. He revealed considerable talent in his early work in the years 1793–1795, but his artistic career seems to have been halted by his father at that time, so as not to interfere with the succession of Kiyomitsu's grandson Kiyomine—who never, unfortunately, developed any marked talent in the field.

For final mention in this brief chapter on some of the later eighteenth-century masters of female portrayal, we have reserved one whose work was perhaps the loveliest of all, Eishosai Choki—who worked from the 1760's to the early 1800's. In Choki we can perceive myriad sources of influence: Kiyonaga, Eishi, Sharaku, Utamaro—but indirectly, and perhaps most of all, Harunobu. The wonder of it is that though Choki may not be ranked equally with any of the men he studied, in a small number of his finest prints he somehow surpassed them all in the evocation of poetic atmosphere and in the creation of an ideal of feminine beauty that is second to none in ukiyo-e (Plate 105).

One of the loveliest prints by Choki is that shown in Plate 104, a design which might well be chosen to represent all ukiyo-e—even, perhaps, to epitomize Japanese art and ideals in the Edo Period. The scene is a simple one: an innocent girl rests her arm upon a manservant's shoulders as the latter bends to clean the snow off her sandals. What is remarkable is the breath-taking color, the bold and startling composition, the idealized girl—

Overleaf 101 and 102:

(Left) Shuncho. Girls in Country. Mid-1780's. Two ladies from the manor pass a farm girl carrying a water pail and lunch for the field hands. In the background, rice paddies and the lord's mansion. Medium-sized color print. (Right) Shumman. Girls at Stream. Mid-1780's. At left, a lady meets two country girls ladling water. In the background is a rustic house and flying plovers, and to the right, a stream. One of a series of medium-sized color prints depicting The Six Jeweled Rivers.

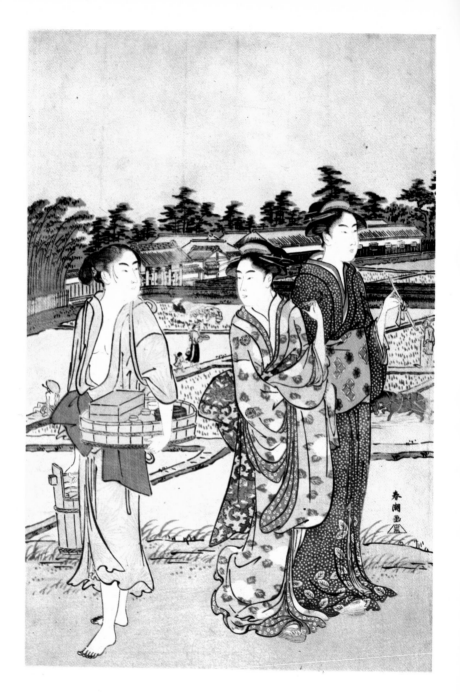

214

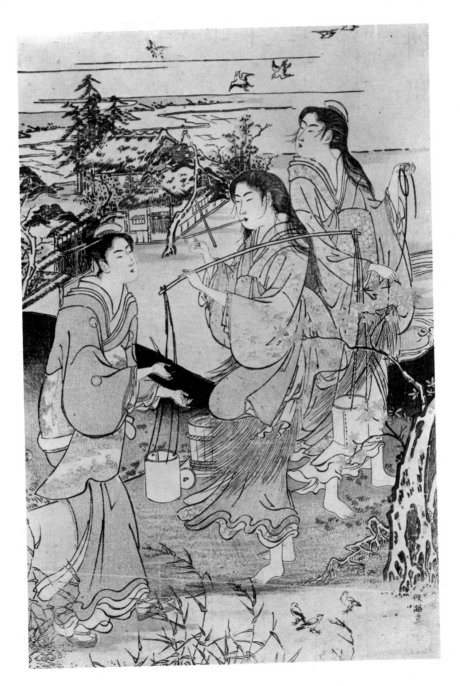

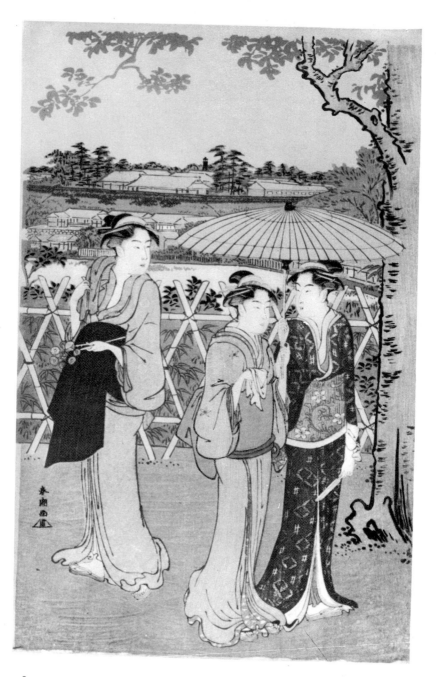

the sum total of traditional Japanese culture wrapped up within the confines of one small print.

Choki's compositional technique is worthy of further comment. Bust portraits had come into fashion with the 1790's and Sharaku made striking employment of two actors' heads in a single print. Yet I know of no artist but Choki who even attempted this difficult compositional form of close-up with secondary figure.

Imagine, for a moment, the print with full-length figures, such as are found so frequently in Harunobu's designs. The picture would still be charming, but hardly so profoundly impressive. What Choki does, in effect, is to give us the total scene with telephoto effect, reduced to its essentials, cut, indeed, a bit beyond the limits any photographer would dare to crop. But it is this very boldness of concentration that makes the print great. Once we realize the situation, there is no longer any need to see the remainder of the pairs' figures, or any more background than the gently falling snow. The picture is complete and inviolable; it is one of the few perfect prints.

103 (Left) Shuncho. Women on Promenade. Late 1780's. Medium-sized color print; one panel of a triptych.

Overleaf 104 and 105:
(Left) Choki. Girl in Snow. Mid-1790's. A girl in her late teens holding a snow-laden umbrella as her manservant cleans off her sandal. (Right) Choki. Firefly-Catching. Mid-1790's. A woman and a little boy engage in a favorite diversion on a summer evening. Beside them winds a stream with irises. Both medium-sized color prints.

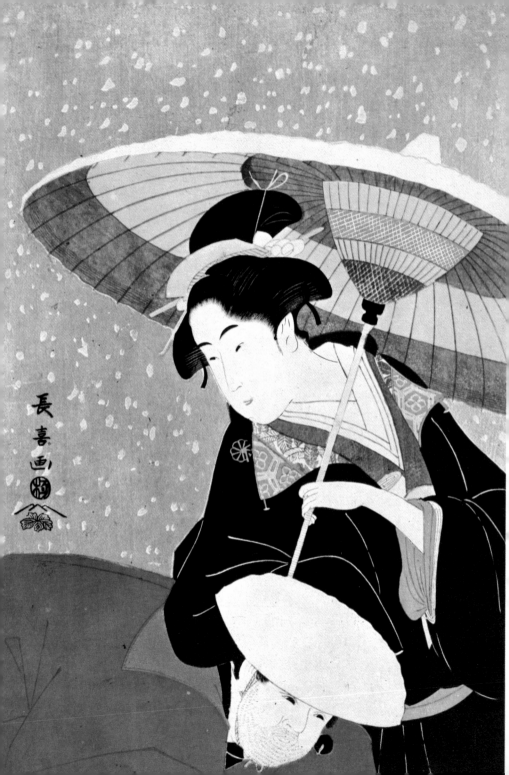

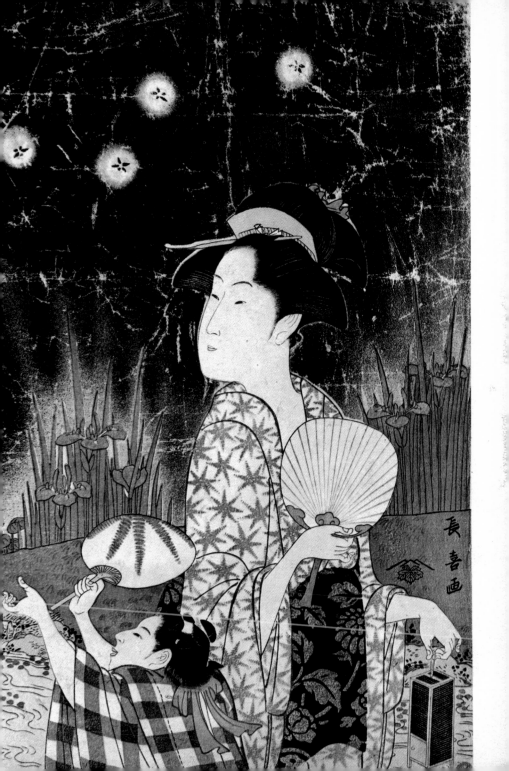

Chapter X

A TOUCH OF DECADENCE

Utamaro and After

THE 1790's mark a peak and a turning point in the development of ukiyo-e. Technically, the color print was at its height despite attempts by the feudal authorities to limit its increasing luxuriousness. With Sharaku and Toyokuni the realistic actor print reached its culmination, and with Utamaro, Eishi, and Choki, the female face and figure received perhaps the greatest and most concentrated tribute since the beginnings of Japanese art. Yet, in view of the decline that figure prints were already to experience in the following decade, we cannot escape the impression that the 1790's represent a brief and final glory before the fall. Whether the trend of the times may be termed decadent or not is largely a problem of definitions; certainly it is clear that ukiyo-e prints, after only a century of full growth, were entering a period of decline, and that, seemingly, even the force of genius could slow but not halt the downward course.

Just as Kiyonaga dominated the 1780's, so does Utamaro rule the decade that followed.

Kitagawa Utamaro (1753–1806) was a pupil of the influential teacher Toriyama Sekien, but owed his greatest debt to Kiyonaga. The first decade or so of Utamaro's published work was devoted mainly to book illustration, culminating in the famous Insect, Shell, and Bird albums of 1787–1791, remarkable artistic tributes to the rising spirit of scientific inquiry.

By the late 1770's Utamaro had already been taken in as protégé by the great publisher Tsutaya, and within a decade had begun to establish his own mature style. To the boldly graceful, lifelike women of Kiyonaga he added a strong element of eroticism based on an intuitive grasp of the

nature of female psychology. It is this element that has made Utamaro the best known in the West of the dozens of able Japanese portrayers of womanhood: his girls and. women speak directly to the viewer in terms of a frankly sensual beauty; and, behind this surface attraction, in Utamaro's finest works we sense the mind of the "eternal female," seemingly oblivious of her own charms, yet well aware of their effect upon her male audience and of their profound influence upon her own life and her concept of happiness. Despite his varied talents Utamaro's fame will always rest principally on this new ideal of womanhood which he helped create—majestic of carriage, elongated of figure, reserved yet subtly erotic in demeanor, rather more feminine than the women of the prints had been since the graceful dreams of Harunobu—but quite another woman again.

Utamaro's most informal prints reveal a freshness that is never quite regained in the more impressive work of his maturity (Plate 106). We see Utamaro at his most typical, probably, in such prints of the early 1790's as the famous bust portraits of courtesans and teahouse girls, poised and resplendent in rich robes, against a luxurious background created by applying mica dust to the prints (Plate 107). Equally renowned are Utamaro's scenes of women at work, and his magnificent murals composed of three to six prints in series. Plate 108, the center panel in a series of five, shows something of both these forms: three girls actively engaged in the annual spring house cleaning. As with most such panels, however, the composition is surprisingly complete in itself; and our wonder at what may have caught the girls' attention (it is a man, of course) only serves to increase the interest of the print. Although the background is filled with the dismounted doors, stacked mats, and scattered bric-a-brac betokening a general house cleaning, it is saved from appearing cluttered by Utamaro's magic sense of design. With an impeccable sense of coloring Utamaro avoids the inherent danger of garishness and overelaboration. The girls are typical of Utamaro's late period—elongated, a trifle stiff, with aristocratic features, but touched throughout with a sexuality all the more effective because they are simple housemaids and not courtesans.

These are but a brief sampling of the wide range of Utamaro's representations of the female form. His work also includes psychological portraits of women in love, idyllic outdoor scenes, Yoshiwara festivals and drinking bouts, beauties from history and legend, pairs of famous lovers, scenes of veiledly erotic mother love, bathers and shell divers, and toilet and boudoir

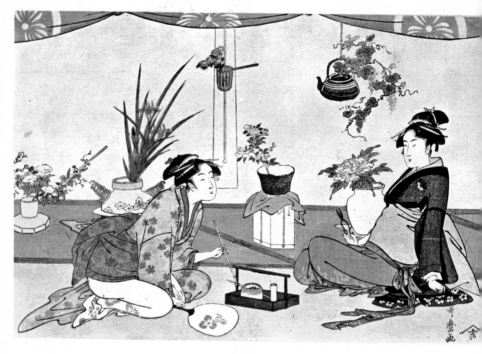

106 Utamaro. Girls Arranging Flowers. Early 1790's Two famous teahouse beauties, Ohisa and Okita, relaxing after a flower-arranging session. Medium-sized color print.

107 (Facing) Utamaro. Courtesan. Early 1790's. The Yoshiwara courtesan Miyabito in a full-dress close-up. Medium-sized color print with mica ground.

scenes galore—in fact, practically all the devices ever invented by Japanese artists to display female beauty, but with many embellishments distinctively his own.

It is no accident that the book in which Edmond de Goncourt discovered Utamaro for the West was subtitled *Le Peintre des Maisons Vertes*. Utamaro is the artist pre-eminent of the demimonde, in both its psychological and fleshly aspects. It is not surprising, then, to discover that he was one of the greatest and most prolific artists of erotica in the long annals of Japanese art. Except for a few works by, say, Sugimura, Harunobu, or Koryusai, there are no prints as effective as Utamaro's in this field.

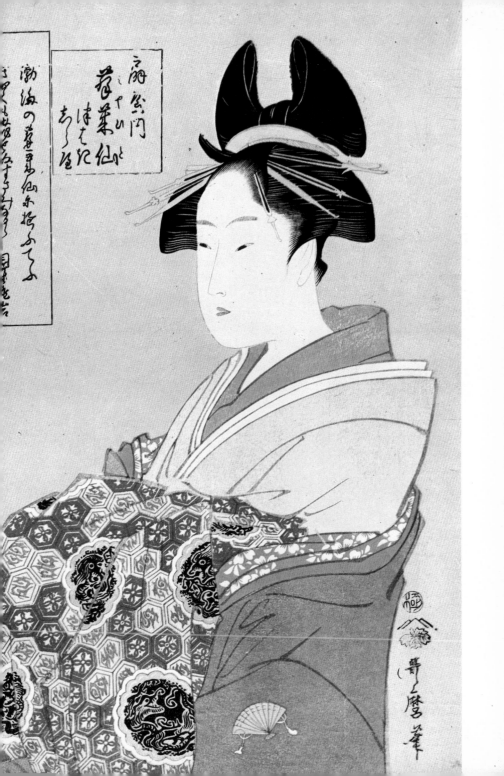

It happens that the introductory plates and frontispieces to Utamaro's erotic books and albums are usually only vaguely suggestive, and hence may be reprinted without difficulty. Such a picture is that shown in Plate 109, frontispiece to what is perhaps the most outstanding of all Utamaro's erotic series. The scene is one familiar to us by now, an intimate (but not too intimate) view of a fair courtesan and her handsome lover in a Yoshiwara house of assignation. The season is winter, as is evidenced by the heavy robes and the brazier at left. The sleeves and skirt of the courtesan's outer robe bear a seasonal design of plum blossoms and courtly caps and fans; in the background is the folding screen that shuts the lovers off from the outer world.

In viewing here what Japanese connoisseurs have often considered the ultimate in idealized figure work—equivalent, perhaps, of the nude in Western art—it is of interest to refer back again to the long line of semi-erotic masterpieces that preceded it (Plates 10, 17, 20, 21, 22, and 82 to cite only a few notable prints with similar motif). And shortly we shall see a gem of Hokusai's middle years on the same theme (Plate 124).

The reader (whether indignant or pleased) may well wonder whether there were no authorities to censor the occasional licentiousness of the ukiyo-e artists and publishers. There was, indeed, an elaborate system of censorship which affected all phases of Japanese life during the Edo Period. Yet so far as publication went, the only real offenses in the eyes of the law were the production of seditious matter and publication without the censor's seal of approval. Production of pornography as such was considered no very serious crime, and as late as Koryusai in the 1770's we still often find artists' true names signed to their erotica. When, indeed, Utamaro did at last run into difficulties with the authorities in the year 1804, it was not for his erotica, but for some uncensored historical prints depicting the sixteenth-century Shogun Hideyoshi, whose heir had been deposed by the current Tokugawa regime, and about whom the governors naturally felt the pangs of a guilty conscience. Utamaro's punishment consisted of a brief term of imprisonment, but he seems never to have recovered from the experience. The prints of his final two years are lacking in power and were often doubtless the work of his assistants.

With Utamaro's decline, the great period of ukiyo-e figure work ended and true decadence set in. There remain, however, a number of notable contemporaries to be discussed, men who had developed in the period of

224

Kiyonaga, but who found their principal inspiration in the greatness of Utamaro.

Utamaro's immediate pupils and imitators were numerous and frequently skillful, yet they contributed nothing new to the master's style, and need only be mentioned in passing: direct pupils such as Kikumaro (Tsukimaro), Hidemaro, Shikimaro, Yukimaro, Toyomaro, and Utamaro II, and such notable imitators as Banki, Sekijo, and Shucho. The greatest of Utamaro's followers was a man named Eishi, who had the most unusual origins of any ukiyo-e artist.

Chobunsai Eishi (1756–1829) was the eldest son of a noted samurai official in Edo; as such his future was assured in the form of a generous annual stipend from the Shogun. Eishi studied painting first under official Kano school teachers, and even served as official painter to the Shogun for several years. Then, abruptly, around the age of thirty, Eishi gave up his noble heritage and turned wholeheartedly to the plebeian ukiyo-e prints which had been his first though hidden love for some years. It says something for the influence and tolerance of the artist's family that he was allowed to make this drastic step down into the masses without complete ostracism or even direct government interference; indeed, he was even allowed to retain his art name Eishi ("He Glorifies"), which had been bestowed on him in admiration by the Shogun himself.

Eishi's early prints date from the period of Kiyonaga's dominance, yet already reveal a refined sweetness that was to remain his trademark. Like his later mentor, Utamaro, Eishi's work was devoted principally to designs of girls, whether courtesans of the Yoshiwara or idealized maidens in idyllic surroundings. There are also prints that fall in neither category, and form one of the most curious aspects of this serene artist's work. Plate 110 shows one such print. It depicts the immortal "Chrysanthemum Youths" of Japanese and Chinese legend—fair young boys who pass their days in an eternal idyl, surrounded by the meandering chrysanthemum stream, sustained forever by its elixir of eternal youth. The concept of this complex legend is rather different from our own symbol of the fountain of youth, and the reader may well wish the lovely figures were girls rather than boys. The picture is, however, a masterpiece both of ukiyo-e ideals and of commercial printing, and the delicate coloring and gauffrage of the chrysanthemums are, if anything, a step beyond the intricate but limited and less expansive craftsmanship of the Harunobu period.

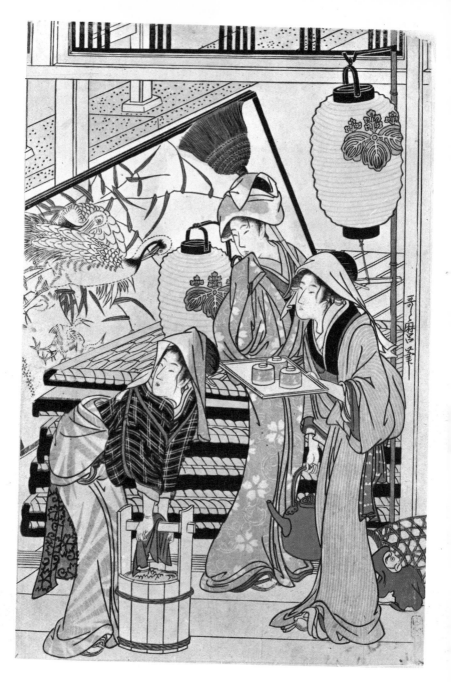

108 (Facing) Utamaro. Maids at House-Cleaning Time. Early 1800's. The maids of a wealthy family are shown in the midst of spring cleaning. Medium-sized color print; one panel from a five-panel series.

109 Utamaro. Lovers. Early 1800's. In a house of assignation a courtesan leans on the shoulder of her lover. Medium-sized color print; frontispiece to an album of erotica.

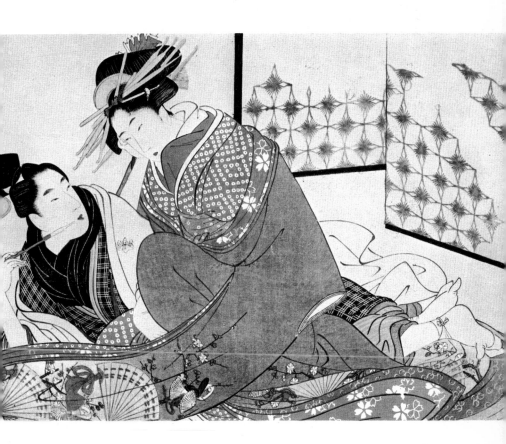

Eishi's prints are almost always at their best in the poetic idyl, of which Plate 111 forms a more worldly example. Here we see girls from an upper-class family engaged in the stylish summer pastime of firefly hunting, an elegant form of recreation popular to this day in Japan. But though the girls are real and the situation, a common one, in Eishi's magic hands a new enchantment is cast over the scene, creating a poetry of mood which nearly equals the rare gems of his contemporary Choki.

With the coming of Eishi's middle years, his work shows a trend toward increasing elongation of the human figure, a style which has disturbed many critics as "abnormal and decadent," but which seems hardly anything to complain of so long as the end result is beautiful. It is of interest, however, to compare the differing aspects of this fashion for svelte figures as revealed in Eishi and Utamaro. Utamaro is universally conceded to be the greater artist, yet as was the case with Kiyonaga, we may find ourselves loving the lesser artist the more. There is no doubt, of course, that Kiyonaga, and later Utamaro, formed the basis for Eishi's style; yet in its final analysis an Eishi print is a world apart from these masters of the robust or the erotic. For Eishi stands with Choki as one of the true aristocrats of ukiyo-e; his work may lack power but never refinement or grace.

Despite his aristocratic upbringing (or in reaction to it) the prints of Eishi's middle years concentrate more and more on the Yoshiwara courtesans, in particular showing them in the variegated costumes of their ceremonial parades through the gay quarter. By the turn of the century Eishi seems to have realized that he was, at the insistence of his publishers and his wide audience, being forced into a rut; at the same time he was doubtless at least subconsciously aware of the over-all decline of the figure print in general at this time. Eishi was no great innovator, or he might have effected a revival, as Masanobu, Harunobu, and Kiyonaga had done in earlier periods; instead, he simply quit the field of popular prints to devote the remaining decades of his life to painting long hand scrolls and alcove paintings of courtesans and life in Edo; these were the delight of the wealthy connoisseurs of the day. One such scroll, showing scenes along the River Sumida, so impressed Eishi's aristocratic patrons that they took this masterpiece all the way to Kyoto and presented it for a special showing before the Imperial family—an honor perhaps never accorded to any ukiyo-e artist before or after.

Eishi's principal activity as an ukiyo-e painter extends for three decades, from the 1790's to his final years; due both to his genius and his " blue-

blood origins," he was accorded far greater acclaim from aristocrats than any other ukiyo-e artist. Thus it is that his paintings are still extant in considerable quantities today. Among them we find such many-paneled masterpieces as his "Twelve Hours in the Yoshiwara," one scene of which is reproduced in Plate 112. It is often, I feel, in such candid works of the painter as this—rather than in the elaborate paintings of a single set figure— that his true nature is best revealed. For in a series such as this we see the totality of the artist's insight into the world he has chosen to depict. It is true genre art, a fresh view of "decisive moments" in the ever-changing world of the gay quarter. We may well be grateful that Eishi had the considerable courage to abandon his noble heritage, renounce a lifetime of tracing conventionalized landscapes of a China he had never seen, and devote his art to painting the subjects he himself treasured and understood best.

Although, coming as he did at the end of an epoch, Eishi did not create any long-lived school, his pupils, though ephemeral, are among the most fascinating secondary figures in ukiyo-e history.

Chokosai Eisho (who worked in the 1790's), for example, brings Eishi's idyllic beauties down to earth, endowing them with a certain robust element that is reminiscent of both Kiyonaga and Utamaro (Plate 113). Eisho's principal innovations in technique lay in his prints which feature large heads of girls; this artist's women lack the aristocratic refinement of Eishi's, but they are sometimes more human, more lifelike, and we may suspect that the sweetly childish, slightly silly look on the faces of his courtesans mirrors, perhaps unconsciously, one strong element of personality to be found in the Edo gay quarter.

Rekisentei Eiri (who worked in the 1790's) represents another facet of

Overleaf 110 and 111:

(Left) Eishi. Fountain of Youth. Late 1780's. Four of the immortal " Chrysanthemum Youths " of Far Eastern mythology pose beside the flower-laden stream of eternal youth. Dressed in Chinese fashion, one holds a saké cup, one a fan, and one seems about to inscribe a verse upon a leaf before setting it adrift upon the stream. (Right) Eishi. Girls on Raft. Mid-1790's. Three girls drift about, catching fireflies on a summer evening. One panel of a triptych. Both medium-sized color prints.

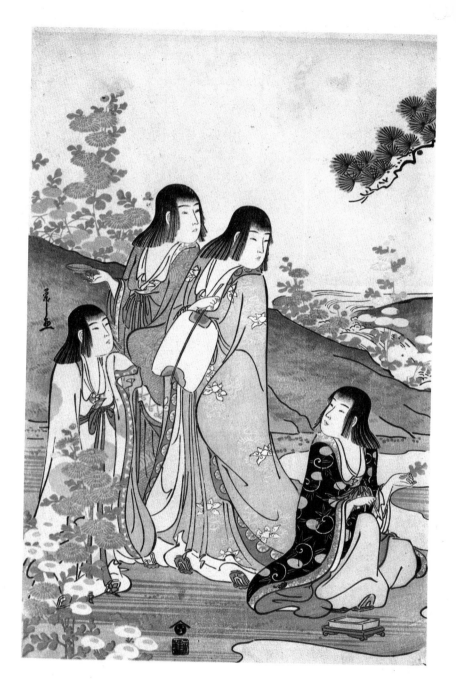

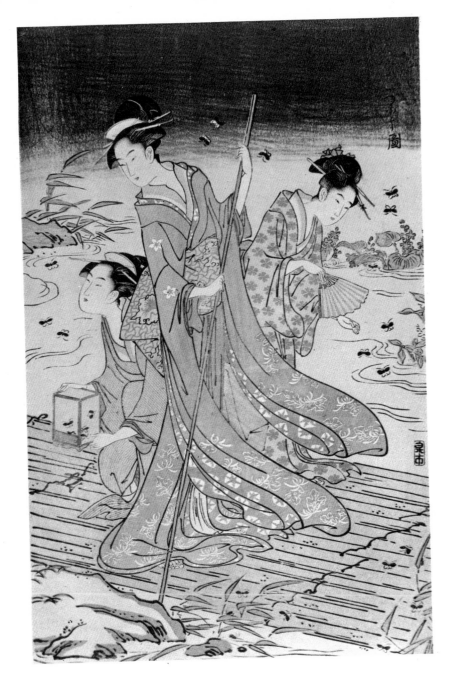

the Eishi manner, but in the opposite direction: his girls are sometimes almost excessively fragile and doll-like, yet on occasion their sumptuous charm approaches that of Choki; and in his sets of "lovers prints" and erotica, Eiri sometimes succeeds in creating a mood of romantic drama rather rare in ukiyo-e (Plate 115).

Of Eishi's remaining pupils we shall mention but one, Ichirakutei Eisui (who also worked in the 1790's); with Eisho, he excelled in occasional large heads of girls such as we see in Plate 114. These prints, though they identify the courtesan by name and address, are not really intended as portraits, but are generalized "pin-ups" for the patrons or, more likely, the would-be frequenters of the Yoshiwara. They bear even less relation to the originals than our cinema posters do to the film itself; yet they do serve to convey a mood and a certain stylized beauty, and we would certainly be loath to trade them for the best realistic paintings or photographs. They demonstrate, certainly, the magic of ukiyo-e art, which can distort and depart so much from reality and yet still express a sensitive human beauty.

From the golden age of the 1790's we must now retrogress briefly to the preceding generation in order to describe the origins and development of a school which was to dominate much of ukiyo-e during its final half-century. This was the Utagawa school, and its founder was Toyoharu.

Utagawa Toyoharu (1735–1814) is, with Shigemasa, surely the most neglected ukiyo-e master of his period. Born in the western regions of Japan, Toyoharu first studied painting in Kyoto. In the mid-1760's he migrated to Edo, where he seems to have become a pupil of Sekien, and possibly of other ukiyo-e masters as well. In the late 1760's and early 1770's Toyoharu produced notable prints of girls and actors, often under the strong influence of Harunobu; soon after, however, he began to develop his real specialty, historical or genre group subjects and perspective landscapes—most often the two combined. In this field Toyoharu may well be considered the main precursor of Hokusai in his maturity.

We have already noted, in passing, some of the occasional appearances of landscape in ukiyo-e, from the early topographical screen-paintings and Moronobu (Plate 16) to the first full-scale development of the perspective print and the landscape-with-figures at the hands of Masanobu and Shigenaga (Plate 52). Even the early panoramas and landscapes of the last two masters may well have been influenced by Western art, for it was just in

that period, the 1720's and 1730's, that the government authorities had allowed the importation of foreign books for the first time in nearly a century. With the mid-century, the methods and styles of Western painting and etching had (often via Chinese imitations) come to be felt more directly by several artists both in and out of the ukiyo-e school. Some of these, such as Gennai and Kokan, made their aim the depicting of Japanese scenes in frankly Western styles, while others, such as Okyo and Toyoharu, strove to create a new form of Japanese art based on a blending of the foreign with the native. Meanwhile, the traditional landscape styles were also being adapted to ukiyo-e by such masters as Harunobu and Shigemasa (Plate 95), with only a minimal degree of foreign influence.

Toyoharu's special contribution to ukiyo-e was the "perspective print" (uki-e), an innovation which, in its primitive form, had been employed as a novelty by Masanobu, Kiyotada, and others a generation earlier. Now for the first time it became a form closely integrated into Japanese art. By the time of the great landscapes of Hokusai and Hiroshige in the following century, the style had become so completely assimilated that Western students first seeing Japanese prints almost invariably settle upon these two late masters as representing the pinnacle of Japanese art, little realizing that part of what they admire is the hidden kinship they feel to their own Western tradition. Ironically enough, it was this very work of Hokusai and Hiroshige that helped to revitalize Western painting toward the end of the nineteenth century, through the admiration of the Impressionists and Post-impressionists.

Overleaf:

112 Eishi. Morning in the Yoshiwara. Mid-1790's. A tired gallant, sword in hand, bids adieu to a weary madam of the Yoshiwara, as the lively tradesmen and mendicants of the quarter commence their morning rounds. Painting on silk; one panel of a long hand scroll depicting Twelve Hours in the Yoshiwara.

113 Eisho. Girls in a Boat. Mid-1790's. A humorous view of girls attempting to draw in a fisherman's net as their boat rides in Edo Bay. Medium-sized color prints; two panels of a series.

114 Eisui. Courtesan after Bath. Late 1790's. The Yoshiwara courtesan Someno-suke with fan in hand and bathrobe half thrown about her shoulders. Medium-sized color print; one of a series of Five Beauties in Season.

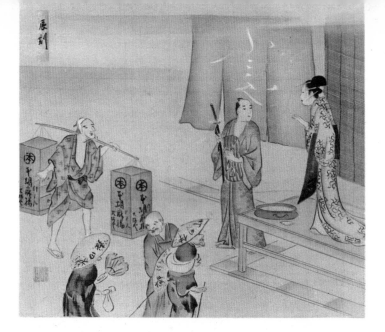

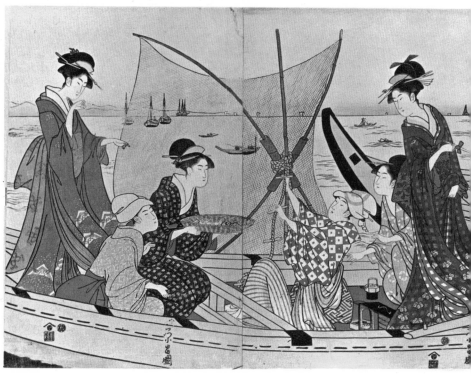

234

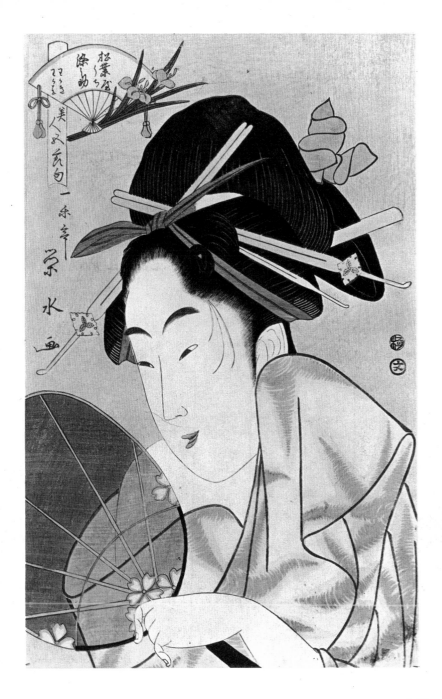

235

To appreciate the change Toyoharu effected in Japanese landscape and panorama prints, we must digress a moment to consider traditional Japanese (and Chinese) concepts of perspective. Somewhat akin to Egyptian art, Japanese perspective was basically subjective rather than optical; the size of an object depended more upon its importance to the design and the purpose of the painting than on its distance from the viewer. This is shown very graphically in Moronobu's topographical scroll in Plate 16, where, since the center of interest must remain the life on the great highway—the basic subject of the scroll—foreground figures and details are made subordinate in size, as are trees, houses, mountains, and anything else that would tend to interfere with maintaining emphasis on the principal travelers. The same method will be found throughout much of early ukiyo-e landscape, yet it follows a definite method and logic, and can hardly be considered distorted—rather might it be termed subjective, or stylized perspective. By the time of Harunobu and Shigemasa, this subjective view had already been insensibly modified by the gradual influence of Western art; Toyoharu was to consolidate the "wide-angle lens" into ukiyo-e, contributing an extremity of optical perspective which, in combination with his mastery of traditional Japanese techniques and subject matter, was to prove the rage of his day.

Although the majority of Toyoharu's perspective prints feature historical or legendary subjects, we have chosen for illustration one of his masterpieces depicting the contemporary world. The perspective print of Plate 116 reveals, as probably no other medium could, the incredible color and confusion of the Kabuki district of Old Edo at dusk toward the end of the year. The foreground, however, is kept relatively clear, the figures carefully selected and placed; aside from its importance to the composition, the latter device serves to impress upon us the vast variety and inherent interest of the mass of heads seen bobbing in the background. The long vista in exaggerated perspective is the characteristic of this type of print. The plate is typical of Toyoharu's best work in that it combines exotic style with carefully assimilated native subject matter, and relates each part to the whole for a unified effect. Certainly this type of print is about as close as we can ever get to knowing the actual teeming, variegated life that occupied the streets of Old Edo.

115 Eiri. Secret Lovers. Late 1790's. Medium-sized color print.

237

116 Toyoharu. Theater District at Night. Early 1780's. The hurly-burly of the Kabuki district of Edo just after dusk toward the end of the year. Actors, playgoers, sightseers, and tradesmen mingle before the gaudy facades of the principal Kabuki and puppet theaters. Medium-sized color print.

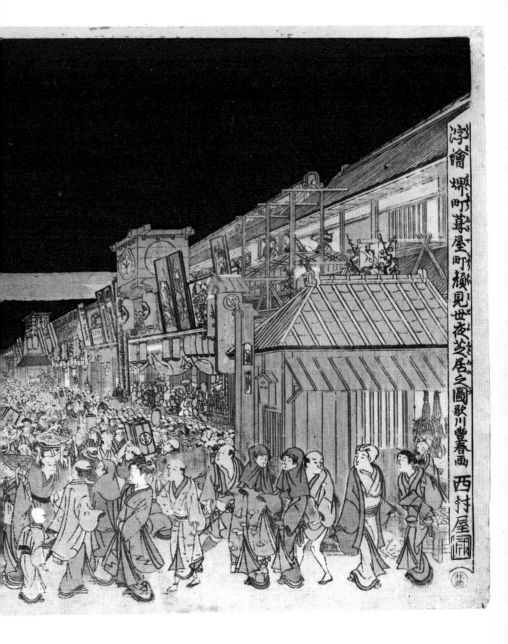

浮繪堺町葺屋町櫪見世夜芝居之圖歌川豐春画 西村屋板

Toyoharu's perspective prints—a bridge, in effect, between ukiyo-e and Western art—were widely imitated by many of the fledgling artists who were soon to become the masters of the following decades; such prints represent a significant, though little-known facet in the early work of such different artists as Utamaro, Masayoshi, Eisho, Eiri, Toyokuni, Hokusai, and several others.

The contribution to ukiyo-e made by Toyoharu's perspective prints is, however, somewhat difficult to evaluate, for the prints themselves were popular principally during the 1770's and 1780's, after which Toyoharu turned to his secondary specialty, sumptuous paintings of girls and courtesans. His contribution to the landscape print—besides the intrinsic merit of his own work—lies chiefly in the prints of his followers. Toyoharu almost singlehandedly created the new popular interest in landscape prints, and at the same time introduced historical and legendary incident as an integral part of landscape; in this sense he might well be considered the father of the two forms that were, with the actor prints, to become the staple of nineteenth-century ukiyo-e. Certainly it is difficult to envision Hokusai's most characteristic work without detailed reference to this much-neglected preceptor.

Although it was Toyoharu who founded the Utagawa school of ukiyo-e, to his pupil Toyokuni must go the credit for making the name known throughout the world.

Utagawa Toyokuni (1769–1825) entered the studio of his neighbor Toyoharu at an early age, issuing his first book illustrations in his mid-teens. He lacked the classical background of such contemporaries as Utamaro and Eishi, having been trained entirely in the ukiyo-e tradition. Toyokuni's most impressive early prints are his dramatic landscapes after the manner of his teacher, such as that shown in Plate 118. Toyokuni was, however, the great eclectic of ukiyo-e, and soon he was reaching out over the whole range of his contemporaries for styles to emulate. He studied successively the work of Kiyonaga, Shumman, Choki, Eishi, and Utamaro in the field of girl prints, and Shunsho, Shun-ei, and Sharaku for actor prints. Plate 119 shows Toyokuni at his best during his "Kiyonaga-Utamaro period." Yet though we speak of Toyokuni's predominantly imitative talent, we must always add

117 Toyokuni. Actor Portrait. 1796. Medium-sized color print.

240

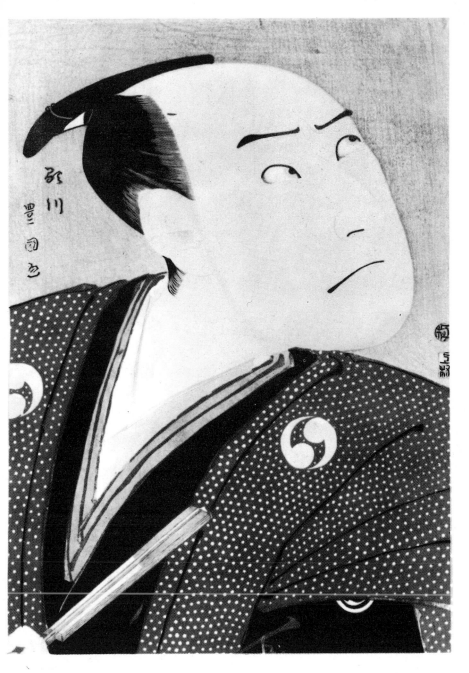

241

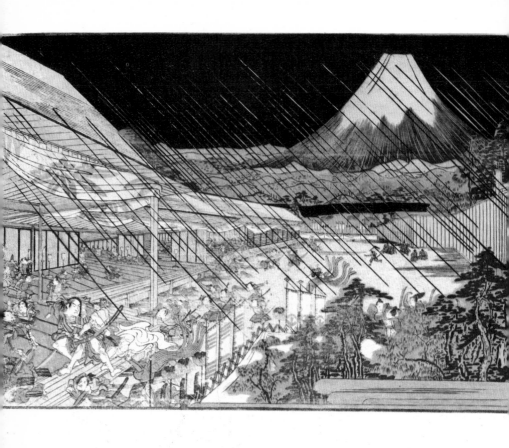

118 Toyokuni. Revenge at Mt. Fuji. Late 1780's. A historical landscape print combining the dramatic vendetta of the Soga brothers against the murderer of their father (lower left) with the ghostly beauty of snow-clad Fuji on a stormy night. Medium-sized color print.

119 (Facing) Toyokuni. Lovers in the Wilderness. ca. 1790's. Clad in sumptuous matching garments, a girl and her lover stroll in the wilds of Mt. Koya. At left, a waterfall, and in the distance a Buddhist temple. One of a series of medium-sized prints of The Six Jeweled Rivers.

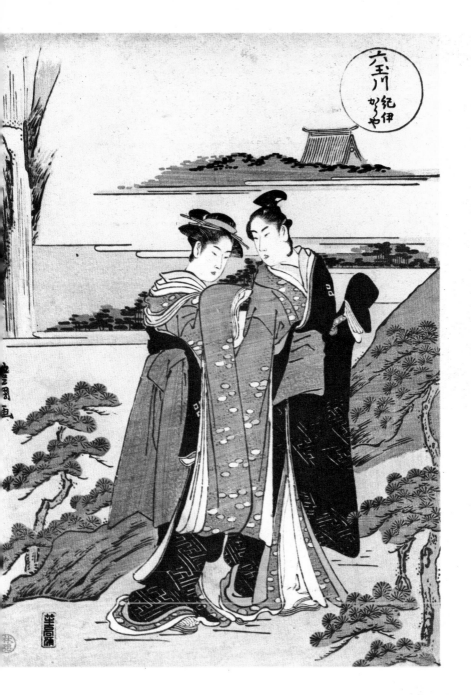

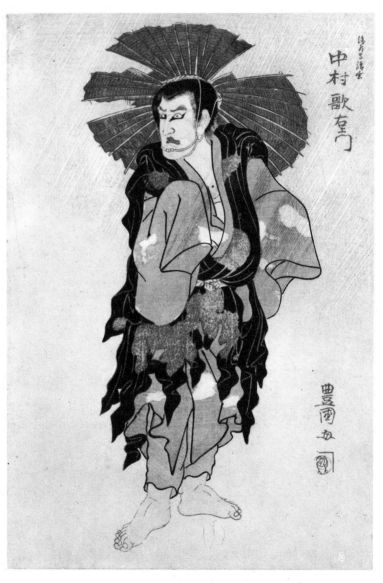

120 *Toyokuni. Kabuki Villain in Rain. 1812. Medium-sized color print.*
121 *(Facing) Toyohiro. Geisha on Veranda over River. Late 1790's. Medium-sized color print.*

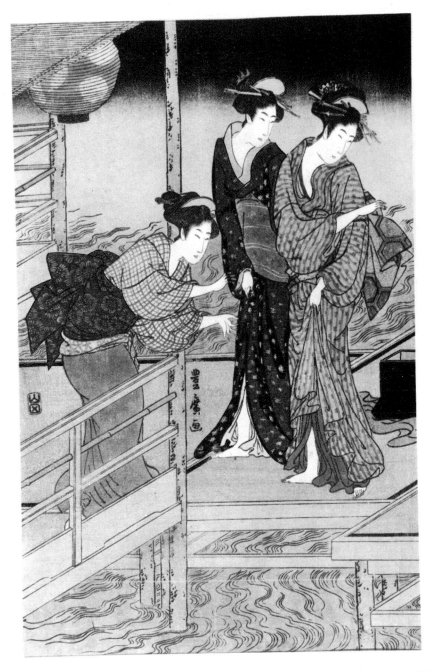

245

that his work, in whatever style, would never be mistaken for another master's, and sometimes, as here, even manages to equal or surpass the original model.

Indeed, it is not so much Toyokuni's tendency to emulate his betters that relegates him to secondary rank in ukiyo-e history as it is his basic insensitivity as an artist. For although he produced many a strong and notable design, Toyokuni seldom succeeded in achieving the grace or delicacy of any of his masters. Thus he is inevitably at his best in work where the bold and coarse form a desirable element—as in some of his historical prints and Kabuki scenes, as well as in a few prints of girls in which the poster coloring compensates for any inherent crudity of insight or design.

Toyokuni worked in many fields, but it was in the portrayal of Kabuki actors that he made his greatest name, dominating the field for nearly three decades. Toyokuni's best-known actor prints are the several dozen minor masterpieces issued in the years 1795–1796 under the title *Views of Actors on Stage*. These, and the impressive "large heads" of actors, pale beside the grandeur of Sharaku's competition in the same months, yet show that Toyokuni could almost achieve greatness under the proper stimulus (Plate 117).

Ukiyo-e figure prints were already moribund before Utamaro died, but in Toyokuni's work the decline with the coming of the nineteenth century is most pronounced of all. Whatever charm he had conveyed in his youth or under the influence of greater men is gone, and what is left is mainly sound and fury, repetitious posturing. (This late work is printed, nonetheless, with immaculate skill, for the artisans retained their craftsmanship long after the great figure designers were gone.) Occasionally Toyokuni does manage to rise above his clamoring world of mass production. But he does this most often in a rare print, such as Plate 120, where a certain coarseness and vapid horror successfully convey the gruesomeness of a macabre Kabuki tableau.

The causes of this decline in the figure print have never been adequately explained, but they clearly lie in a combination of declining talent among the artists, overproduction for a mass audience, and deteriorating taste on the part of the changing print public. The century and a half of

122 *Kunimasa. Kabuki Actor. 1796. The great Ebizo in the dramatic make-up of the role "Shibaraku." Medium-sized color print.*

development of ukiyo-e figure work had seen the prints change gradually from the decorations for a connoisseur's chamber to the "pin-up" for the laborer and clerk; the latter form could, theoretically, have been the equal of the former; in practice, however, mass production led to decline both in taste and in quality, and ukiyo-e figure design of merit survived but fitfully into the nineteenth century, and this far more often in the commissioned paintings than in the popular prints.

A fellow pupil of Toyokuni under Toyoharu, and just possibly a greater artist—though one who never achieved his full potentiality—was Utagawa Toyohiro (1763–1828). Certainly of equal talent with Toyokuni, Toyohiro yet chose to leave the gaudy, popular aspects of ukiyo-e to his confrere, and devoted his life to a quieter, less hurried view of life and beauty. His work is thus relatively rare. The ladies of Toyohiro's prints characteristically display a certain weary detachment, together with a far greater sense of refinement than those of his fellow pupil, a quality which links Toyohiro most of all to Eishi (Plate 121). Toyohiro is best known today as teacher of the great Hiroshige. The former's few landscapes form a necessary prelude to the achievements of his pupil, and there is little doubt that Hiroshige's art would have been quite different without the patient guidance of this humble and restrained master.

Of Toyokuni's all-too-numerous students, several will be noted in a later chapter on the landscape print. The most important pupil who followed him in depicting Kabuki scenes was Utagawa Kunimasa (1773–1810), who began his work early and died young, thus escaping the general decline of his generation. Kunimasa excelled in actor portraits which strove to combine the intensity of Sharaku with the decorative pageantry of his master Toyokuni. He succeeded in the latter attempt but not the former, and thus it has been his inevitable fate to be treated as a "minor Sharaku." Kunimasa may appeal to those who find the biting genius of Sharaku disquieting. Certainly he achieves a more valid portrayal of the bombast and pageantry of a Kabuki performance, whereas Sharaku's genius depicts not only an artistic goal seldom achieved by even the greatest performers, but also the human failings of the human being behind the role (Plate 122).

The myriad pupils of Toyokuni literally overwhelm the final half-century of ukiyo-e figure prints, and it is almost exclusively their work that crowds the shelves of print shops the world over, while the more sought-after

masters are carefully hidden in the dealers' vaults or hoarded in the chambers of collectors. With careful searching and discrimination, however, notable figure prints may be discovered even in the declining days of ukiyo-e. Such Toyokuni pupils as Kunisada, Kuniyoshi, Kunihisa, Kuninao, and such later followers of the Utamaro manner as Eizan, Eisen, Shunsen, Goshichi, well deserve further study by amateurs and scholars. Yet there is no denying that we should be happy to discover an occasional gem in their work, and that the great period of the figure print was gone forever at least a generation before the Black Ships of Commodore Perry battered down the doors of Japanese resistance to the Western world.

"THE OLD MAN
MAD WITH PAINTING"

Hokusai

LONG considered in the West the prime consolidator of the Ukiyo-e school, Katsushika Hokusai was, in fact, practically the last great figure in its development.

In his youth Hokusai (1760–1849) passed through wide and useful experience—adopted first by a mirror-maker, then apprenticed to a woodblock engraver and, later, to the proprietor of a lending library. From childhood on he was fond of sketching, and at eighteen became one of the numerous pupils of Shunsho, the great innovator of stylized realism in Kabuki prints. This early training formed the basis for all of Hokusai's subsequent work, though its influence is often overlooked because of the great modifications he made in its effects.

Within a year of his apprenticeship, Hokusai had produced his earliest extant prints—under the name "Shunro," the first in a long series of pen names. Hokusai's early work was in the direct style of Shunsho, but already almost the equal of the master's in all but originality. Hokusai remained nominally within the Shunsho school for a dozen years, though he soon came to be influenced as much by such contemporaries as Shigemasa, Kiyonaga,

123 Hokusai. Wrestlers. Late 1780's. In a sumo *ring the noted wrestlers Dewanoumi and Kimenzan grapple like amorous pachyderms. Medium-sized color print. Center panel of a triptych; signed with Hokusai's early name "Shunro."*

鬼面山谷五郎
出羽海金藏

勝春朗画

251

and Shun-ei as by his original master. Under the shadow of Shunsho, Hokusai produced a number of notable prints of actors, wrestlers, and girls, as well as many historical landscapes in the pseudo-European perspective-print manner. In his *sumo* wrestlers, done during his period of apprenticeship, Hokusai, though following the manner of Shunsho and Shunko, first found a subject that was adapted to his fascination with the gross and realistic; in Plate 123 we find one of Hokusai's earliest masterpieces, an arresting print which captures the essence of *sumo* and reminds one, more than anything else, of two pachyderms in amorous embrace.

With Shunsho's death in 1795, Hokusai, then aged thirty-five, took the opportunity to escape from the confines of his school and set out on his own. It is traditionally said that he was expelled from the group by Shunsho. If so, it is probable that Hokusai's lack of proper feudal regard for his school led to his expulsion; but this does not seem to have occurred officially until after Shunsho's death, and then principally because of the exposure of Hokusai's period of secret study under the Kano master Yusen. A feudal society could not allow for two lords in any field, whether military or artistic. For Hokusai, however, there could be no such limitations to the range of his study, and throughout the first half of his long career he was attracted in rapid succession by a dozen or more masters and schools, ever striving to produce a truly unique amalgamation of styles—and often almost succeeding.

In addition to the basic concepts of direct observation and stylized realism, Shunsho gave Hokusai a clear grasp of the special qualities inherent in the woodblock print and the most effective use of bold though limited coloring. From the Kano school (a style which Shunsho as well, like many ukiyo-e artists, had studied indirectly) Hokusai learned the importance of brushwork in painting, and acquired the whole world of Chinese imagery that was to flavor so much of his sketching and, unfortunately, encourage some of his dullest work. Hokusai studied, moreover, the ink paintings of the ancient master Sesshu (for a time, Hokusai called himself the "Thirteenth Descendant of Sesshu"), the decorative paintings in the Korin and Tosa styles of his contemporaries Torin, Sori, and Hiroyuki, and the whole range of later Chinese painting, in particular the flower-and-bird, and the figure paintings, of the Ming and Ch'ing periods. In the words of a contemporary, "Calling this the 'Hokusai Style,' he painted ukiyo-e with the brush-strokes of Ming paintings; Hokusai was the founder of the style of Japanese

252

painting modeled on the ancient and modern Chinese styles." We may add that though Hokusai's work in the direct Chinese manner (for example, the famous series of small color prints with birds and flowers) has at times been exceedingly popular in the West, it hardly ranks among his great creative achievements; it will doubtless be relegated to its proper secondary place once collectors come to appreciate the clear distinctions between Chinese and Japanese art, and the special features of both.

Hokusai's eclecticism was not even bounded by the Orient, and he studied Western prints and paintings avidly from what limited materials were available in late eighteenth century Japan. As a pupil of Shunsho he had already in the 1780's designed a number of perspective prints in which a limited conception of Western perspective was applied to Japanese scenes and techniques. And he was often quite equal to the achievements of Toyoharu or Toyokuni (Plates 116 and 118) in bringing this curious style to its logical perfection within the Japanese format. In 1796 Hokusai appears to have had the opportunity of studying under the great pioneer of Western-style painting and engraving, Shiba Kokan, and this was certainly to prove one of the major influences in his later landscapes. For a period in the early 1800's, indeed, Hokusai produced several series of notable landscapes in direct imitation of the manner of European copper engravings, though the subjects and part of the coloring styles were quite Japanese. In this, Hokusai combined the pseudo-Occidental techniques of the perspective prints with the direct-sketching styles of Okyo, Gennai, and Kokan to produce curiously compelling woodblock prints in a basically unpromising medium. None of this derivative work, however—whether following the Shunsho, Chinese, or Occidental styles—ranks as Hokusai's best.

Because he would not subscribe to the concept of allegiance to a single master and school, Hokusai had no easy time of it in the fickle field of commercial art; for a while he was even forced to make his living as a peddler of condiments and calendars. He nonetheless managed to found his first great style just as the other masters of figure prints were beginning to decline. Hokusai's girls of the late 1790's and early 1800's represent the peak of his portrayal of frail womanhood, and all his figures of the period display a tenuous delicacy which harks back to Harunobu—and even more, Buncho—but is nonetheless a modern and original invention. It was during this period, that is, from about 1798 to 1805, that Hokusai produced such stylish love scenes as we see in Plate 124, his long *surimono* greeting prints,

and his finest colored book-illustrations, such as that shown in Plate 126 and in such sustained productions as *Songs of Itako, Views of the Eastern Capital, Views of Both Banks of the River Sumida,* and *Mountain upon Mountain.* During this cycle of his work Hokusai achieves an originality and a naturalness of graceful figure design amidst harmonious landscape elements which he was seldom to capture again in his period of greater fame.

Though he did not quite reach the universality of Harunobu or Choki in his expression of the frailty of idealized womanhood, Hokusai was not far behind them, and had his work ended around 1805, he would be remembered as a first-rate figure artist of equal rank—and mystery—with Buncho or Choki. Hokusai went on, however, for another full generation or more, his tremendous output equaling that of a dozen other artists combined. By 1810, Hokusai's figure drawing, partly under the influence of his Chinese studies, had developed a certain hardness that detracts from its beauty, but his skill as a draftsman, nature painter, and landscapist had increased to the extent that he was certainly the greatest artist of the age in these fields. At the same time, there is apparent an enhanced sense of drama, such as we find in the noted series of *Chushingura* prints (depicting the famous story of the vendetta of the Forty-seven Ronin), one of which is shown in Plate 125.

Hokusai discovered, as we have seen, his first strikingly individual style in the mid-1790's, and this type of frail, wistful female figure was highly popular at the time under the designation of the "Sori style"—so called from one of Hokusai's pen names of the period. In addition to the rare and lovely prints, the exquisite color plates for books of light verse, poetic guides to Edo and the Tokaido Highway (Plate 129), and the elaborate greeting cards and souvenir sheets so popular in those years, Hokusai began receiving painting commissions from wealthy patrons. At least a dozen *kakemono* masterpieces from this early period are still extant, displaying—in addition to their other charms—a dexterity of brushstroke seldom equaled in the annals of ukiyo-e. (For it should be added that, though all the ukiyo-e

124 Hokusai. Lovers. Late 1790's. On a snowy afternoon the Yoshiwara courtesan Azuma dallies with her young lover Yogoro at the window of a house of assignation. One of a series of medium-sized color prints of pairs of famous lovers; signed with Hokusai's pen name "Kako."

255

greats were masters of design and coloring, they often betrayed their origins in the Yamato-e and Tosa schools through a certain relative weakness of brushstroke, visible most clearly in their paintings and sketches.)

Around the year 1805, following his experiments with Occidental techniques, Hokusai began a period of concentrated study of Chinese painting and illustration in connection with the voluminous illustrations he was called on to prepare for the lengthy, Chinese-style "Gothic" novels then in vogue in Japan. He brought a new precision and dramatic power to such works, and his thousands of illustrations show a remarkable consistency of execution. The contemporary importance of the illustrations to these novels will be readily appreciated when we learn that the great novelist Bakin had to be dismissed in the midst of one publishing venture—and another novelist retained—when Hokusai found himself unable to work compatibly with the former.

Shortly after this he began the famous *Manga* sketchbooks, a series whose publication extended from the year 1814 to well after his death. Then for a decade beginning about 1823, Hokusai published his best-known and most unified series of prints, the *Thirty-six Views of Mt. Fuji*, which, with a supplement, was to number forty-six prints in all. Here the sacred mountain was seen from every conceivable distance and angle, in all seasons and moods, a revelation entirely new to ukiyo-e, including some of the true masterworks of Hokusai's career. "Fuji on a Clear Morning" and "The Wave" are justifiably famous, though in their suppression of the importance of man they are not typical of Hokusai's fundamental approach to landscape. Only slightly less famous is "Fuji from Ryogoku Bridge" (Plate 127), which shows a fine balance of interest between the figures and the landscape, a notable synthesis of all Hokusai had learned from both Eastern and Western art. Typical of the more neglected prints from the series is "Fuji from the Aoyama Pine Tree" (Plate 128), a masterful employment of all the most effective devices of the printer's craft.

It is perhaps worth repeating here that Hokusai's great landscapes of this series represent, in a sense, the final assimilation and culmination of Occidental concepts in traditional Japanese art. This hidden perspective has contributed immeasurably to making Hokusai, with Hiroshige, the best loved of Japanese print artists. This subtle Western influence echoes somewhere in the modern viewer's mind as a thing not so wholly alien.

In many respects the Fuji series also constitutes the first real culmina-

tion of the independent Japanese landscape print. Hokusai himself must have realized its significance when he later wrote of this period, "I finally came to understand somewhat the true quality of birds, animals, insects, fishes—the vital nature of grasses and trees."

Hokusai was already seventy-three in 1833 when Hiroshige, thirty-seven years his junior, published his tremendously popular Tokaido landscape series. Hokusai, who had been temporarily satisfied by the success of his own great Fuji series, was once again driven to surpass himself. The result this time was, in the following year, the three-volume picture book *One Hundred Views of Mt. Fuji*, one of his most unified artistic works and the one which (republished in London in 1880) was to have the greatest influence on European art. This work was followed by several great series of prints which marked a new manner for Hokusai, though they never quite matched the achievement of the early, delicate figures or the *Thirty-six Views of Mt. Fuji*. Neither could they revive the public acclaim that had met his earlier works. The world now belonged to Hiroshige, and when Hokusai, "The Old Man Mad with Painting," died a decade later in 1849, his plea to the gods, "Give me but ten years more of life—nay even but five years —and I will become a true artist"—was but a vain wish by a master who could never know, and but seldom achieve, perfection. In the late spring Hokusai died at the age of eighty-nine, with this as his parting *haiku* verse:

> *Even as a ghost*
> *I'll gaily trod*
> *The summer moors.*

Though not too much is known of Hokusai's family life, he seems to have married twice and had several sons and daughters; two of the latter studied painting under his direction and, after unsuccessful marriages, returned at various times to live with their father. Just as in his work nothing is static and he was forever moving from one style to another, so movement marks much of his personal life as well. He used, for example, some thirty-one pen names during his lifetime, each one supposedly signifying a mutation in style or approach. Too, he changed his residence at least ninety-three times (a directory of the time lists him as "residence not fixed"), obviously never satisfied with his current position, whether artistic or geographical.

Hokusai's production was extravangant in more than one respect. During his lifetime he painted well over thirty thousand designs, an average of

125 *Hokusai. The Night Attack. 1806. The final scene of the famous* Chushingura *epic: the long-persevering Forty-seven Ronin attack the enemy's stronghold and achieve vengeance against the villain who had caused their lord's death. Medium-sized color print.*

nearly two works for every day of his long artistic life. He was fond, too, of public exhibitions of his skill, such as dramatically painting a great Buddha on a huge expanse of paper before an admiring crowd of spectators. Though he loved to travel, Hokusai neither drank nor smoked nor ever knew the state of his own finances; he seems to have devoted his life quite literally to art. *Gakyo-rojin*, Hokusai's favorite pen name of his later years, typifies his nature: "Old Man Mad with Painting." His famous declaration in his mid-seventies sums up his character as a painter:

"From the age of six I have had a mania for sketching the forms of things. From about the age of fifty I produced a number of designs, yet of all I drew prior to the age of seventy there is truly nothing of any great note. At the age of seventy-three I finally came to understand somewhat the true quality of birds, animals, insects, fishes—the vital nature of grasses and trees. Therefore, at eighty I shall gradually have made progress, at ninety I shall have penetrated even further the deeper meaning of things, at one hundred I shall have become truly marvelous, and at one hundred and ten, each dot, each line shall surely possess a life of its own. I only beg that gentlemen of sufficiently long life take care to note the truth of my words."

Strangely, though Hokusai on many later occasions equaled the level of his best early figure work at the turn of the century, the average quality declined sharply, and to one who examines his total *oeuvre* there often comes an impression of overabundant production, of indiscriminate energy and too little selectivity. The famous *Hokusai Manga*, some fifteen volumes of random sketches compiled as copybooks for art students, displays a marvelous fecundity and energy, but far too little of permanent value as art. The difficult task of the critic, then, is to provide the discrimination where Hokusai does not, and to attempt to assess the cream of his work rather than the total average, which, though high in draftsmanship and variety, tends to obscure, rather than illumine, his undoubted genius.

Hokusai's primary greatness lies, I feel, in the rare figure prints and paintings of his middle years, and the well-known Fuji landscapes of the seventh decade of his life. Judging these series only, Hokusai stands as a master of two unique styles, each sufficient to place him in the top ranks of ukiyo-e. Whether one can forgive him his lack of discrimination is another matter; the best Japanese critics long relegated him to secondary rank for this fault, and changed their views, I feel, only under the influence of foreign opinion. I myself would tend to see their point, for having once experienced

the tastelessness and crudity of the lower levels of Hokusai's work, it is indeed difficult to view his genius with complete detachment. This is obviously a matter of personal taste, however, and need not lessen our appreciation of the true masterpieces. In short, Hokusai possessed in abundance all the qualities of genius, excepting only discrimination. One has the strong feeling that he would not even understand why we call certain of his works marvelous creations of beauty and others simply products of competent draftsmanship. As I have suggested elsewhere, in whatever he did Hokusai's work is so full of humanity as almost to obscure the true quality of his artistic genius.

For the most part ukiyo-e prints were essentially a product of middle- and upper-class bourgeois Edo, and were accordingly replete with an urbane and cosmopolitan atmosphere. Although Hokusai had mastered this manner perfectly in his earlier works, it seems to have been alien to his own nature; once he had escaped from the restraining influence of his masters, the plebeian, provincial qualities of his character came more and more to the fore. His prints reveal, therefore—more than those of any other ukiyo-e master— the realities of life among the lower classes, without the romantic, sophisticated idealization one finds in artists who had never used their eyes in direct observation. It is this essentially provincial quality of much of Hokusai's late work that has, together with his related lack of discrimination, lowered his stature in the eyes of the traditional Japanese critics. This quality is readily apparent even in comparing Hokusai's work with that of late contemporaries such as Hiroshige. In Hiroshige's landscapes every element is subjected to the over-all mood; travelers become a part of the total pattern and seldom live as separate beings.

Hokusai, however, chose the most difficult goal of any ukiyo-e artist— the depicting of everyday man as an individual amidst the elements, but with a total effect of beauty rather than simple genre realism. He did not always succeed, even in the eyes of his greatest enthusiasts, and it is significant that the prints of Hokusai most often chosen for international recognition—"The Wave," "Fuji on a Clear Morning," "Fuji in Lightning," for example—are least typical of his work, subordinating the human elements to the natural and often omitting the former altogether. To acclaim such works alone is not really to recognize the essential Hokusai, though to know all of him is, as I have suggested above, sometimes to lose sight of his abstract greatness.

126 Hokusai. Rustic Scene. 1798. A bridge near Edo. Medium-sized color print, a plate from an album; signed "Hokusai Sori."

Yet if commonplace humanity is the essential element of Hokusai's theme, design is surely the keystone of his artistry. His human figures may sometimes distract from the total effect, but his sense of proportion never fails, and it is this element, with the daring of his visions of nature, that has made him the favorite of European artists and amateurs alike. Even in the numerous prints that one cannot honestly love, the sense of proportion and the originality of design are always impressive. Among modern Japanese painters and print designers it is common to hear such views as, "Hokusai is the greater; but I love Hiroshige the more"; or, "Hokusai is the greater artist but tires one with his overflowing energy; Hiroshige is the lesser man, but somehow fills one with the greatest delight." Indeed, admiration of Hokusai's impeccable technique is all too often cited as the basis of his greatness, rather than the total impression which really constitutes great art. In any event, Hokusai devoted his long, full life to expressing the world as he saw it: he painted anything and everything; he loved all equally and

without discrimination, whether animal or mineral, whether attractive or not. Doubtless, he would neither have understood nor appreciated our demand for greater selectivity.

Although Hokusai's pupils were numerous, few can be cited as original talents of any great consequence. Probably the most interesting is Shotei Hokuju (worked from the late 1790's to the mid-1820's), who took up and carried out the development of the perspective print that Hokusai had extended under Western influence in the early 1800's (Plate 131). Where Hokusai went on to amalgamate this alien manner with powerful native elements to produce the great Fuji prints, Hokuju was content to devote his work entirely to skillful variations on the traditional style. His early empha-

127 Hokusai. Fuji from Ryogoku Bridge. Late 1820's. In the foreground, travelers cross the Sumida River at dusk by ferry, while in the background, beyond Ryogoku Bridge, looms Mt. Fuji. Medium-sized color print from the series Thirty–six Views of Mt. Fuji.

128 Hokusai. *Fuji from
the Aoyama Pine Tree.
Late 1820's. Medium-sized
color print; from the series*
Thirty-six Views of Mt.
Fuji.

*129 Hokusai. Boys Sweeping Leaves. 1804. "Numazu," from a series of very
small color prints representing the* Fifty-three Stages of the Tokaido.

sis on cubistic forms in landscape, though derived from Hokusai, is one of
the most striking elements of his work.

Shinsai, Hokkei, Hokuba, Gakutei, and Shigenobu are other artists who
leaned heavily on Hokusai for artistic inspiration. Equally imitative—but
with far greater excuse—were Hokusai's two daughters, already mentioned.
Oei (Oi) is the best known of these girls, and worked from the 1810's to the
1840's. Aside from assisting her father in his work, she proved adept at book
illustration and paintings of girls, and produced, as did her father, some of
the more remarkable erotica of the period. Like Hokusai himself, Oei was
unfortunately little concerned with household matters, and thus proved of

130 *Miss Tatsu (Hokusai's daughter). Girl with Morning-Glories. 1810's. On a summer morning, a sumptuously dressed girl, with fan in hand, sits beside the flowers she has just plucked and arranged. Painting on silk; medium-sized hanging scroll.*

small help in keeping his finances in order. Several years after her father's death Oei left her house one summer day and was never seen again.

Another Hokusai daughter, less famous but equally talented, was Miss Tatsu, who painted girls in a manner more delicate but otherwise hardly distinguishable from the work of her father in the 1810's. She seems to have died young, perhaps in the early 1820's, and her work is rare. Plate 130 shows what is perhaps the finest of her extant paintings.

It is doubtless only fitting that the most strikingly individual figure in the Ukiyo-e school should have been almost the last, and that Hokusai, who epitomized the total range of Far Eastern art and combined it with all he

131 Hokuju. Seascape at Choshi. Early 1820's. Medium-sized color print.

could learn of Western painting and prints, should have been the major figure in the introduction of ukiyo-e to the Occidental world. To his own countrymen he had seemed only a prodigious eccentric, but to Europeans of the late nineteenth century he appeared an overpowering genius. Perhaps he was both. At any rate, Hokusai was the first Japanese artist successfully to combine the two worlds into an artistic whole; he formed the necessary bridge between Eastern and Western tastes. It is a pity that this was never again achieved by any artist of equal genius.

VIEW FROM AN ENCHANTED WINDOW

Hiroshige and the Japanese Landscape

IN a dozen years of life among the Japanese people I have seen only five girls who looked as though they came straight out of ukiyo-e — one Moronobu, one Sukenobu, one Kaigetsudo, one Utamaro, one Choki. These girls were not necessarily beautiful, but each possessed to a notable degree the quality each of these artists saw as his ideal. On the other hand, as you travel the highways of Japan or even gaze from the window of a speeding express train, it is Hiroshige who flashes into your mind many times in any day. And this is particularly true when some special aspect of nature — rain, snow, fog, mist — has lent the landscape that poetic sheen which flavors the best of Hiroshige's works.

In a sense it was Hiroshige who really taught us to see the inherent poetry of nature, where the earlier Chinese and Japanese landscape masters had never quite succeeded in reaching the common heart with their more subtle and exalted essays upon the rhythms of nature.

Ando Hiroshige (1797–1858) was the son of a member of the official Tokyo Fire Brigade attached to Edo Castle — a position entailing more ceremony than actual work. He inherited the hereditary post at his father's death in 1809, but passed it on to his own son as soon as he was able. Hiroshige had studied drawing from an early age, including brief periods under a minor Kano artist-friend, as well as painters of the Literati school and the naturalistic Shijo style. Attracted to ukiyo-e, Hiroshige, after failing in an attempt to enter the popular, crowded Toyokuni school, was accepted by Toyohiro in 1811, at the age of fourteen. Although Toyohiro had been

*132 Hiroshige. The Cave at
Enoshima. Early 1830's. Trav-
elers enter the shrine-grotto of
Enoshima Island as a huge wave
beats on the shore. Medium-
sized color print from the series*
Famous Views of Japan.

Toyokuni's fellow student in the atelier of the landscape pioneer Toyoharu, as we have pointed out earlier he had never, despite his talent, achieved the renown of his colleague; this was doubtless due to his own retiring nature and lack of driving ambition.

Hiroshige's early work as a pupil of Toyohiro consists generally of undistinguished actor and warrior prints. In his mid-twenties he shifted to making girl prints in the direct manner of Eizan and Eisen—rather "decadent" artists who had taken the lead by default after the passing of Utamaro. Hiroshige was thirty-one when his master died; for some reason he declined the customary privilege, as the leading pupil, of adopting the name "Toyohiro II" and taking over Toyohiro's atelier. Instead, he turned to a field which had attracted him all along: landscape and nature studies. It was just at this time that Eisen and other figure-print artists were also turning to landscape, and the reason for this was clearly Hokusai's great step in developing the Japanese landscape print as an independent genre.

After a few initial experiments in which he directly emulated Hokusai, Hiroshige was already able, in 1831, to produce his first landscape prints in a unique style. These were the *Famous Views of Edo*, a series of ten prints which served to establish Hiroshige's name almost overnight. In the striking qualities of the bold, unconventional compositions and the Occidental overtones, Hiroshige was certainly indebted to Hokusai; but the rare and sustained poetic mood was clearly his own innovation, and one which was thereafter always to distinguish his finest work. In the following year, Hiroshige really hit his stride, beginning the production of such a masterly series as the *Famous Views of Japan*; Plate 132, from this series, will show both his superficial indebtedness to Hokusai and the elements of sinuous grace and forceful beauty of coloring he contributed from his own genius.

Already in the next year Hiroshige had begun his first and finest version of the *Fifty-three Stations of the Tokaido*. It was probably his greatest single production, and the one that was to bring both enduring fame at home during his lifetime and world renown in a later generation.

The Tokaido Highway between Kyoto and Edo, though established in early times, rose to prominence in the beginning of the seventeenth century with the selection of Edo (now known as Tokyo) as the military capital of Japan. Officially, the highway was provided for the visits of attendance by the various provincial feudal lords; but the average travel-loving Japanese also profited greatly by its development. Where the wealthy traveled by

palanquin or horse, the average man went by foot. The trip was not always an easy one, requiring up to two weeks for the three hundred-odd miles between Edo and Kyoto; but it offered a variety of adventure otherwise denied the citizens of a nation which had purposely cut off intercourse with the outside world. In the richly varied traffic of the highway—the great daimyo processions, pilgrims, messengers, itinerant priests, merchants, and entertainers—the wayfarer could obtain a broad view of Japan in miniature; and in the pleasures of the road—the new and lovely sights and tastes, the hot bath at dusk and the pleasures of easy and willing female companionship in the evenings—he could enjoy both physical and aesthetic stimulation. So it was that around the great highway grew a body of legend, an aura of romance, that suffused even wayfarers who had traversed it many times. And thus grew increasingly the market for guidebooks and pictorial maps intended for those planning the trip, as well as prints and paintings for those who could not go.

The Tokaido Highway was divided into fifty-three convenient stages or rest stops, with inns and restaurants at each. Both factual and fictional guidebooks and scrolls devoted to the sights of the highway were already popular in the seventeenth century, and we have seen in Moronobu's Tokaido scroll (Plate 16) perhaps the finest example of this work now extant. However, the Tokaido was rather slow in breaking into the prints, if only for the reason that, prior to the nineteenth century, a full set of the fifty-five prints (the fifty-three stations plus the cities of Edo and Kyoto at either end of the highway) would have been beyond the means of the average citizen, and representations of portions of the highway might not have been very meaningful to a citizenry interested primarily in the subject matter rather than in the art itself.

As prints came to be mass produced for a more plebeian audience, however, their price (and quality) fell, and more extensive series on a particular theme became possible. At the same time, and even more important, interest both in travel and in the various details of Tokaido life increased, and the way was paved for a Tokaido "boom" in both literature and art. In literature the most notable production was Ikku's famous *Hizakurige* ("By Foot along the Tokaido") of 1802–1809, a novel which related with great wit the ribald adventures of a pair of Edo rascals on a trip to Kyoto. In art, Hokusai, the great innovator of the independent landscape print, was probably the first popular artist to depict the Tokaido extensively. We

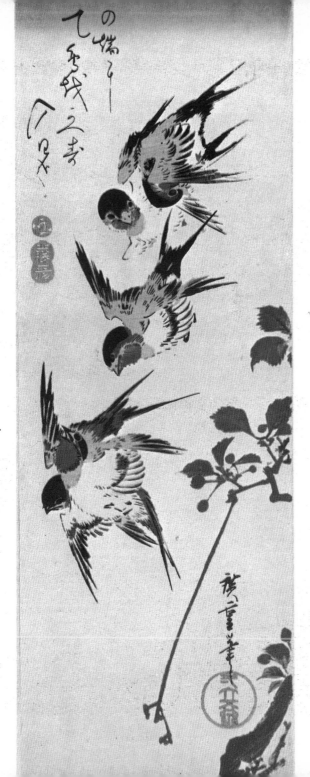

cing page: 133 and 134.
(above) Hiroshige. Rain at
ono. ca. 1833. Wayfarers
d palanquin-bearers scurry
m a sudden shower. From the
ies Fifty-three Stations of
e Tokaido. (Below) Hiro-
ige. Pine Tree in Rain.
. 1834. The ancient pine
e of Karasaki, sheltering
shrine beneath its stilt-
pported branches, stands
ooding in the heavy night
n. From the series Eight
iews of Lake Biwa. Both
dium-sized color prints.

5 Hiroshige. Birds in
ight. Early 1830's. Five
allows fly joyfully past a
anch of cherries at dusk. Small
or print.

have already seen in Plate 129 an example of one of his early series of *Fifty-three Stations of the Tokaido* But these remarkable series were produced at a period when Hokusai was still placing primary emphasis on his figures rather than on landscape, and probably his greatest influence on Hiroshige was mainly in the Tokaido and related scenes in his great Fuji series, created during the decade preceding Hiroshige's first major work. The more restrained, simplified landscape prints of Hokusai's pupils, Hokuju and Shinsai, may also have been a strong influence on Hiroshige's style. We may add that Hiroshige's own teacher Toyohiro had also produced a series of Tokaido prints, but that these show surprisingly little direct relation to the pupil's later work.

It was in the Eighth Month of 1832 that Hiroshige had begun his first tour of the Tokaido Highway—as a minor retainer in an official mission of the Shogun to the Kyoto court. Hiroshige's duties appear to have included the painting of certain ceremonies involved in the mission—a commission doubtless resulting from his status as a former official of the Fire Brigade rather than any governmental recognition of ukiyo-e. The most significant results of Hiroshige's sketches along the way were his great print series, the *Fifty-three Stations of the Tokaido*. These designs began to appear shortly after his return, and in their unique combination of romance and realism set a new trend in Japanese prints and proved, at the same time, a tremendous success. Hokusai, as we have seen, was at this time spurred to even greater efforts in the landscape field, but could never regain his old popularity. Thus, in the same year that an old star fell, a new one rose.

The fifty-five prints of the series were first sold separately, but on their completion in 1834 they were issued as an album, complete with preface and colophon. Despite a number of guidebooks and scrolls and Hokusai's skilled but somehow impersonal depictions of the region, this was the first time that the viewer of a Tokaido print could feel that he really knew the great highway. There was a human touch that no artist of the school had heretofore achieved; these pictures revealed a beauty which seemed somehow tangible and intimate, even to men who had hitherto thought little of nature's wonders.

Plate 133 shows one of the dozen or more masterpieces of Hiroshige's first Tokaido series, and possibly the finest of them all. We glimpse here a forceful union of images of temporal man and eternal nature that Hokusai could but seldom achieve. Though one of the most active of Hiroshige's

compositions, there is yet a restful beauty to the landscape and coloring that remains in the mind even after the memory of the human figures has departed. We recognize it as a scene that could occur at any moment—even though it seldom does; we feel a rapport between ourselves and the scurrying, anonymous figures, for like ourselves they are part of a landscape that will remain long after they are "out of the picture."

Despite its venerable tradition in Chinese and Japanese painting, before Hokusai and Hiroshige landscape had served in the prints mainly as a background for figures. Occasionally, as in Plates 52 and 95—which were both parts of series devoted to famous localities—there is emphasis on both. Hokusai was the great innovator of the pure landscape print; Hiroshige, who followed him, was a less striking personality but an artist who frequently achieved equal masterpieces in his own calm manner. Hokusai's approach is the more austere and realistic, and closer to the Chinese styles that he had studied. Hiroshige lacked Hokusai's broad and yet intensive training in many styles, but created his own genial, poetic view out of the tradition of Japanese popular painting.

Hiroshige's prints, despite their basis in actual sketches, are far from being realistic in a superficial sense; one seeks in vain the actual scenes he drew. Moreover, he adapted and altered not only landscape details but also the very seasons (on his first Tokaido journey he had seen only the autumn) to suit the particular mood he envisaged. Yet we are not exaggerating when we speak of seeing any number of Hiroshige scenes in any day of travel beyond the Westernized districts of modern Japan. He had absorbed Japan's beauty, both natural and human, into his subconscious, and it was this ideal image that found expression in his evocations of specific scenes. At the urging of his publishers he was to issue, in various periods, several dozen other series of Tokaido prints. Each contained its share of fine prints, but none was ever to equal the first in unity of conception and general excellence.

About the time that he had finished his first Tokaido series, Hiroshige designed a small group of pictures that was to achieve nearly equal renown, the *Eight Views of Lake Biwa*. These scenes, transposed from a classical Chinese poetic and artistic theme, had been popular in Japanese art for several centuries (an early print by Shigenaga on this theme is illustrated in Plate 52). Hiroshige's new series shows considerable influence of the Literati school of landscape painting, and he seems to have taken special efforts to produce his unique effects through the use of as little coloring as possible.

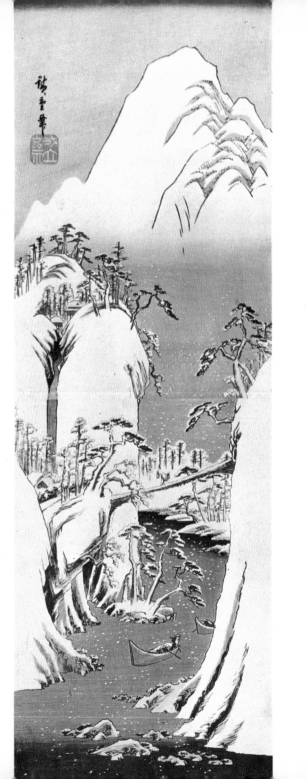

136 Hiroshige. Mount
Gorge in Snow. Early 184(
Boatman and woodsman
dwarfed by the towering mo
tains of the upper reaches of
River Fuji. Large color pr

Plate 134 shows the greatest in the series, a print standing with Hokusai's "Fuji on a Clear Morning" as an eternal tribute to nature little influenced by man. As with much of Hiroshige's most appealing work, it is the more spectacular forces of nature—snow, mist, rain—which lend the final enchantment to a graphic composition anchored on a bedrock of natural quietude.

Other remembrances of Hiroshige's Tokaido trip were soon to appear, notably his celebration of the ancient capital in the ten prints *Famous Views of Kyoto*. Hiroshige was, however, normally at his best in painting unexploited themes. In depicting the Imperial capital Kyoto, he succumbed to the temptation to utilize traditional artistic conventions and to employ designs derived from guidebooks. He may even have been compelled to do so either by his publisher or by the knowledge that those familiar with so well-known a spot would demand a greater accuracy than they would for less celebrated scenes along the Tokaido. Perhaps he was thinking of the type of critic who says, "Yes it's a nice design; but of course you can't actually *see* Mt. Fuji from that spot." Hiroshige, particularly as a designer of prints for highly popular circulation, was doubtless dogged by such critics throughout his career, and this may well have contributed as much to the curtailment of his imaginative powers as did overwork and natural factors. Whatever the causes, it is only natural that the more Hiroshige attempted to design realistically, the less successful were his over-all compositions and the total effect of the moods he was attempting to convey. His was the difficult task of depicting actual scenes with sufficient accuracy to identify the place and satisfy critics, yet create a poetic masterpiece of sustained mood and impeccable composition. It is a wonder he succeeded as often as he did.

Hiroshige's sudden arrival at mastery after more than two decades of largely undistinguished work extended to several fields. In the same year that he commenced his first Tokaido prints, he also began his important works in the field of flower-and-bird prints—another area where Hokusai then reigned almost supreme. Plate 135 shows one of the finest of Hiroshige's works in this time-honored genre of Far Eastern art. I myself feel that nine-tenths of Hiroshige's prints in this field are too saccharin and sentimental to rank with his major works; however, in the example shown, the coloring and approach are more restrained and the total effect is one closer to nature than the sweetened image that pervades much of this genre. Even so, Hiroshige's sentimental birds and flowers are usually preferable to Hokusai's frequent descents into unnatural realism when the latter essayed the same field.

Neither artist, however, ever quite achieves the heights of his forerunners in China, Korea, and Japan, many of whom used the simplest of mediums—black ink on paper—to create a living world of nature unequaled by more elaborate methods.

Although Hiroshige's most impressive individual works date from his first few years as a landscape designer, it was not until about 1838 that he was able clearly to escape the influence of earlier landscape views of Japan. His *Eight Views of the Suburbs of Edo*, and the *Sixty-nine Stations of the Kiso Highway* are notable works of this period, though they never quite equal the sustained level of the first Tokaido series.

Hiroshige's coloring is one of his acknowledged charms, yet shades of black, gray, and white predominate in many of his finest compositions. He surrounds us today with such a variety of inferior greeting-card miniatures that it is easy for his more casual admirers to grow tired of him without realizing just why. With all the print masters there can be no substitute for studying the original in an early edition; with Hiroshige this is most mandatory, for his woodblocks were used by avaricious publishers for thousands upon thousands of printings, even well after they were worn down. In Japan, Hiroshige impressions are classed in nine grades, but the average collector is lucky to acquire even a medium grade in fine condition—though even this may differ greatly from the first impression. Often the first impression was the only one made with special care and under the artist's supervision, frequently for distribution among the connoisseurs of the time.

When Hiroshige was forty-four, the Tempo Era reforms (1841–1843), which again attempted to alleviate the financial and other difficulties of the Japanese government through austerity edicts and the like, had an unfortunate influence on his work: popular demand forced him at first to turn from landscapes to historical prints, and then, when the reform had failed, to the girl prints which were once again the vogue. Though the government policy principally banned elaborate or extended editions and prints of actors and girls, the resulting sudden rise in popularity of historical, didactic, and warrior prints forced Hiroshige into works far from where his strength lay. Publishers' demands for landscapes soon mounted again, however, and either Hiroshige was unable to say no, or else his mode of life demanded quantity production to gain him sufficient income; whatever the reason, the general quality of his work declined sharply, though from the thousands of prints he produced in his late years, enough still stand as masterworks to

prove that he had certainly not lost his inspiration (Plates 136, 137). During this period Hiroshige also received a daimyo's commission to paint a number of landscape scrolls; however, though his paintings are skillful enough, all too often they fall back (perhaps by the nature of his official commission) upon traditional Kano methods and coloring, and reveal little of the artist's genius for massive design and bold color effects.

We have commented several times on Hiroshige's popular triumph over Hokusai, yet one doubts that there was ever any feeling of rivalry on the part of the younger man. Hiroshige's work is far closer to the artist's own nature than is that of the complex and eclectic Hokusai. Hiroshige owed much to the old master, but seems to have absorbed this debt in the natural process of maturing during the years of Hokusai's great landscape prints. With Hiroshige, one gets the impression of a largely self-taught artist who limited himself to the devices and capacity of his own nature. Hiroshige thus studied—and suffered—far less than Hokusai; in his lifetime he produced but one distinct style, and followed it to his death. He did not pretend to be versatile or a genius; he preferred to enjoy life rather than take solitary pleasure in an abstract god of art. In his later years, Hiroshige produced far more than he could do with any regard to quality; but this was simply to meet the demands of clamoring publishers and his own financial requirements—not, as in the case of Hokusai, to fill a gnawing inner need for continuous artistic expression.

Thus, by all odds, Hokusai should be classed as a rare and wonderful genius, Hiroshige as a popular craftsman of but moderate talent. This is not, however, the case.

Though we readily admit Hokusai's genius, we do not always love him for it; though we recognize that Hiroshige was lacking in the outward personality of a genius, we find a peculiar pleasure in his work, and in the end must conclude that his real masterpieces were quite the equal of Hokusai's—and just as numerous as well. For though Hiroshige lacked Hokusai's immaculate draftsmanship, he possessed a rare vision of nature as poetry; when he had the time to evolve his theme at leisure, his inspiration, his evocation of the totality of a mood, is unsurpassed in any art. When, however, he is forced to work without inspiration, the results are but mediocre, well below the always admirable draftsmanship of Hokusai. In a word, Hiroshige was inspired by total moods, Hokusai by total compositions. The poet was at a loss without inspiration, whereas the draftsman was not.

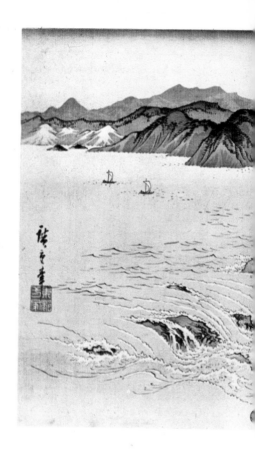

137 Hiroshige. The Whirlpools of Awa. 1857. Triptych consisting of three medium-sized color prints; one of a set of three such landscape triptychs.

It is a rare print of Hokusai's in which the total mood overpowers the design; with the best of Hiroshige the mood always comes first, and the design follows. In Hokusai, surface movement dominates, whereas Hiroshige moves through an inner emotion. Hokusai's pictures are full of the artist; Hiroshige confronts us directly with nature.

Like Hokusai, Hiroshige was fond of travel, but there the resemblance largely ends. Hiroshige loved wine and good food, and in his other tastes was a true citizen of Edo. Dying, he did not, like Hokusai, demand of heaven additional years to prove his greatness. He only enjoined his family to refrain from excessive funeral ceremony, quoting an old verse that well expresses the hedonism of Old Edo:

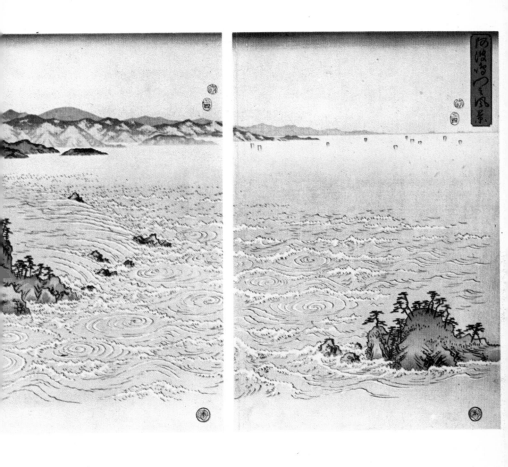

> When I die
> don't cremate me don't bury me:
> just throw me in the fields
> and let me fill the belly of
> some starving dog.

Hiroshige's own final verse went:

> Leaving my brush behind
> in Edo
> I set forth on a new journey:
> let me sightsee all the famous views
> in Paradise!

Hokusai and Hiroshige are quite justly chosen by critics to epitomize the final half-century of ukiyo-e's greatness. This same period saw the peak of popularity of the prints among the general populace, with a consequent multiplication of skilled artists to fill this need. Thus, the critic approaching the nineteenth century is always faced with the problem of dealing with masses of secondary figures, several of whom were once considered at least the equal of Hiroshige, and some of whom are even today the favorites of certain Japanese and foreign collectors—though often for reasons other than artistic. Although I do not agree with the harsh critics who dismiss the whole nineteenth century with the exception of Hokusai and Hiroshige, it must be admitted that few of its artists stand equal in genius to the masters of the first century of ukiyo-e prints. That this was entirely the fault of the times, I rather doubt.

Toyokuni was the popular giant of the new ukiyo-e, and just to list his pupils would take a full page. Two, however (in addition to his early pupil Kunimasa, already discussed), stand out as nearly the equal of their master; which is to say that their artistic failures outnumber their successes, and their fame was greater in their own day than it is likely ever to be again.

Kunisada (1786–1865), like all the pupils of Toyokuni and Toyohiro, bore the art surname Utagawa, and the whole Utagawa school in the nineteenth century bears the mark of the stereotype into which Toyokuni had sunk following the death or retirement of his betters at the opening of the century. Kunisada, who had also studied the style of Itcho, was the most famous and prolific figure-print artist of his day, and he is still admired by Japanese connoisseurs of the decadent days of Old Edo—particularly for his prints of courtesans and for his erotica. (We may add that the latter genus flourished as never before, reaching the lower strata of Edo society now probably for the first time, and appealing more and more to tastes less and less artistic. Even Hiroshige was induced into the genre, with the results probably the most inept of all his work.) Kunisada is easily dismissed by the casual admirer of the earlier masters, but it must be admitted that through-out his long career he produced huge quantities of courtesan and actor prints consistently more adept than that of any but one or two of his rivals; and his work as a whole doubtless better typifies the neurotic and unstable tendencies of his age than that of any other artist. At the same time, Kunisada's rare landscape prints reveal a talent far more universal than that we glimpse in his figures. It is of interest—though somewhat chilling—to

imagine the results had their publishers or popular demand forced Hiroshige and Kunisada to change places in the print world. Kunisada would certainly be the better known today, even though his actual achievement in the landscape had never approached that of Hiroshige.

Kunisada's great fellow pupil in the atelier of Toyokuni was Utagawa Kuniyoshi (1798–1861)—who should not be confused with the modern Japanese-American painter of similar name. Kuniyoshi might well be cited as the last important active figure in traditional ukiyo-e, though he himself, in his frequent experiments at consolidating Western styles, also pointed the way to the inevitable future direction of Japanese art in general. Kuniyoshi rather resembles Hokusai in his intense study of many styles and masters— from Toyokuni, Shuntei, Torin III, Zeshin, and European etchings to the works of Hokusai himself.

Kuniyoshi's great forte was the historical print—particularly the powerful portrayals of ancient warriors in violent combat. In this field he certainly reigned supreme in his age—though before judging his rank in the whole range of ukiyo-e, one had best compare his work with the less bombastic but even more effective warrior prints and book-plates of Moronobu and his fellows during the beginnings of ukiyo-e. (Compared with the great Japanese battle scrolls of the medieval period, Kuniyoshi's work in this field would certainly fall even further.) Battle scenes and prints of bloody combat have never, somehow, appealed strongly to the modern rediscoverers of ukiyo-e. These are, after all, mostly early historical scenes, representing figures in an age the artist knew only indirectly; they are "ukiyo-e" not in subject matter, but mainly in the sense that they appealed strongly to the *audience* of the floating world.

Kuniyoshi's efforts in two other fields, satire and landscape, have more significance to us today. Satire had been a minor element of Japanese art throughout its course, a mild outlet for emotions all too often suppressed in a predominantly feudal society. The gradual weakening of the feudal government—evidenced in the failure of the aforementioned Tempo Era reforms—led to the increasing appearance of satire in ukiyo-e, and Kuniyoshi was perhaps the greatest master of this genus. Once, when he went too far in his lampooning, he was punished by the government for such prints; the fact that this put no damper on his efforts speaks both for his own strength of character and for the weakness of the declining feudal government. Of greater artistic interest than Kuniyoshi's political cartoons are

138 Eisen. Bridge on the River Ina. Mid-1830's. At Nojiri, torrents cascade be-neath a bridge famed for framing with its undersur-face an imaginary view of Mt. Fuji. Medium-sized color print from the series Sixty-nine Stations of the Kiso Highway.

such print satires as that shown in Plate 139, where the traditional transform-
ations possible to bewitched Japanese foxes are displayed after the manner
of a Kabuki rehearsal. But despite the interest of Kuniyoshi's historical and
social prints to students of Old Japan, as an international artist he—like
Kunisada and Eisen—must stand or fall on the quality of his landscapes.

Compared to other contemporary specialists in the figure print, Kuni-
yoshi produced a relatively large number of landscapes, though they some-
times combine a historical element that was omitted—doubtless on pur-
pose—by Hiroshige. Plate 140 shows the most famous of Kuniyoshi's land-
scape prints (a work which would be far more impressive if we did not
know that he had lifted the background, unchanged, out of a book illustra-
tion by the Kyoto artist Bumpo). Though they are less picturesque, Kuni-
yoshi's Edo landscape scenes with artisans and laborers displayed promin-
ently in the foreground are doubtless more typical of his new approach to
landscape—a rather "photo-journalistic" one, influenced by Western art,
and later to be even more strongly reflected in the prints of Kiyochika.

Of the dozens of lesser pupils of Toyokuni, let me resurrect just one
whose artistic life was brief, and many of whose prints are worthless, but
who, in one rare series of landscapes, well justified his existence. Toyokuni II
(1802 to about 1835) was theoretically the first Toyokuni's legitimate suc-
cessor, but he succeeded to his father-in-law's name upon the latter's death
in 1825, against the jealous objections of such older Toyokuni pupils as
Kunisada, who insisted upon calling himself, and signing his prints, "Toyo-
kuni II"—though today we more usually refer to him as "Toyokuni III."
Whatever his lineage, the earlier "Toyokuni II" produced little of great
merit among his figure prints and miscellaneous subjects, but in the series
Eight Famous Views he somehow managed to design several prints the equal
of all but the finest work of his more famous contemporaries, and one print
(Plate 141) that may well bear favorable comparison even with Hiroshige.
How he accomplished this, I do not know. He owed much, certainly, to
Hokuju and to Hokusai, as well as to skillful engravers and printers; but
one gets the strong impression that Toyokuni II might well rank with
Eisen, Kunisada, and Kuniyoshi had he been given further opportunities
to develop his unique view of landscape.

Although it is always somewhat perilous to characterize an alien society
Japanese city-dwellers from the late eighteenth century seem to have entered

139 Kuniyoshi. Bewitched Foxes Rehearsing Their Roles. 1840's. Medium-sized color print.

upon a period not only of suppressed ferment, of dissatisfaction with the dead end reached by an inbred society, but frustration with the means of escape. Gradually we find a turn to novelty and meaningless variation to relieve this boredom. At the same time there was greater and greater government interference in the arts. In ukiyo-e, with the nineteenth century, the result in figure design was often a confused combination of superficial realism and escapist fantasy—decadence, if you like, but certainly a period of decline in much of Japanese art. Connoisseurship itself suffered a fall with the general decline in taste and in the "Edo spirit."

Further, the vital interest of the Edo connoisseurs in fine prints had gradually cooled with the commencement of the nineteenth century; it was they, it will be remembered, who supported and directed much of the glory

of Harunobu, and lent their taste to many another artist and publisher during the last quarter of the eighteenth century.

With these refined critics largely gone, the ukiyo-e print was gradually reduced to a more directly popular art, and soon declined to the level of its new audience. Coincidentally, though an inherited sense of design continued to serve the later ukiyo-e artists, not many of them were the equal of even the lesser masters of the previous century. In effect, then, imaginative leadership was lacking either among critics or among the artists themselves; and this was a fatal lack in a form which trod the narrow line of sensitive artistry above a base of semipopular support. It was only when the artist escaped to nature from the world of man that he was able to revive a beauty that seemed almost lost from ukiyo-e.

With the death of Utamaro and the effectual retirement from the field of figure prints of such masters as Kiyonaga, Shumman, Choki, Eishi, the genus lost its impetus as a universal art. It soon fell into a form of plebeian pin-up which, despite its general effectiveness in design and printing, rarely ranks as fine art. The early prints of Eizan, Shuntei, Shunsen, and Kunisada sometimes effectively reflect the glory of Utamaro, but by the 1810's one must plow though literally thousands of figure prints to find one worthy of comparison with even the minor achievements of two decades earlier.

Eizan's pupil Eisen (1790–1848) stands with Kunisada as the most popular and prolific figure-print designer of the nineteenth century, but despite his obvious skill and consistently careful craftsmanship, he was unable to escape the corrupt conventions that the figure print had insensibly fallen into. Not unlike others of his contemporaries, he produced his most memorable work in the sideline of landscape prints. It was Eisen who commenced the great series of *Sixty-nine Stations of the Kiso Highway* which Hiroshige was to conclude.

In comparing Eisen's rather neglected landscape prints of the series with the too often reproduced work of Hiroshige, there is always the danger of mistaking variety for quality. Nevertheless, one feels that in his compromise between the overpowering draftsmanship of Hokusai and the evocative poetry of Hiroshige, Eisen often achieved a stimulating effect not far below the average of the greater masters. Plate 138 could, I suppose, be analyzed as "Hokusai foreground, Hiroshige background"; but the total effect is an impressive one, rather consistently felt throughout Eisen's landscapes, and it may well justify us giving him prominent secondary rank (with Hokuju

*140 Kuniyoshi. Priest in Snow. Mid–1830's. A Buddhist priest toils through snow
on the remote Island of Sado. Medium-sized color print; one of the Scenes from the
Life of St. Nichiren. Several early versions of this print exist, some omitting the
horizon.*

and Kuniyoshi) in the world of ukiyo-e landscapists of the late Edo Period.

Ukiyo-e prints of the third quarter of the nineteenth century were large-
ly the products of the pupils or followers of Kunisada, Kuniyoshi, or Hi-
roshige, but there are few names deserving even passing mention here.
Perhaps the finest print designer of the period was Yoshitoshi (1839–1892),
a Kuniyoshi pupil who stands almost alone in preserving ukiyo-e vigor
during these years of social, political, and artistic upheaval.

Though only an occasional worker in the ukiyo-e medium, Kyosai
(1831–1889)—at one time a Kuniyoshi pupil—also deserves mention here,
if only for his prints in non–ukiyo-e styles such as that shown in Plate 143.
Such works might well be mistaken for parts of the "modern print move-

ment"—if we did not know that Chinese and Japanese ink painting was already replete, many centuries earlier, with "modern" elements of bold simplicity almost approaching abstraction.

For the most characteristic figure of late nineteenth century ukiyo-e prints we must turn to Kobayashi Kiyochika (1847–1915), who is unique in that he could be cited as representing either the last important ukiyo-e master, or the first noteworthy print artist of modern Japan. Since, however, the ukiyo-e print tradition practically died with Kiyochika, it is probably most accurate to regard him as an anachronistic survival from an earlier age, a minor hero whose best efforts to adapt ukiyo-e to the new world of Meiji Japan were not quite enough.

Kiyochika was the son of a minor government official, but lost his inheritance with the revolution—that is, the Meiji Restoration of 1868. Subsequently he studied the new art of photography under a Japanese pioneer in Yokohama, and Western-style painting under the English artist Charles Wirgman, who was Japan correspondent for the *Illustrated London News*. Thus, ironically yet logically, Kiyochika, last of the ukiyo-e masters, directly embodied in his own art the two innovations that were to spell the doom of ukiyo-e.

Just as photography is often thought to have killed off the art of portraiture in Western painting, so may it be said to have hastened the demise of ukiyo-e. The Japanese "pictures of the floating world" were, by the mid-nineteenth century, based principally upon a popular market which little understood or appreciated the unique art form it was supporting. When a more novel and cheaper method of depicting the current scene—mass-produced photoengraving—appeared, ukiyo-e prints were automatically doomed. (Ukiyo-e paintings, however, with a more aristocratic and stable basis of support, have continued in mutated form even to the present day.

Had photography and English art proved the principal sources of Kiyochika's work, he would, of course, hardly require mention here. The fact is, however, that he had been a self-taught artist from an early age, and subsequently studied under such masters of traditional Japanese painting as Kyosai, Zeshin, and Chingaku; and when in 1877 Kiyochika commenced producing his famous landscape prints, the results combined not only these varied influences, but above all a strong flavor of ukiyo-e, derived most probably from a study of the works of Hiroshige and Kuniyoshi.

Kiyochika's new style of print design was a logical extension of the

earlier work of Kuniyoshi in a semi-Western manner. For the first time the popular Japanese audience found their local scenes depicted, through wood-block prints, in a manner at once exotically foreign yet not so alien as the copperplate experiments of Kokan and Denzen a century earlier.

Kiyochika's prints were a popular success, and he produced them in great numbers during the years 1876–1881, which marked the early peak of his art. Kiyochika continued to sketch and publish throughout most of his long life, but his extensive work in book, magazine, and newspaper illustration, his cartoons, and his large prints glorifying the battles of the Sino-Japanese and Russo-Japanese wars seldom equal his early still lifes and the abundant genre scenes of the Tokyo landscape, which form such a fascinating contrast to those of Hiroshige.

In Japan, indeed, Kiyochika is often dubbed "the Hiroshige of the Meiji Era"; but to the foreign viewer their similarities will appear largely those of subject matter. Certainly what Kiyochika most lacks is the unified poetic view of nature that pervades the best of Hiroshige. In contrast to Hiroshige, Kiyochika appears most often a successful but hardly great realist, an artist whose prints may bring pleasant pangs of nostalgia for the changing Japan of the 1870's and 1880's, but which seem more often a substitute for creative photography than an outstanding artistic achievement.

Of Hiroshige himself, of course, there is the traditional Japanese criticism, "Out of one hundred prints, eighty are dull, ten excellent, nine superior, one breath-taking." Although Kiyochika never reached the level of Hiroshige's "breath-taking" work, a similar assessment would doubtless apply well to his *oeuvre*, and a successful Kiyochika print such as that shown in Plate 142 may surely be ranked with the finer landscapes of Kuniyoshi and Kunisada.

With Kiyochika, however, a nonartistic factor intervenes, an element that may well put his work permanently outside the range of collectors whose only interest in Japan is in its prints. This problem arises from the age in which Kiyochika lived and worked—the first period of wholesale adoption of the appurtenances of Western civilization in Japan. Thus, although we are able to savor appreciatively and perhaps nostalgically the "quaint" flavor of our own nineteenth-century engravings, there is something incongruous and basically ugly to us in the image of a sedate Japanese gentleman sporting English bowler and black umbrella in the midst of an otherwise enchanting landscape.

141　Toyokuni II. Mountain Temple in Rain. Early 1830's. A driving rain, fantastically colored by the alternate light and shadow of dusk, beats down on the sacred mountain Oyama and its temple to the god Fudo. Medium-sized color print; one of a series of *Eight Famous Views.*

To the Japanese of Kiyochika's time such elements had, on the contrary, considerable fascination—they were symbols of a great but only half-known civilization which was soon to overwhelm the Japanese nation and conquer at least the superficial side of its life. Kiyochika's lack of popularity today rests in his honest realism and in the indiscriminantly catholic tastes of his contemporary audience. The bowler and black umbrella may be splendid symbols of the superficial encroachments of Western civilization in Meiji Japan; but to us they are incompatible with our idealized image of Old Japan, and hence (at least until we know Japan well enough to feel our own kind of nostalgia for its nineteenth century) we are repelled by the un-Japanese elements in Kiyochika, and may well prefer to state categorically, "Ukiyo-e died with Hiroshige."

The new Western elements were, indeed, so popular in the Japan of

294

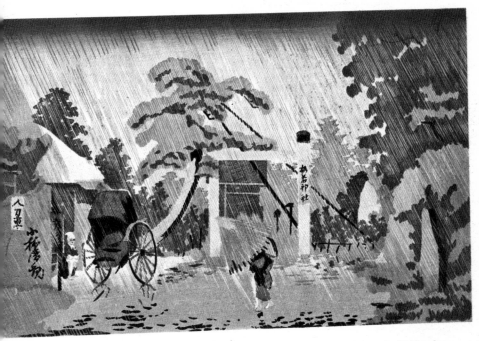

142 Kiyochika. Shrine in Rain. ca. 1879. A woman traverses the mud, hidden by her umbrella; a coolie squats by his rickshaw station. The scene is the melancholy Umewaka Shrine in Edo, raised in memory of a child murdered here in ancient times. Medium-sized color print.

Kiyochika's time that they probably pervade his prints far more than they did the actual lives of many of his contemporaries. For the sake of restoring Kiyochika to his proper place as the last of the important ukiyo-e print artists, it would certainly be useful to form a collection of the many prints in which foreign elements are absent or play but a minor role. Such a selection would, however, omit a majority of his most notable prints, so predominant was the taste for the exotic foreign elements in his day—and ever since. Even in the Kiyochika print chosen for illustration, the foreign element only escapes us due to our own forgetfulness. Though the ricksha may seem very Oriental to us today, it appears actually to have been the invention of an American missionary in the Japan of Kiyochika's youth!

More than anything else, it was Daguerre's invention that spelled the end of Kiyochika's art, and that of notable disciples such as Ryuson and

Yasuji. By the time the public came vaguely to comprehend that photography, however wonderful an invention, could only rarely approach even the minor achievements of a Kiyochika, the habit of buying prints was forever dead, and so for the main part were the remarkable artisans who had made the prints possible. Europe's discovery of the Japanese print came too late to effect any revival. Even had foreign enthusiasm erupted decades earlier, it is a bit painful to imagine a man like Kiyochika having to cater to rose-colored foreign tastes, and convert to archaic Hokusai-Hiroshige concepts as the only alternative to abandoning his art. The ukiyo-e print was an ever-changing but always essentially Japanese art, deeply rooted in the native soil, directed, at its best, by an inspired group of artists and critics, but seldom in its later stages more than a hair's breadth removed from the dictates of popular taste.

Epilogue

FROM UKIYO-E
TO INTERNATIONAL ART

The Twentieth Century

WITH the Meiji Restoration of 1868 Japan underwent a change so revolutionary in all cultural fields that it would be difficult to believe had we not the effects so evident today throughout the life of modern Japan. The change was all the more abrupt for following two and a half centuries of strict seclusion, during which contact with the rest of the world was strictly limited to trade with a few Dutch and Chinese ships per year in the isolated port of Nagasaki. By this very token, curiosity about the West was practically at fever pitch by the time Japan was opened to foreign intercourse—even among those who, for political and personal reasons, opposed the move in principle.

We have already seen how, in ukiyo-e, vaguely comprehended concepts of Western art had been seized upon as ultramodern, enjoying a wider popularity than the artistic results justified. It may be well to recall here some of the non–ukiyo-e pioneers of Western–style art in Japan, the men to whom such artists as Toyoharu, Hokusai, Hiroshige, Kuniyoshi, Kiyochika, owed their basic acquaintance with such matters as Western-style perspective and realistic depiction.

Gennai, Kokan, Denzen, and several minor artists had pioneered the production of Western-style oil paintings and engravings in the eighteenth century. Though these men often chose contemporary Japanese scenes for their work, such etchings, prints, and painting were hardly ukiyo-e, and in general bore little relation to any of the traditions of Japanese art.

297

Several ukiyo-e artists, however, soon followed the lead of these early experimenters in applying semi-Western technique to Japanese scenes, and the results were usually ukiyo-e, despite their superficially Occidental overtones. By the time of Hokusai's great landscapes, these foreign elements had been well digested and provided a needed stimulus to a revolt against the outworn conventions into which ukiyo-e figure depiction and landscape had fallen. With Hokusai and Hiroshige the foreign element became so well integrated that it is imperceptible to the average viewer today; nevertheless, its subconscious influence has, in the West, rendered these two artists the best loved (or at least, the most readily understood) Japanese masters—to the exclusion of dozens of equally admirable artists in ukiyo-e as well as in many other styles.

One subdivision of Japanese prints may be mentioned incidentally here, the Nagasaki prints. These were a group of "folk-art" prints produced in Nagasaki in the late eighteenth and early nineteenth centuries, usually by anonymous artists of only moderate ability. They served, doubtless, as souvenirs for visitors to the only port of foreign intercourse, and depicted principally quaint Chinese and Dutch scenes and figures in a semi-foreign style, but printed according to traditional ukiyo-e methods. The Nagasaki prints form an interesting chapter in Japanese cultural history, but are of dubious artistic significance. Nevertheless, they (along with the equally exotic but inartistic Yokohama prints, depicting the early foreign traders in that port after the opening of Japan) have attracted a passionate group of collectors. The Nagasaki prints are generally most successful as art in their frequent representations of foreign ships on the open sea, where the combination of detailed observation plus excellent color printing often produces an effective pattern of folk art.

Were our story to be concerned exclusively with ukiyo-e, it would end most effectively with the nineteenth century—with Hokusai, Hiroshige, Kuniyoshi all dead, a new Japan arising; their followers to carry on for but a few decades with what momentum remained to a once glorious school of art. In this concluding chapter, however, we shall try to provide some kind of link between the past and the present, and it seems best, therefore, to begin with a brief consideration of ukiyo-e's last struggles in the revolutionized world of new Japan.

With Hiroshige's death, the traditional ukiyo-e print approached its end, and Kiyochika succeeded but briefly and imperfectly in adapting it

to his age. It will be recalled, however, that ukiyo-e had always consisted of two principal mediums, the relatively inexpensive prints (and books), primarily for popular consumption, and the paintings, commissioned by affluent connoisseurs—as well as by wealthy people with a blank wall to cover and a taste for the modern rather than the classical. By the end of the nineteenth century the ukiyo-e prints and books were dead. Their place was never really filled, although photographs, reproductions, and magazine illustrations nominally bridged the gap.

For the prestigious ukiyo-e paintings, however, no such mechanical substitutes were possible. Among the intelligentsia, to be sure, a strong taste for European-style painting had risen, supplied both by imports, by reproductions, and by the growing number of expert native painters in Western style. One gets the impression, however, that traditional styles of Japanese painting lost more customers to European-style art than did ukiyo-e.

Paintings in the various Japanese styles had always been designed primarily to be hung in the recessed vertical alcove (*tokonoma*) provided for that purpose in the Japanese parlor. Until the very architecture came to be modified along Western lines, the picture alcove had to be filled with a hanging scroll (*kakemono*)—a format unsuitable for oil paintings on canvas and rarely a successful medium for displaying any other form of European art either. This gap was filled in part by painters in the varied traditional styles of Japanese painting, but there were many collectors who remained unmoved by the more classical, "detached" schools of Japanese art. In addition, as decorative elements in geisha houses and other establishments which specialized in lively entertainment, there was really no substitute for the vivid color, the human grace and charm evinced in a fine ukiyo-e girl painting or a scene from the spectacular Kabuki drama. Thus ukiyo-e continued to live, after a fashion, in the paintings long after the prints were dead. And a school of skillful semi-ukiyo-e painters continues to this day, with little sign of further decline until that sad, unlikely day when native Japanese styles of architecture may be found only in historical monuments and museums.

Modern ukiyo-e painting ranges in scope from romanticized Kabuki representations and re-creations of nostalgic scenes from bygone days to straightforward paintings of lovely maidens and geisha from many periods, both past and near-present. Unlike the work of Kiyochika and the other late print artists, twentieth-century ukiyo-e generally avoids non-Japanese elements: whether the subject is of the seventeenth or the twentieth century,

it is romanticized or at least simplified so that no elements distract from the purely Japanese mood. Of course, if ukiyo-e by definition implied portrayal of the *current* world, the modern paintings are generally not ukiyo-e; however, "traditional" ukiyo-e, too, employed great numbers of scenes from the past. Still, there is no objection to dubbing the more modern work as "neo-ukiyo-e," for it is essentially a re-creating of the past. Indeed, there is only a limited present suitable for recording in the traditional ukiyo-e manner—and what there is, derives primarily from the traditional theater and geisha districts, themselves nostalgic holdovers from an earlier age.

Having thus introduced an aspect not, so far as I know, hitherto discussed by writers on ukiyo-e, I must hasten to add that there are few great works of art in neo–ukiyo-e. The attempt to re-create the romantic past leaves little room for great creative achievement. Furthermore, it may be suggested that ukiyo-e painting lost something vital and irreplaceable when it discovered itself all alone, abandoned by the broad base formed by the popular prints. Indeed, the greater part of modern ukiyo-e gets short shrift in Japan itself and is generally deported via the eager hands of tourists.

The few really notable neo-ukiyo-e painters are, it happens, more highly valued by Japanese connoisseurs than many of the older masters--at least, demand is always relatively great for living or still-remembered artists, and hence prices are too high to interest the casual tourist. Between the universally recognized artists (Kiyokata, Shinsui, Shoen, Yumeji, among others), and the second-rank modern ukiyo-e painters, however, there is still considerable room for personal discovery, and for illustration we have chosen two masters (Plates 145 and 146) nominally in the latter category.

Far more than was true among the traditional ukiyo-e masters, the contemporaries show great variations in quality of inspiration. Such famous moderns as Shinsui, for example, are sometimes outdone by the best paintings of their lesser rivals. Overproduction and complacency are ever the popular artist's chief foes.

In sum, it may be said that Japan itself has simply moved out of the range of ukiyo-e. This remarkable art was inextricably bound to the age

143 Kyosai. Heron in Rain. ca. late 1870's. After a painting by the seventeenth-century master Kano Tanyu; a similar copy was also made by Kyosai's English pupil, J. Conder. Medium–sized color print.

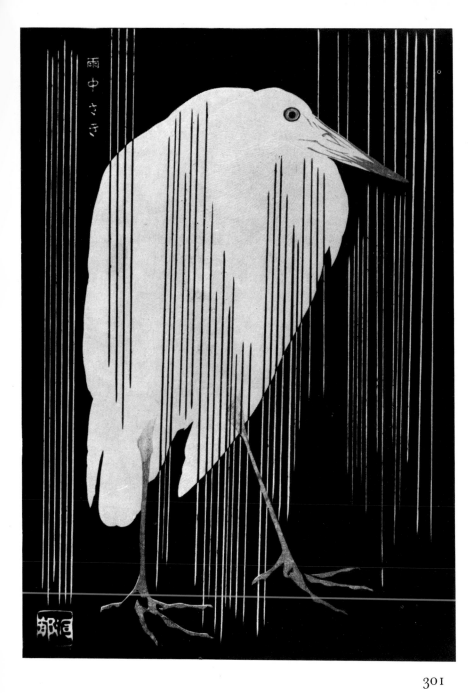

雨中さぎ

in which it grew and developed. The ukiyo-e print is long since dead. Neo-ukiyo-e paintings are survivals which persist largely to satisfy a practical need in the decoration of the traditional Japanese architecture. Perhaps it is we moderns who have failed ukiyo-e, lacking, as we are, in a civilization al colorful as that which this unique art form celebrated.

Although doubtless beyond the scope of the present book, it may be of interest to add a few words here on the subject of modern Japanese prints —sometimes thought to represent the inheritors of the ukiyo-e tradition.

Personally, I wonder if part of the modern Japanese print's current fame is not based on some such premise as this: "Japanese ukiyo-e artists in past centuries produced the greatest color prints the world has known; it stands to reason that prints by modern Japanese artists should also be great." Art appreciation is not without its idealistic aspects, and there is ample room to doubt that the modern Japanese print—in the face of much adept Western competition—would be very widely renowned today were it not for the "advance publicity" given it by Harunobu, Utamaro, Hokusai, and Hiroshige—together with the exotic spell the country itself has cast on foreign collectors. This is not to deny the fact that many modern Japanese prints are good; it is, however, to deny that modern prints owe any direct, notable debt to their alleged native ancestors.

The fact is that most modern Japanese artists have consciously rejected their heritage; they often pay their respects to the ukiyo-e greats only because their real teachers—Whistler, Cézanne, Toulouse-Lautrec, Gaugin, Van Gogh, Klee—have persuaded them to. Modern Japanese printmakers belong, in short, to an international rather than Japanese school of art. We may grant that they have inherited a certain sureness of design and taste in coloring from their native environment. But that very environment has become, in general, so Westernized (and in a quality hardly of the finest) that they must often consciously, and with great effort, seek to re-create the heritage they are supposed to have inherited. Once, however, the international, nontraditional nature of modern Japanese prints is accepted, we may discuss them with greater understanding.

144 Onchi. Abstraction. 1953. A quiet composition by a pioneer leader of the modern print movement. Large color print.

302

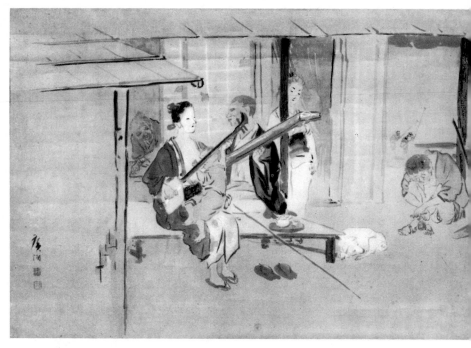

145 Takahashi Koko. House of the Blind. Early 1900's. Painting in colors on paper; medium-sized hanging scroll.

146 (Facing) Miss Ito Shoha. Classical Courtesan. ca. *1925. Painting in colors on silk; detail of large hanging scroll.*

Logically enough, the first modern Japanese prints were the work of the pioneers of Western art in Meiji Japan. Such oil painters and print experimenters as Aono, Takahashi, Goda, and Hosui Yamamoto produced, during the last quarter of the nineteenth century, a number of European-style engravings and lithographs of native scenes, of which the best one can say is that they might often be mistaken for the work of European artists resident in Japan.

Of greater significance was the attempt, in the 1910's and following, to revive ukiyo-e prints through combining the talents of the neo–ukiyo-e painters with the skills of the few remaining engravers and printers. (The latter had managed to survive through engaging in the reproduction—or forgery, depending upon the use to which they were put—of the older

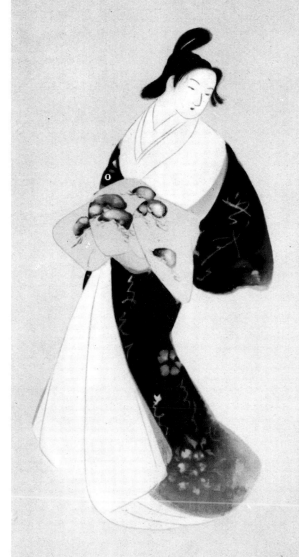

ukiyo-e masters, usually for export.) The idea of reviving ukiyo-e prints was logical, and typically Japanese in its assumption that the hands of art's clock could be so readily set back. The results are of some interest, yet have never appealed strongly to collectors either in Japan or the West, for while the artists' paintings were often pleasant enough, their print designs were seldom prepared with the peculiarities of the woodblock adequately in mind. The results were often either a hardness of contour not consonant with the effeminate softness of the artist's line, an incongruous mixing of three-dimensional and flat, decorative elements in the same plane, or the total impression of a painting arbitrarily reproduced by woodblock. Such artists as Goyo, Shinsui, Kiyoshi Kobayagawa, Hasui, and Kogan made pioneer attempts in this potentially interesting revival, but the genus has never achieved sufficient popularity to warrant exploration of its full possibilities by the artists.

The final stage in the development of modern Japanese prints—and the one that has aroused the greatest interest today—resulted, basically, from an unwitting reintroduction into Japan of artistic concepts often derived from ukiyo-e itself!

The story of ukiyo-e's impact upon the Post-Impressionist painters in France of the late nineteenth century is well known; it included not only a superficial fad for things Japanese, but also a profound change in the painters' concepts. European artists were approaching a dead end, with photography fast encroaching upon their traditional function. In Japanese prints the Post-Impressionists found part of the solution—first, the abandonment of surface realism, and then the reduction of nature to a decorative pattern of only two dimensions.

The enthusiastic new Japanese students of Western painting were not, of course, prepared to be directed back to their own heritage; they patronizingly accepted their foreign teachers' admiration for Japanese ukiyo-e prints, but they themselves were usually influenced only indirectly—that is, through their masters' assimilation of them.

The following, a notation from the Goncourt brothers' diary of 1867,

147 Munakata. Seated Figure. 1954. A vibrantly crowded composition by one of the most active artists in the revival of ancient Oriental styles. Large woodblock print with hand coloring.

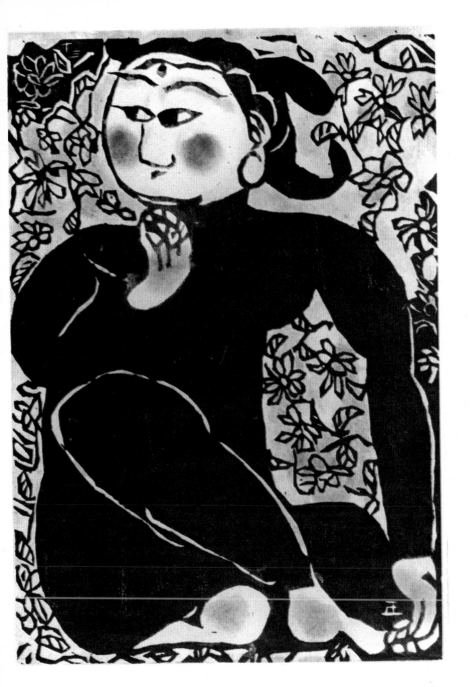

307

may indicate something of the negative attitude toward native tradition which suffused both the European and the Japanese artists of the time: "Why does a Japanese gateway charm me and please my eye when all the architectural lines of Greece seem to my eye tedious? As for people who pretend to feel the beauties of both these arts, my conviction is that they feel absolutely nothing." Only a few years were to pass before Japanese artists and connoisseurs were to feel the same way about their own glorious heritage.

Several of the more progressive Japanese painters of the early twentieth century could have produced prints well suited to setting the modern print movement into motion —Fujishima or Kawamura, for example. But they preferred the more highly esteemed oil paintings, and it remained for a lesser painter, Kanae Yamamoto (1882–1946), to produce the earliest "modern Japanese prints"—in the limited sense of the phrase.

Aside from their emphasis on design specifically for the block (sometimes, indeed, design primarily *on* the block, from only the vaguest of sketches), the modern printmakers have usually insisted upon the necessity of executing every step of the carving and printing themselves—a principle only abandoned by a few artists who have become too popular to be able to spare the time. (In the early 1900's Shisui Nagahara was also already producing notable modern prints, though he entrusted the engraving and printing to specialists. His prints appeared most often in the artistic "little magazines" of the time.)

Lacking, as they do, a popular audience at home, the lot of the modern Japanese printmakers has not been an easy one. With the 1950's they came gradually to be accepted by foreign collectors, but by now their number far exceeds the possible demand. Such artists as Koshiro Onchi (Plate 144), Un-ichi Hiratsuka, Shiko Munakata (Plate 147), Yozo Yamaguchi, Kiyoshi Saito, and Rokushu Mizufune (Plate 148) have now been accepted as "established," but every year in Tokyo there appear a dozen younger men with great potentialities but who often disappear after a brief display of talent.

Suffice it to say here that the trend of modern Japanese printmaking in general is away from the intimate effect, the exact delineation, of ukiyo-e. The finest of the modern prints are bold posters, seen at their best decorating an ultramodern room; unlike ukiyo-e, they are often too big to be held comfortably in one's hands, and there is seldom much in their content to

308

hold one's undivided analytical attention for more than a few moments. The modern prints sometimes warrant their name in Japanese, *sosaku hanga* (creative prints), in an ironical way, for the artist in some processes finds it technically impossible to produce any two prints alike, and is frequently surprised at the results. The role of accident is of course a subject of controversy in modern art in general, and it must be admitted that the purposeful "happy accident" is generally more interesting in detail than the ponderously overdeliberated print.

With the increasing trend of prints to compete in scale with Western-style paintings, the subject becomes further and further removed from the spirit of ukiyo-e prints, though doubtless possessing, coincidentally, something in common with the massive, decorative quality of earlier Japanese screen paintings. Modern Japanese prints, in any event, are no longer the product of one locality, but of the world.

In concluding our story, several general misconceptions regarding ukiyo-e remain to be reviewed. The most common is, of course, that ukiyo-e is synonymous with "Japanese prints." We have already seen ample evidence that the prints, though representing the greatest output in numbers, were accompanied by quantities of ukiyo-e paintings, done for the more wealthy patrons who could afford them. Indeed, for most of the formative first century of ukiyo-e there were yet no prints at all, only paintings. Other lesser-known work of the ukiyo-e artists included painted theatrical billboards, printed greeting cards and announcements, great quantities of book illustration, and erotica in both painted and printed format; but we are, nevertheless, safe in generally defining ukiyo-e as the product of individuals in a definite artistic school, consisting of paintings and prints devoted primarily to scenes of the contemporary world, though often harking back to well-known figures and allusions from both Japanese and Chinese history. At the same time, most of the great artists of ukiyo-e had studied the classical styles of painting, whether Tosa, Kano, or those derived directly from China, and they could, when they wished, produce expert work almost totally devoid of ukiyo-e content or approach. Such work does not really represent ukiyo-e, even though produced by an ukiyo-e master. With a highly eclectic artist such as Hokusai, of course, the amount of non–ukiyo-e and semi–ukiyo-e is tremendous. Modern Japanese prints, as we have seen, bear hardly any relation to ukiyo-e; probably they are the poorer for it.

Two further problematic points—asserted even by advanced amateurs on the subject—are that ukiyo-e is a folk art and an entirely popular art form. Although the product of a definite tradition and school—even the least talented of whose members could produce commercially salable prints —ukiyo-e was the work of individuals, nearly all known clearly by name, and each a separate personality. Ukiyo-e borrowed widely from the vast mass of Japanese legend and tradition, but is not a folk art according to any definition I know.

Even more widespread is the belief that ukiyo-e is a purely plebeian art, solely the product of popular demand. It is true that ukiyo-e almost became that in the nineteenth century, and thereby practically killed itself off. Ukiyo-e paintings, of course, were never cheap enough to be available to the masses; but what of the prints?

Even the quantity-produced prints were, I feel, during the seventeenth and eighteenth centuries primarily directed toward a highly select audience, not necessarily composed primarily of art connoisseurs, but still, people who had a discriminating taste and a good eye for beauty of color and design. To suppose that a total populace could be naturally endowed with such taste is to romanticize and, moreover, to ignore the fact that when the prints did become mass-produced for a plebeian audience, they soon lost many of their finer aesthetic qualities. Harunobu's is an extreme case of the cultivated literati's having a benign influence on ukiyo-e prints. More often it was simply the taste of the artist and publisher, directed toward a highly discerning audience, that governed the general tone and level of ukiyo-e prints. Even in the nineteenth century this audience still existed, and no doubt provided the market for the *surimono* and the first editions of the great Hokusai and Hiroshige prints. The same prints, however, once mass-produced for cheaper sale, gradually became almost parodies on the originals. Working with hand-printing methods, the difference even between printing editions of three hundred and three thousand is almost enough to account for the technical decline. In addition, with the extreme popularization of the form, a fair part of the elite audience doubtless grew cold to the prints and withdrew their patronage, thus hastening the decline. Since the supreme efforts of the designer and printer were now wasted on a less sensitive audience, some of the greatest artists turned from prints to painting, while those who remained grew lax and careless in the absence of active criticism and an audience responsive to creative effort. The new audience demanded

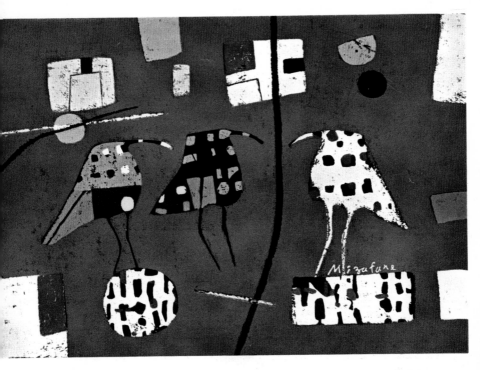

148 Mizufune. Three Birds. 1959. A firmly balanced fantasy by a noted sculptor experimenting in the print form. Very large color print.

primarily movement and bright colors of their prints, and these they got in ample measure.

In broad outline it seems to me that ukiyo-e's development during three centuries follows somewhat these lines: Paintings for the aristocracy; paintings and prints for the cultivated upper middle classes; prints primarily for the urban masses. Ukiyo-e was not, by any means, an essentially "popular" art. I suspect it was our own romantic nineteenth-century collectors who made it so. Yet these collectors, who rediscovered an art by then degraded and repudiated in its own country, were intuitively just in their appreciation of ukiyo-e as a striking achievement in the history of art. Beyond this, it does not really matter who supported and nurtured the Ukiyo-e school: its artists were remarkable and their audience was enthusiastically responsive. The result is now history.

NOTE ON PRONUNCIATION AND
SIZE OF PRINTS

In Japanese pronunciation the vowels may be described most simply as similar to those in Italian or Spanish, the consonants rather like those in English. Thus *ukiyo-e* is pronounced oo'kee–yoh'eh, Kaigetsudo is ki'gets –doh, and Hiroshige is hee'roh–shee'geh; *g* is always hard, and *j* is always soft; e.g., Genji is ghen'gee. Japanese diacritical marks have been omitted in this book.

Traditional Japanese artists are known by their art–name rather than by their surname; we have followed the Japanese form of surname first, art–name last; for example, Katsushika, Hokusai, Ando Hiroshige. Modern Western–style printmakers and painters, however, consider themselves part of an international rather than Japanese movement, and hence usually follow western conventions in signing their work.

Measurements for prints and paintings have been expressed in the general terms "small, medium, large," and vary according to the medium used. Thus a painting or print 8 × 10 inches in size would be considered "small," whereas a single-page book illustration of the same size would be "large."

ACKNOWLEDGMENTS AND CREDITS

Greatest personal thanks are due here to the three gentlemen to whom this book is dedicated; and to the Rockefeller Foundation for a grant-in-aid, administered by the Honolulu Academy of Arts.

Grateful acknowledgment is due to the museums and collectors who have consented to see their prints and paintings reproduced here:

INSTITUTIONS

Boston Museum of Fine Arts: 4.
The British Museum: 101, 105.
Chicago Art Institute: 34, 52.
Freer Gallery of Art: 59, 87.
Honolulu Academy of Arts (principally the James A. Michener Collection): 1, 6, 14, 15, 41, 42, 45, 53, 56, 61, 75, 78, 80, 86, 88, 91, 92, 96, 97, 98, 99, 106, 107, 111, 118, 121, 122, 128, 129, 131, 134, 137, 139, 143, 144, 147, 148.
Los Angeles County Museum (principally the Helen and Felix Juda Collection): 18, 50, 67, 68, 84, 95, 130, 138, 142, 145, 146.
Metropolitan Museum of Art: 20, 28, 89, 127, 133.
Saito Foundation (Osaka): 82.
Tenri University Library (Nara): 55.
Tokyo National Museum: 13, 19, 24, 25, 26, 27, 29, 30, 35, 36, 37, 40, 44, 47, 48, 49, 51, 54, 60, 64, 65, 69, 70, 71, 72, 73, 74, 76, 77, 79, 81, 83, 85, 90, 93, 94, 100, 101, 103, 104, 108, 110, 113, 114, 115, 116, 117, 119, 123, 125, 126, 132, 135, 136, 141.

PRIVATE COLLECTIONS

Sir Chester Beatty (Ireland): 3.
Hara Collection (Tokyo): 5.
Mr. Ralph Harari (London): 124.
Mr. Claude Holeman (Tachikawa): 140.
Mr. Kiyoshi Shibui (Tokyo): 10, 11, 12, 21, 22, 32, 46.
Mr. Nakasuke Tsuihiji (Tokyo): 120.
The remaining items are from anonymous Japanese collections, or the author's collection.

I am also happy to acknowledge the kind permission of Charles E. Tuttle Company to quote from my *Kaigetsudo* (1959).

All translations are by the author.

INDEX

Agents in print making, 153-58
Albums, 49, 51, 58, 76, 81, 102, 108, 130, 204, 213, 224
Anchi, 70
Ando, 6, 61-74
Ando Hiroshige, 269
Artist and artisan, 58
Asakusa, 62

Background, 160, 209
Bakin, 256
Banki, 225
benizuri-e, 95, 116
bijin-ga, 27
Book illustration, 36, 49, 76, 125, 130, 134, 142, 204, 213, 254
Brocade prints, 97, 152, 204
Buddhist priests, 9, 37, 76, 106
Buncho, 172-76, 180, 184, 190, 254

Calendar prints, 150-60
Chikanobu, 74
Children's books, 95
Chincho, 120
Chinese painting, 8, 252, 256, 292, 309
Ch'iu Ying, 149
Chobunsai Eishi, 225
Choki (Eishosai), 190, 193, 208, 213-19, 220, 254.
Choki (Miyagawa), 141
Choshun, 6, 18-41, 178
Choyodo Anchi, 70
Chushingura, 197, 254

Coloring, 34-35
Color printing, 36, 113-16, 152-58
Connoisseurs, 7, 36, 38, 150, 152, 248, 289, 299, 308, 310
Courtesan critiques, 36
Courtesans, 16-17, 20, 29, 32, 64, 106, 126, 134, 171, 204, 221, 224, 228, 232

Denzen, 297
Dohan, 74
Doshin, 71
Doshiu (Norihide), 71
Doshu (Noritane), 71
Doshū, see Doshiu

Edo, 12, 32, 62, 125, 127, 134, 237, 261, 276, 282
Edo Period, 7, 12
Eight Views of Lake Biwa, 119, 277
Eiri, 229, 240
Eisen, 249, 272, 288
Eishi, 184, 200, 220, 225-29
Eisho, 229, 240
Eishun, 74
Eisui, 232
Eizan, 249, 272, 290
Ejima, Lady, 65, 79
ema, 64
engravers, 157
Enkyo, 190
Erotica, 36, 49, 58, 81-82, 131, 142, 163, 169, 181, 208-9, 222, 284

Fashions, 49
Fifty-three Stations of the Tokaido, 272, 276
Figure prints, 246, 290
Floating world, 10, 42
Flower-and-bird prints, 171, 279
Force of tradition, 188
Formalism, 180
Fuji, Mt., 242, 256-57

Gakutei, 266
Geisha, 126, 201
Gennai, 190, 233, 253, 297
Genroku Period, 79, 91
Goncourt brothers, 222, 306
Goshichi, 249
Government edicts, 91, 178
Goyo, 306

Hambei, 75, 126-27
hanamichi, 81
Harunobu, 7, 100, 146, 148-58, 171, 180-81, 184, 200, 205, 213, 232, 254, 310
Harushige, 168
Haryu (Haritsu), 141
Hasui, 306
Hidemaro, 225
Hikone Screen, 29
Hiratsuka Un-ichi 308
Hiroshige, 7, 120, 158, 233, 248, 257, 269-84
Hishikawa Moronobu, 42-60
Hishikawa school, 42-60, 64
Historical prints, 285
Hizakurige, 273
Hokkei, 266
Hokuba, 266
Hokuju, 263, 276, 288
Hokusai, 7, 102, 141, 181, 190, 232-33, 240, 244-68, 273-77, 279, 281-82, 288, 298
Hokusai Manga, 256, 260
Horyuji, 33, 35

ichimai-e, 49
Ikku, 273
Imperial court, 13, 142
Ink prints, 113
Ippitsusai Buncho, 172
ishizuri-e, 112
Isoda Koryusai, 168
Issho, 141
Itcho, 141, 284

Kabuki, 16, 27, 65, 75-81, 112, 116, 178, 205, 237, 246-48, 288, 299
Kaigetsudo Ando, 61-74
Kaigetsudo Dohan, 74
Kaigetsudo Doshin, 71
Kaigetsudo Doshiu, 71
Kaigetsudo Doshu, 71
Kaigetsudo school, 61-74, 122, 138, 200
kakemono, 32, 112, 169, 254, 299
Kako, 254
Kano Hideyori, 13
Kano Naganobu, 13
Kano school, 7, 9, 12-13, 16 29, 116, 130, 141-42, 149, 168, 225, 252, 269, 281, 309
Kansei Reforms, 27
Katsukawa Shuncho, 212
Katsukawa Shunsho, 178
Katsushika Hokusai, 244
Kawamata school, 134, 149
Kikumaro, 225
Kimono, 27, 64, 116, 131
Kitagawa Utamaro, 220
Kitao Masanobu, 204
Kitao Shigemasa, 200
Kiyochika, 292-96, 299
Kiyoharu, 120
Kiyohiro, 94, 101
Kiyokata, 300
Kiyomasa, 213
Kiyomasu, 58, 82-87, 171
Kiyomasu II, 89
Kiyomine, 213
Kiyomitsu, 95-100, 149, 152, 168, 205

Kiyomoto, 75
Kiyonaga, 100, 166, 168, 200, 204-12, 220
Kiyonobu, 58, 64, 75-82, 102, 188, 200
Kiyonobu II, 88
Kiyoshige, 94-95
Kiyotada, 94, 233
Kiyotomo, 94
Kiyotsune, 100, 149, 168
Kobayagawa Kiyoshi, 306
Kogan, 306
Kogyu, 141
Kokan, 168, 190, 233, 253, 297
Koko, 304
Komachi, 32, 89
komuso, 97
Korin, 252
Koriusai, see Koryusai
Koryusai, 166, 168-71, 184, 200
Kubo Shumman, 212
Kunihisa, 249
Kunimasa, 194, 248
Kuninao, 249
Kunisada, 249, 284, 288
Kuniyoshi, 249, 285
Kwaigetsudo, see Kaigetsudo
Kyoden, 193, 204-5, 212
Kyosai, 291-92
Kyosen, 152
Kyoto, 8, 27, 32, 78-79, 125, 127, 131,
 135, 279

Lacquer prints, 86, 89, 109, 114, 119
Lake Biwa, 119, 122, 277
Landscape prints, 54, 120, 201, 232, 253,
 256, 269-296
Line, 34-35
Love novels, 31, 126

Manga, 256, 260
Mangetsudo, 120
Masanobu, 102-20, 205, 232-33
Masanobu (Kitao), 204
Masayoshi, 204-5, 240

Masunobu, 168
Meiji Restoration, 80, 292, 297
Mica prints, 221
Michinobu, 134-38
Mitsunobu, 134
Miyagawa Choshun, 138
Mizufune Rokushu, 308
Modern Japanese prints, 302-9
Momoyama Period, 11
Morofusa, 57
Moromasa, 120
Moronobu, 7, 42-60, 64, 75, 103, 106,
 138, 141, 160, 171, 184, 200, 205, 237,
 273, 285
Moroshige, 57, 120
Munakata Shiko, 33, 308

Nagahara Shisui, 308
Nagasaki prints, 298
namban-byobu, 13
Nara-e, 16
Nara pictures, 16. 27
Narihira, 21, 32, 178
Naturalism, 209
Neo-ukiyo-e, 300
Nichiren, 111, 291
Nihombashi, 210
Nishikawa Sukenobu, 130
nishiki-e, 152
Noh, 81, 106, 172, 188
Nude, the, 27, 124

Oei (Oi), 266
Okumura Genroku, 109
Okumura Masanobu, 102-20
Okuni, 78
Okyo, 190, 233, 253
Onchi Koshiro, 308
One Hundred Views of Mt. Fuji, 257
Orange-green books, 38, 126
Orange prints, 38, 61, 83, 113
Osaka, 79, 134
Osen, 163, 201

Otsu-e, 13
Otsu pictures, 13, 33

Painting, ukiyo-e, 6, 11-33, 54, 61-74, 100, 116-19, 132, 134-48, 168, 178, 184, 209, 228-29, 240, 254-56, 281, 292, 299-302, 304-6, 309-11
Paper, 34
Perspective, 237, 253, 256
Perspective prints, 233-40, 253
Photography, 292, 295-96
Pillar prints, 169
Poem cards, 32-33
Portraiture, 181
Printers, 157
Printing, 34, 113, 125, 152, 280, 308
Publishers, 7, 86, 119, 153, 188, 193, 204
Puppet theater, 79, 178

Realism, 162, 174, 180, 190
Red prints, 95, 116
Ryu, Miss, 134
Ryukosai, 194
Ryusen, 57
Ryuson, 295

Saikaku, 20, 106, 127
Saito Kiyoshi, 308
Samurai, 17, 27-28, 168
Satire, 285
Sekien, 220, 232
Sekkei, 142
Sessai, 142
Sesshu, 9, 13, 252
Settei, 142-48
Sex manuals, 41
Sharaku, 79, 186, 188-89, 205, 220, 246, 248
Shigemasa, 168, 200, 205, 212, 232
Shigenaga, 120, 149, 171, 277
Shigenobu (Nishimura), 122

Shigenobu (Takizawa), 74
Shigenobu (Yanagawa), 266
Shikimaro, 225
shikishi, 33
Shimabara, 27
Shimmachi, 20, 27
Shinsai, 266, 276
Shinsui, 300, 306
Shinto, 78, 132, 162
Shoen, Miss, 300
Shogun, 8, 9, 65, 91, 149, 225
Shoha, Miss, 304
Shokosai, 194
Shucho, 225
Shumman, 204, 212
Shuncho, 186, 200, 208, 212
Shundo, 186
Shun-ei, 186, 190
Shunjo, 186
Shunko, 186, 190
Shunman, *see* Shumman
Shunro, 186, 244
Shunsen, 29, 249
Shunsho, 141, 168, 178-88, 190, 200, 244, 252
Shunsui, 141, 178
Shunyei, *see* Shun-ei
Shunzan, 186, 212
Shusui (Jusui), 134
Sixty-nine Stations of the Kiso Highway, 280, 290
Soga brothers, 242
Sori, 254
sosaku hanga, 309
Space, 34-35
Stage, 81
Sugimura, 58-60, 82, 160, 171
Sukenobu, 130-34, 149, 160
Sukeroku, 208
Suketada, 134
Sukeyo, 134
sumizuri-e, 113
sumo, 181, 192, 252
surimono, 213, 253, 310
Suzuki Harunobu, 149

Tale of Genji, 104
Tales of Ise, 21, 32, 100-101, 181
tan-e, 38
tanroku-bon, 38, 126
Tatsu, Miss, 267
Tatsunobu, 134
Tempo Reforms, 280, 285
Thirty-six Views of Mt. Fuji, 256
Tokaido Highway, 47, 54, 254
Tokyo, 12, 272
Torii Kiyonaga, 205
Torii Kiyonobu, 75-82
Torii school, 75-101
Tosa school, 7, 8, 11, 13, 16, 28, 31, 32,
 100, 130, 252, 309
Toshinobu, 119
Toshusai Sharaku, 188
Townsmen, 17, 94
Toyoharu, 232-40, 253
Toyohiro, 248, 269, 276
Toyokuni, 186, 194, 220, 240-49, 253, 284
Toyokuni II, 288
Toyokuni III, 288
Toyomaro, 225
Toyomasa, 124
Toyonobu, 122-24, 149-50
Travel, 54, 272
tsubushi, 160
Tsukimaro, 225
Tsukioka Settei, 142
Tsunemasa, 134
Tsunenobu, 116
Tsuneyuki, 134
Tsutaya Juzaburo, 190, 193, 205, 220

uki-e, 233
ukiyo, 10
ukiyo-e, 6, 7, 10, 34, 285, 300, 309-11

Ukiyo-e school, 55, 61
Ukiyoye, see ukiyo-e
ukiyo-zoshi, 20
urushi-e, 89
Utagawa school, 232-49, 284
Utagawa Toyokuni, 240
Utamaro, 7, 59, 68, 190, 193, 200, 208,
 220-25, 228, 240, 290
Utamaro II, 225

Warriors, 42
Western art, 190, 233, 256, 257, 268, 285,
 288, 293-99, 302-9
Wirgman, Charles, 292

Yamaguchi Yozo, 308
Yamamoto Kanae, 308
Yamato-e, 8, 256
Yasuji, 296
Yedo, see Edo
Yeisen, see Eisen
Yeishi, see Eishi
Yokohama prints, 298
Yoshida Hambei, 75, 126
Yoshikiyo, 128-30
Yoshinobu, 168
Yoshitoshi, 291
Yoshitsune, 51
Yoshiwara, 7, 20, 36, 62, 83, 103, 134,
 140, 163, 204, 224, 228-29, 232
Yukimaro, 225
Yumeji, 300

Zeshin, 285, 292